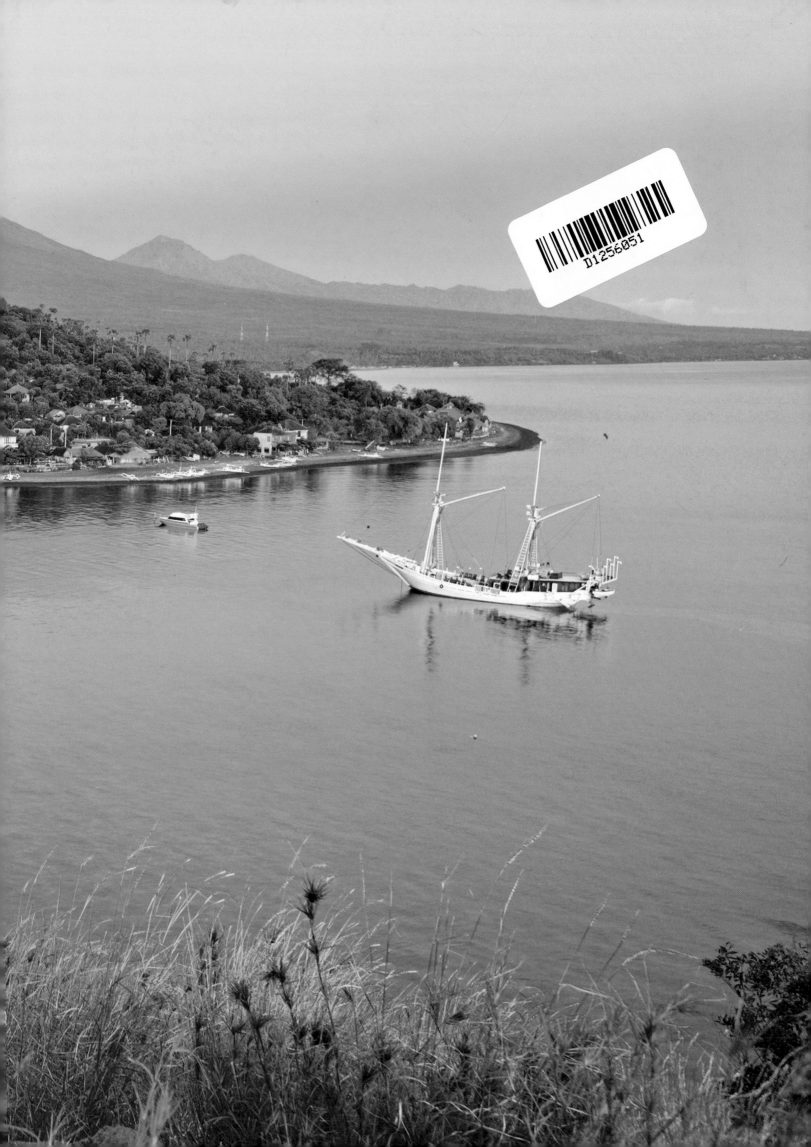

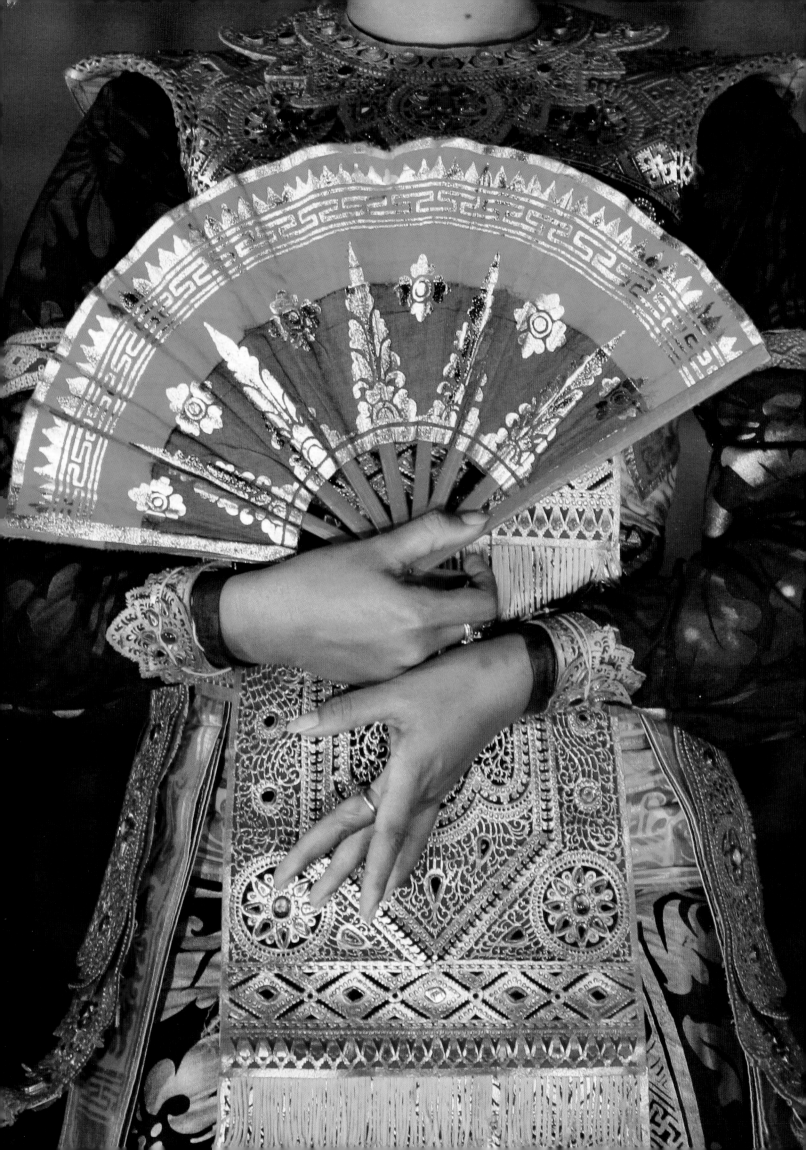

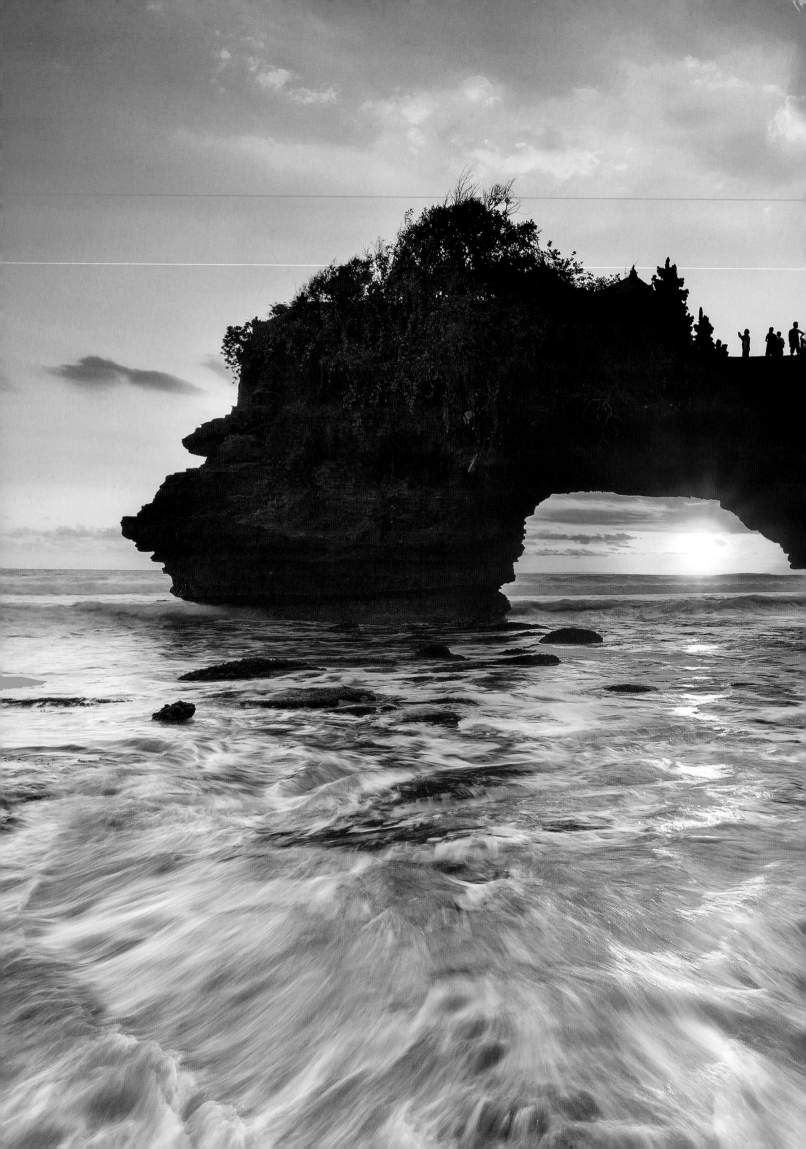

JOURNEY THROUGH
BALI
& LOMBOK

PAUL GREENWAY

TUTTLE Publishing
Tokyo | Rutland, Vermont | Singapore

Published by Tuttle Publishing, an imprint
of Periplus Editions (HK) Ltd

www.tuttlepublishing.com

ISBN: 978-0-8048-4386-7

Distributed by
North America, Latin America & Europe
Tuttle Publishing
364 Innovation Drive
North Clarendon
VT 05759-9436 U.S.A.
Tel: 1 (802) 773-8930; Fax: 1 (802) 773-6993
info@tuttlepublishing.com
www.tuttlepublishing.com

Japan
Tuttle Publishing
Yaekari Building, 3rd Floor
5-4-12 Osaki
Shinagawa-ku
Tokyo 141-0032
Tel: (81) 3 5437-0171; Fax: (81) 3 5437-0755
sales@tuttle.co.jp; www.tuttle.co.jp

Asia Pacific
Berkeley Books Pte. Ltd.
61 Tai Seng Avenue, #02-12
Singapore 534167
Tel: (65) 6280-1330; Fax: (65) 6280-6290
inquiries@periplus.com.sg; www.periplus.com

Indonesia
PT Java Books Indonesia
Kawasan Industri Pulogadung
JI. Rawa Gelam IV No. 9
Jakarta 13930
Tel: (62) 21 4682-1088; Fax: (62) 21 461-0206
crm@periplus.co.id; www.periplus.com

20 19 18 17 16
1 2 3 4 5

Printed in Singapore 1601CP

FRONT ENDPAPERS The far eastern edge of Bali is
dotted with fishing villages where *jukung* boats
compete for space along the black volcanic
sand with the occasional villa and yacht.
PAGE 1 Each stitch of cloth on a Legong dancer's
costume, and even the angle of her fingers,
has a symbolism linked to Bali's unique Hindu
culture and religion. **PAGE 2-3** Jutting out along
one of many rocky outcrops along Bali's southern
peninsula, Pura Batu Bolong temple is part of the
renowned Tanah Lot complex. **RIGHT** A *jukung*
fishing boat is used if a temple ceremony is
held on an offshore island from Bali or if ashes
are to be scattered in the ocean. **OVERLEAF** Rice
terraces are irrigated by an elaborate network
of man-made channels, aqueducts and dikes
that have been laboriously constructed and
maintained by hand for centuries.

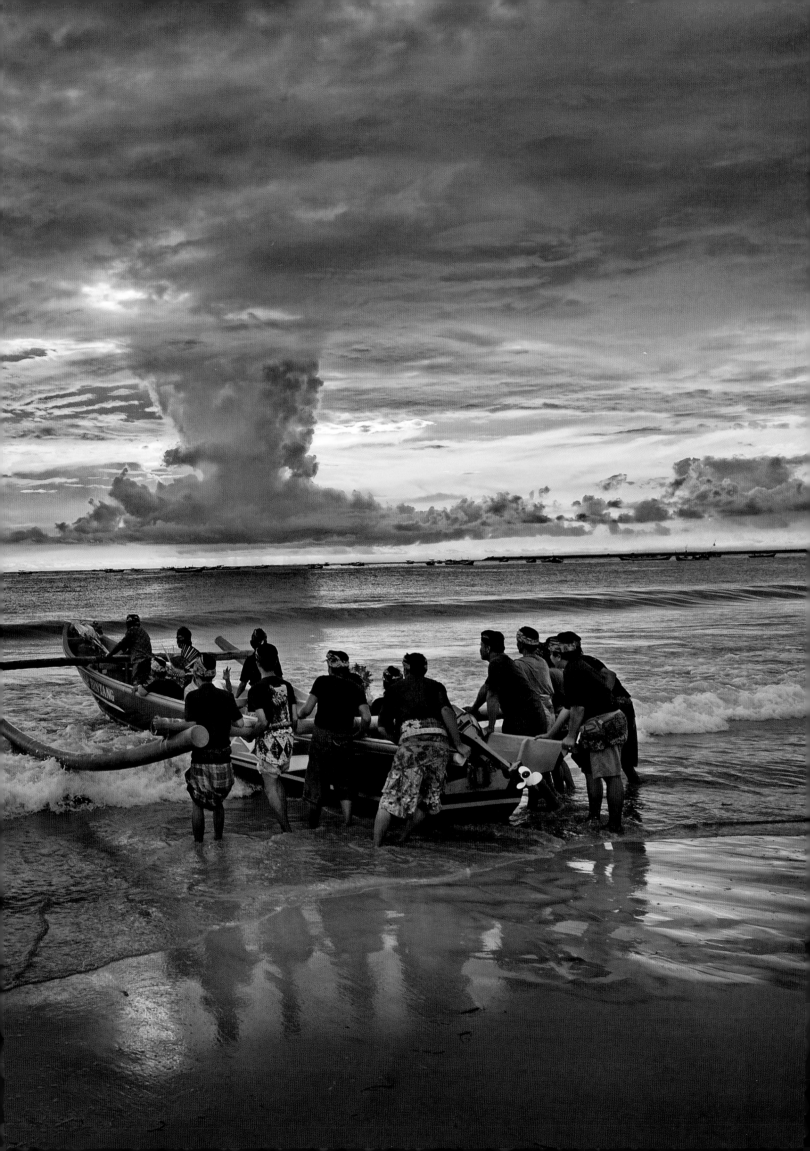

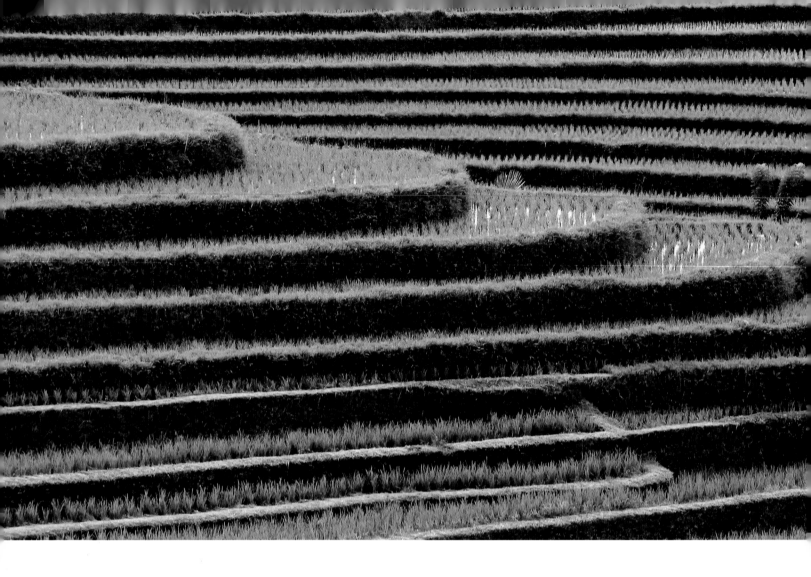

CONTENTS

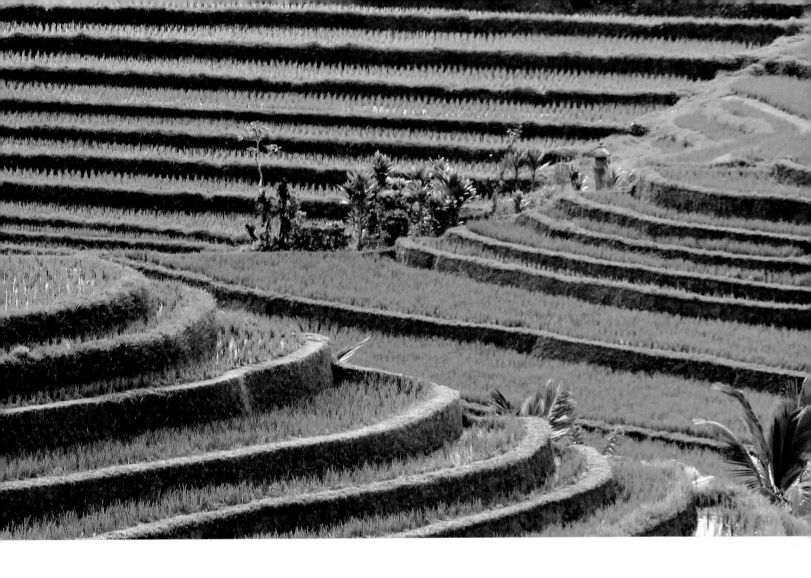

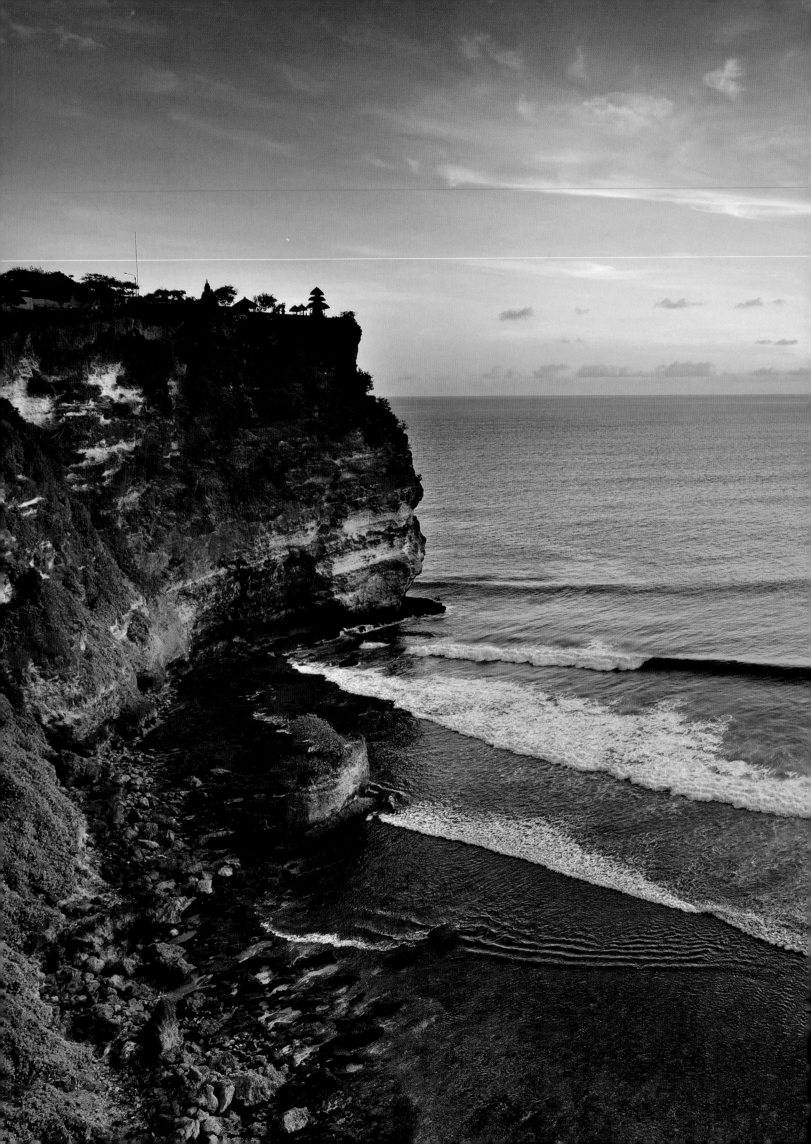

PART ONE INTRODUCING BALI

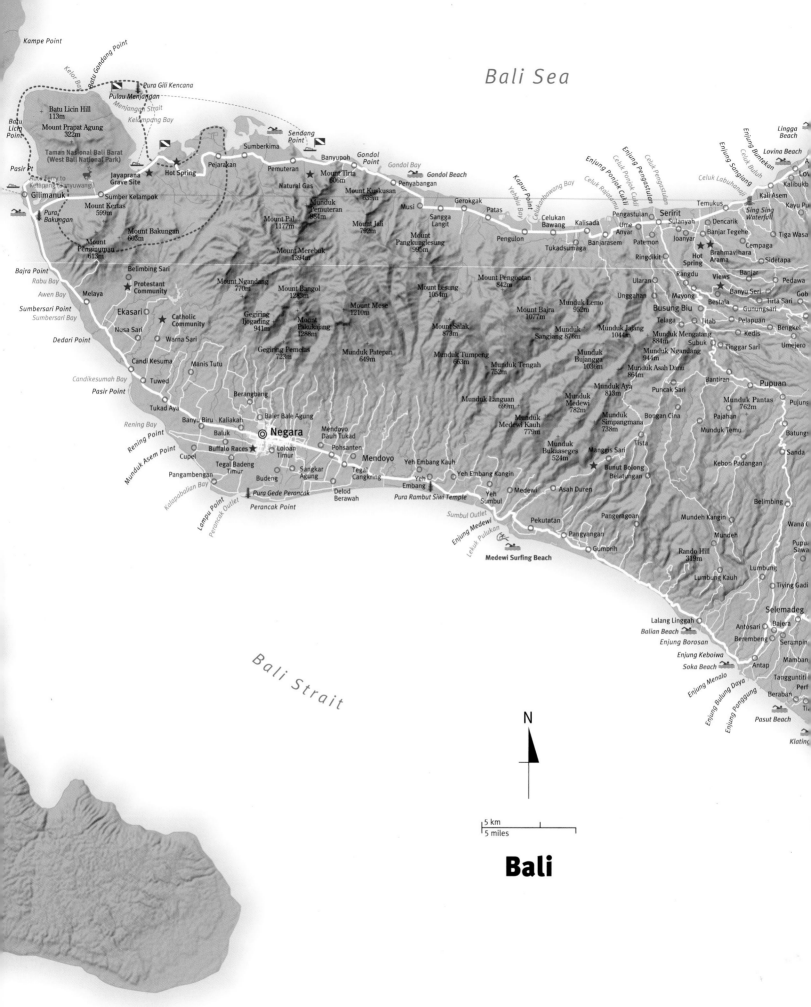

Bali

Bali Sea

Bali Botanical
Gardens (Kebun Raya)

Bungkulan Point
Pura Beji
Kubu Tambahan
Penarukan
Point
Yudha
Mandalatama
Independence
Monument
Sangsit
Bungkulan
Jagaraga
Bukti
Astina
Sinabun
Jinengdalem
Menyali
Pura Dalem
Bulian
Depeha
Bondalem
Pura Pojok Batu
NGARAJA
Sari Mekar
Suwug
Bila
Tamblang
Tunjung
Julah
Sembiran
Tejakula
Les
Penuktukan
Alas Angker
Sawan
Bukit
Bontihing
Tajun
Madenan
Sambangan
Bebetin
Bebetin
Pakisan
Mendaa Hill
688m
Yeh Mempeh
Waterfall
Sambi Renteng
Tembok
Ngis Point
nji Anom
Pegadungan
Sekumpul
Kutuh
Subaya
Siakin
Ambengan
Silang Jaha
Salungan
Satra
Dausa
Pura Tegeh
Koripan
Tianyar Barat
Tianyar Tengah
Pegayaman
Mount
Tengayang
1117m
Mount Mengandang
1363m
Pangejaran
Selulung
Suka Wana
Belandingan
Tianyar
Salt Panning
Gitgit Waterfall
Gitgit
Lemukih
Mount Catu
1865m
Catur
Belantih
Daup
Mt. Penulisan
1746m
Pinggan
Songan A
Songan B
Pejukung
Sukadana
Baturinggit
Salt Panning
Wana Giri
Mount Langlang
1501m
Tambakan
Belanga
Serahi
Pura Ulun
Danu Batur
Kintamani
Gunung Batur
1412m
Crater Lake
Trunyan
Ban
Kubu
Diving-WW II
"The Liberty" Wreck
Lake
ngihan
Mount
Penggilingan
2153m
Batukaang
Awan
Belanga
Toya Bungkah
Bali Aga Village, Gede
Pancering, Jagat Temple
Dukuh
Tulamben
Tulamben Marine Reserve
Panca Sari
Mount Tapak
1909m
Bali Handara Kosaido
Country Club
Binyan
Gunung Bau
Manik Liyu
Batur Selatan
Lake Batur
Hot Spring,
Volcanic Lake
Batu Niti Point
Mount
Lesung
1865m
Lake Beratan
Pura Ulun
Danu Beratan Temple
Bukit Mungsu Indah
Ulian
Lembean
Belancan
Batur Tengah
Buahan
Mount Abang
2151m
Laba Sari
Purwakerthi
Salt Panning
ubang
Nagaloka
Bedugul
Batukaang
Mengani
Mangguh
Banyung Gede
Bonyoh
Suter
Datah
Culik
Mount Pohen
2063m
Batunya
Pelaga
Bunutin
Katung
Sekar Dadi
Abang Tudinding
Mount Agung
2567m
Kertamandala
Amed
Bunutan
unt Sengayang
2087m
Mount Adeng
1826m
Antapan
Bangli
Batu Tiri
Langgahan
Abuan
Sekaan
Pengotan
Abang Songan
Tapis Hill
1608m
Keresek Hill
8m
Gunung Batukau
271m
Rice Fields & Vista
Persiapan
Sulangai
Pupuan
Penglumbaran
Pura Besakih
Pura Pasaran
Agung
Pidpid
Tista
Bangle
Jatiluwih
Angseri
Mekar Sari
Pura
Lempuyang
Abang
Mount Nampu
729m
a Luhur
atukau
Senganan
Apuan
Puhu
Taro
Tiga
Kayu Bihi
Yangapi
Menanga
Besakih
Sebudi
Rice Terraces
Mount Bisbis
1065m
Mount Seraya
1238m
ongaya Gede
Babahan
Candikuning
Petang
Buahan
Holy Spring
Sebatu
Pempatan
Paninjoan
Budakeling
Bebandem
Padang Kerta
Tengkudak
Mengesta
Luwus
Persiapan
Pangsan
Kedisan
Manukaya
Tirta Empul
Traditional
Village
Kubu
Muncan
Peringsari
Duda Utara
Jungutan
Amlapura
Seraya
Penebel
Biaung
Tua
Pura
Yeh Gangga
Melinggih
Bukian
Tegallalang
Rice Terraces
Tembuku
Rendang
Duda Timur
Sibetan
Puri Agung
Karangasem Palace
Seraya Barat
Penatahan
Perean
Pitra
Perean Tengah
Melinggih
Kelod
Gunung Kawi
Tampaksiring
Jehem
Nongan
Ngoek Hill
512m
Selat
Ababi
Tirtagangga
Water Palace
Seraya Timur
Hot Spring
Pira
Payangan
Kenderan
Topeng Dance
Pura Kehen
Undisan
Nyanglan
Sidemen
Tangkuh Hill
323m
Bungaya
Salt Panning
Rejasa
Jegu
I Gusti Ngurah
Rai Memorial
Carangsari
White Water
Rafting
Bangli
Kawan
Pesaban
Manggis
Ngis
Karang Asem
Pertima
Buruan
Petiga
Abuan
Apuan
Bungbungan
Selisihan
Tenganan
Jasri
Kesiut
Marga
Sangeh
"Monkey
Temple"
Pura Telaga Waja
Pejeng Kaja
Petak
Tamanbali
Nyalian
Tegak
Manduang
Talibeng
Gegelang
Ulakan
Candidasa
Timpag
Sangeh
Sembung Gede
Selanbawak
Reptile
Park
Puri Lukisan
Pura Taman
Saraswati
Pura Krobokan
Goa Garba
Bakas
Akah
Antiga
Bias Tugel
Labuhan
Amuk
Bay
Biaha Island
Mulu Point
Sembung Gede
Batan Nyuh
Holy
Waringin
Tree
Sayan
Ridge
Sayan
Ubud
Market
ARMA
Ubud
Moon of Pejeng
Nyuhkuning
Pura
Dalem
Bebek
State
Temple
Kerbtagosa
Semarapura
(Klungkung)
Pura Silayukti
Padangbai
Blue Lagoon
Tepekong Island
Batuaji
Kukuh
Monkey
Forest
Mengwi
Pura
Taman
Ayun
Legong
Tepi Sawah
Goa Gajah
Temples,
Durga Statue
Gianyar
Gamelan
Smiths
Gunaksa
Pura Goa Lawah (Bat Cave Temple)
Samsam
Tabanan
Gedong Marya
Theater
Abiansemal
Mambal
Basket Weaving
Topeng
Tulikup
Pura
Dalem
Negari
Painting, Gold &
Silver Smiths
Jukung
Fishing Village
Padangbai Harbour
Cokorda's Palace
Carved Bell
Tower
The Green
School
Pura Penataran
Topeng
Silk Weaving
Gamelan Maker
Medahan
Black Sand
ejaten
Gubug
Puri
Agung
Mengwi
Sibang Kaja
Gong Gede
Music
Singapadu
Wood Carving
Pering
Pura Segara
Jumpai
Salt Pans
Nyitdah
Pandak
Gede
Pura Dalem
Lukluk
Peguyangan Kaja
Peguyangan
Waterfall
Bali Safari &
Marine Park
dimara
ku Tibah
Kaba-kaba
Buduk
Sading
Sukawati
Handicraft Market
Gold/Silver
Smith
Beraban
Dalung
Tonja
Penatih
Pura Sadha
a Tanah Lot
Munggu
Ketewel
Tibu Beneng
Kerobokan
Ubung
Kesiman Petilan
Canggu
Kerobokan
Kelod
Dangin Puri
nggu Beach
Batubelig Beach
Pura Petitenget
Tegal Kertha
Dauh Puri
DENPASAR
Sanur Beach
Sanur
Badung Strait
Seminyak Beach
Seminyak
Padang Sambian
Kelod
Renon
Sindhu Beach
Legian Beach
Legian
Pedungan
Pedungan
Sidakarya
Shipwreck Surf Break
Entental Cape
Pemaroan
Cape
Krambitan
Cape
Kuta Beach
Kuta
Sesetan
Sida Karya
Lacerations Surf Break
Jungutbatu
Ped
Cemara Cape
Tuban Beach
Serangan
Playground Surf Break
Cavehouse
Nusa
Lembongan
Ped
Buyuk
Batu
Nunggal
Ngurah Rai
International Airport
Tuban
Serangan
Island
Sanghyang Cape
Toyopakeh
Kutampi
Karang Sari Cave
Jimbaran Beach
Jimbaran
Benoa
Harbour
Tanjung Benoa
Ceningan Reef Surf Break
Nusa
Ceningan
Sakti
Spring
Emas Hill
521m
Puseh Point
Pura Balangan
Benoa
Bay
Nusa Dua Beach
Melajeng Cape
Bungamekar
Klumbu
Suana
Pura Batu Madan
Dreamland
Garuda Wisnu
Kencana Statue
Nusa Dua
Gunungcemeng Bay
Panggang Hill
210m
Nusa Penida
Pura Batu Kuring
Padang-padang Surfing
Ungasan Hill
203m
Nusa Dua Beach
Batubelede Point
Sari Point
Tokadoyah Bay
Jelijih Hill
267m
Sabuluh Waterfall
Pejukutan
Suluban Surfing
Batu
Ungasan
Pura Geger
Gunung Cemeng Point
Seganing Bay
Semu Puteh
Hill 229m
Batu Kandik
Tanglad
Luhur
atu
Pecatu
Pura Gunung Payung
Banah Point
Nusa
Batujinengan
ng-nyang Surfing
Pura
Kulat
Ungasan
Green Bowl
Surfing Area
Pura
Batu Pageh
Batumeling Bay
Pehikan Point
Moling Cape
Atuhlili Point
Suwehan Point
Sekar Taji
Bakung Cape
Kuning Point

Lombok Strait

Auto Ferry to Lembar (Lombok) 4 hrs.

90 mins.
45-60 mins.
60 mins.

Mabua Express to Lembar (Lombok) 2-2.5hrs.

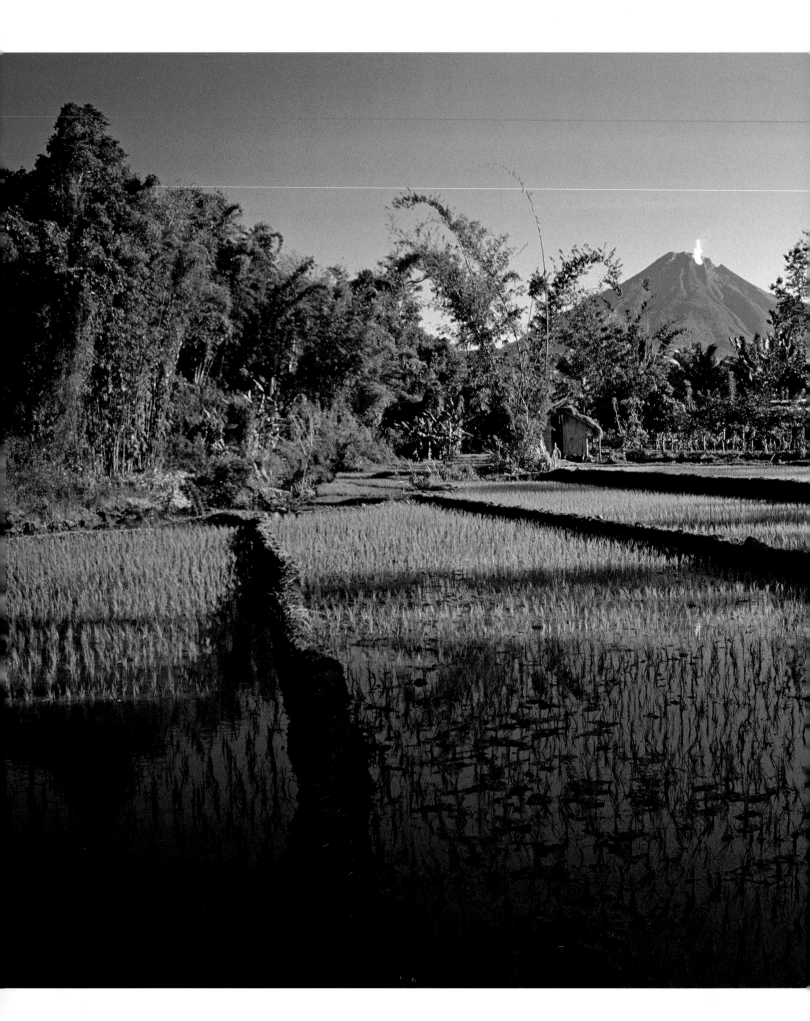

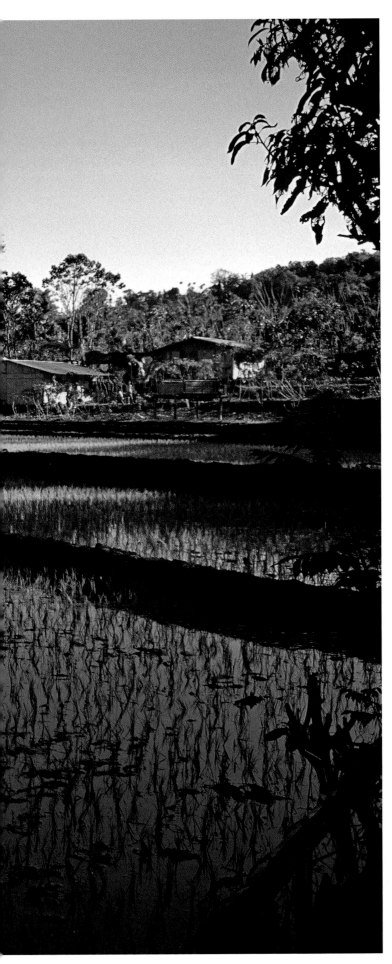

UNDER THE VOLCANO

It's difficult to imagine an island with so much to offer. Whether it's just sun, surf or shopping, or the exceptional culture, lifestyle and landscapes, Bali is justifiably popular. But most tourists just rush through and don't allow enough time to linger and relish the uniqueness of the island.

One of 17,500 islands strung out across the Indonesian archipelago, Bali is dominated and inextricably influenced by a series of volcanoes, six of them over 2,000 meters. The highest, most volatile and, therefore, most revered is Gunung Agung (3,031 m). Only 8 degrees below the equator, and stretching 144 km across and 90 km north to south, the rest of the island is dotted with gorges, rivers and forests, while a national park in the west preserves scarce rainforest, a pristine coastal environment and vestiges of wildlife.

The initial wave of 'visitors' were probably Austronesians from a region that spreads from modern-day China to the Philippines. They inhabited Bali some 4,000 years ago, and by 300 BC communities had evolved and rice cultivation developed. Subsequent settlers brought Buddhism, which thrived for several centuries before Javanese influence became inescapable during the 10th century. The formidable Hindu Majapahit Empire ruled from Java for most of the 14th and 15th centuries before rulers, priests and academics fled to Bali to escape Islam, developing the unique culture, religion and arts apparent today. As the Majapahit Empire declined, Balinese kingdoms flourished and their sovereignty spread to eastern Java and neighboring Lombok.

The first colonialists were the Dutch who arrived in the late 16th century, but waited until the mid-19th century before fully colonizing Bali. The populace fought relentlessly against the merciless Dutch for about 60 years until the entire island fell, only for the Dutch to lose control during (and after) World War II.

PAGES 8–9 The clifftop temple at Ulu Watu on Bali's southwesternmost tip is one of the six most sacred spots on the island.

LEFT Towering above numerous other volcanoes stretched across Bali, Mount Agung is the most feared and revered, and erupted with devastation in 1963.

The Subak System

According to *awig-awig* traditional law, every Balinese who owns a *sawah* rice field must become a member of a *subak* association. This ensures that rice farmers along the coast, up to 20 km from a water source, have as much access to irrigation as those located high on the more fertile slopes. The millennium-old *subak* system reflects the Balinese Hindu philosophy of Tri Hita Karana, which unifies the realms of humans, nature and the spirits in harmony and ensures maximum production of the most essential ingredient of the Balinese meal. From springs, rivers and lakes, water rushes downhill through canals, sometimes cutting through caves and mountains, and along cement aqueducts and bamboo poles raised across roads and gorges. Sluice gates regulate the water flow so that limited amounts flood individual rice fields, while the remainder gushes past and is shared elsewhere. When farmers do not need irrigation for the fields, such as just before harvesting so that the soil is dry for workers, they simply seal the tiny openings along the reinforced mud walls that indicate the boundaries of individual *sawah*. The 1,000 or more democratically operated *subak* associations across Bali also repair canals, tunnels and dikes, advise about seeds and planting and organize ceremonies and offerings to ensure abundant harvests.

ABOVE Methods used by the Balinese, such as sculptured terraces along volcanic slopes and the ingenious irrigation system, have not changed for centuries.

OPPOSITE Most rice in Bali is still cultivated and transported using simple hand-made equipment, such as rattan baskets slung on a bamboo pole.

Other settlers have included Javanese from the Majapahit era, and others who later served Balinese kings, fishermen, particularly Buginese from Sulawesi, and, more recently, tourist workers from across the archipelago. Although a large percentage of the permanent population of about four million reside in the capital Denpasar, the second largest city, Singaraja, and around the southern tourist areas, most Balinese of all religions still follow a lifestyle dominated by village concepts of communal sharing and order. This is most apparent in the *subak* system of shared irrigation for rice fields and the *banjar* village association, mostly composed of married men, that makes societal decisions.

Bali's population almost doubles with tourists, both foreign and Indonesian, each year. Foreigners started visiting Bali about a hundred years ago and, like the European artists who settled in Ubud during the 1930s, left their mark. But the Balinese are remarkably resistant to change and happily cherry-pick what they like and adapt it to their impenetrable mix of tradition, religion and culture. It wasn't until surfers, mostly Australian, 'rediscovered' Bali in the 1960s that tourism exploded, but subsequent economic development was thwarted in the same decade by the catastrophic eruption of Gunung Agung and severe political upheavals that culminated in massacres, and later by the heartbreaking terrorism of 2002 and 2005.

The form of Hinduism that the majority of the island follows is unique and embraces every element of Balinese life, from before birth to cremation after death. Balinese religion is indistinguishable from Balinese culture. Everything, from art, architecture and dance not seen elsewhere on the planet, to innumerable shrines, expensive ceremonies and daily offerings, and so much more in family life, communal values and village regulations not apparent to tourists, has a purpose and meaning aimed at pleasing the gods and appeasing the demons to ensure a happy life, healthy family and abundant harvest. And despite encroaching modernism and tourist-fueled hedonism, the Balinese are almost completely resistant to threats against their unique faith and omnipresent culture.

The Balinese can communicate in Indonesian, the language of instruction in schools and interaction within government administration, but many also proudly speak in Bahasa Bali, a separate complex language influenced by Javanese, although the unique script is rarely used. The Balinese language and use of complete names are connected to the Hindu caste system, which is inconsequential to the majority of Balinese who don't belong to an upper caste.

A short distance across the treacherous Lombok Strait is Bali's sister island. Although the size and topography are almost identical, most people on Lombok follow Islam, a religion that doesn't permeate their society with ceremonies and traditions nearly as much as Hinduism does on Bali. With a separate history, culture and language, the people are just as welcoming, however, and Lombok is an increasingly popular alternative to the utopian but congested island across the strait.

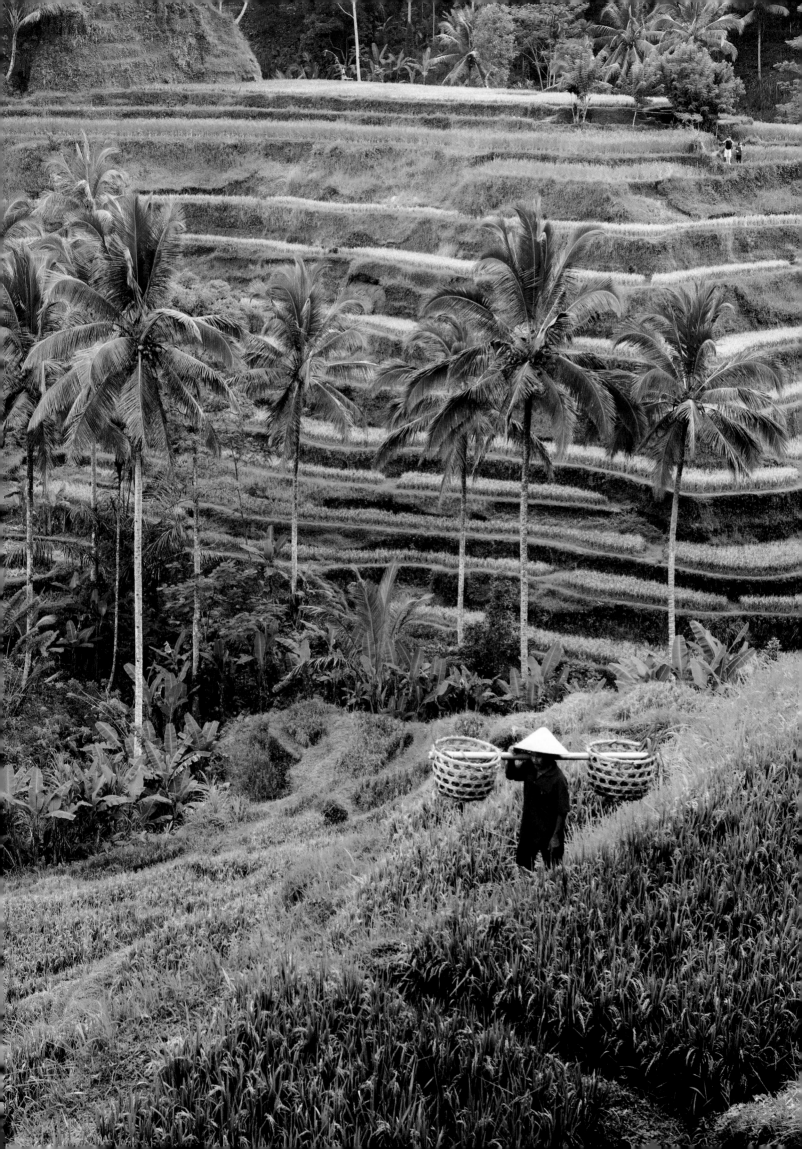

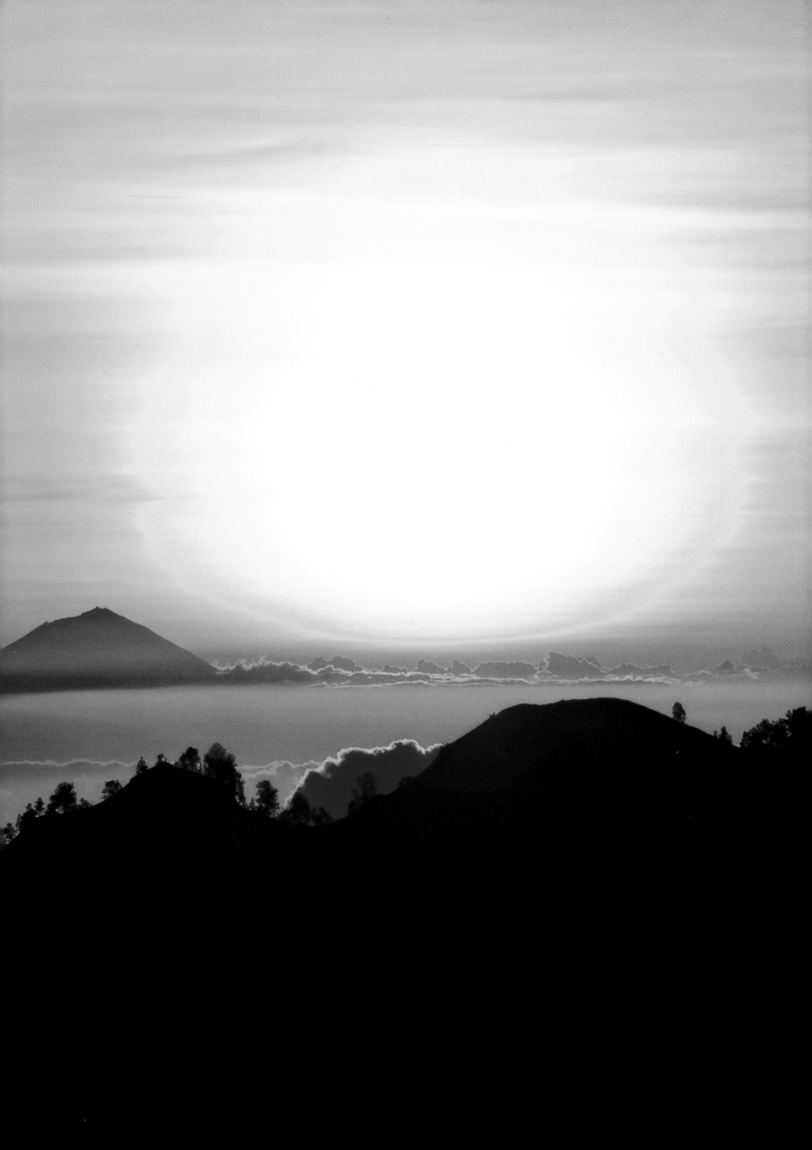

VILLAGE LIFE AND FAMILY COMPOUNDS

Most Balinese are villagers at heart, even if they live in the chaotic capital of Denpasar or work in the tourist enclave of Nusa Dua. And somehow the relentless onslaught of mass tourism has barely affected ancient family traditions and rituals about birth, death, marriage and everything in between that are still decreed by village heads.

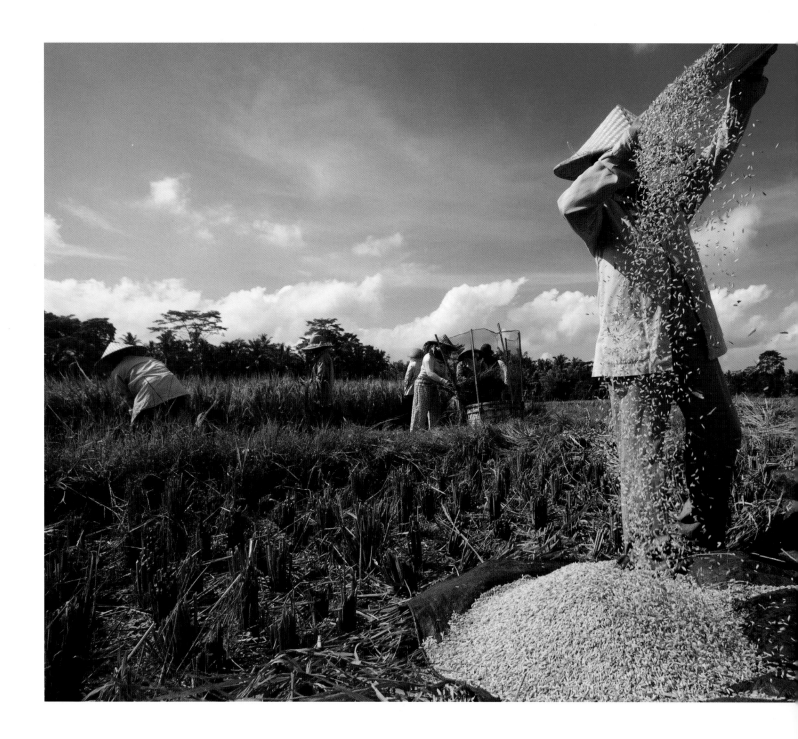

PREVIOUS SPREAD Bali's highest peak, Gunung Agung ('The Great Mountain') seen from the crater of Mount Rinjani on neighboring Lombok.

ABOVE Frequent rains and fertile slopes ensure bountiful harvests of fruit. Many of these may not have been seen before by some tourists, including the *rambutan* and *salak*.

LEFT The arduous task of planting rice seeds and later harvesting and winnowing the rice is almost always undertaken by groups of women.

BELOW Within every Balinese family, the very young and the very old are venerated. Two or three generations of an extended family often live together in the same compound.

D espite urban development and impinging modernism, most Balinese still adhere to a *desa* (village) lifestyle dictated by the concepts of communal sharing and societal order. This is most evident where every person owning a rice field joins a local *subak* association to administer the remarkable system of shared irrigation and the *banjar* association, which represents up to a hundred households within a village. Joining the local *banjar* is compulsory upon marriage, although only men usually attend meetings, which are often announced by the specific pounding of a *kul-kul* drum and held in a *bale banjar* (meeting hall) in the village center.

While local governments provide the normal essential services under the authority of the *kepala desa* (village head), the *banjar* maintains temples, organizes ceremonies and cremations, arranges local finance, mediates in marriages (and, rarely, divorces) and funds a *gamelan* orchestra. It also ensures that the morals and behavior of villagers, especially youth, are maintained through a series of agreed guidelines called *awig-awig*.

Villages are designed according to strict religious and cultural principles. Typically, they are positioned towards *kaja*, which means facing the mountains, home to the gods, normally to the north, and away from *kelod*, which is facing the sea, normally to the south, home to demons and the source of destructive forces. These points of reference, however, are reversed along the north coast, for example, where the mountains are located to the south.

The crucial element of each village is *kahyangan tiga*, the three types of temples: the *pura desa* (village temple) or *pura agung*, located in the village center and dedicated to the protective spirits; the *pura puseh*, positioned in the north and devoted to Brahma, Creator of the Universe; and the *pura dalem*, situated in the south and used for cremations and burials.

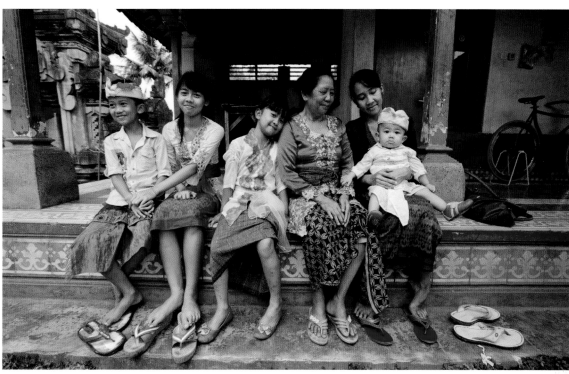

The Role of Women

Balinese women are expected to cook, clean, buy food and raise children with minimal male assistance, but they do enjoy a degree of independence perhaps envied by their compatriots. Women dictate family life, for example, by ensuring strict adherence to all religious and cultural traditions, while men dominate society, such as in the *banjar* village association that sets and implements communal rules. There are some curious demarcations: weaving and pottery are undertaken by women, but most paintings and carvings are created by men; traditional dances are mainly performed by women, yet the *gamelan* orchestra is almost exclusively a male domain and women make offerings to the favorable gods, while men present chicken blood during cockfights to appease the demons. Religious ceremonies are the only occasion when men are usually involved in cooking. Women must still follow austere rules, but so do men, children and adolescents.

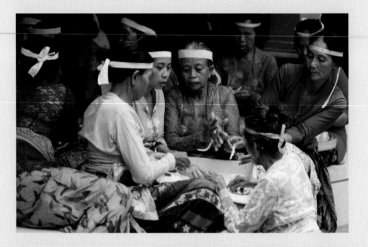

LEFT Dikes between rice fields also serve as pathways for those visiting remote temples and isolated homes. Balancing a basket on her head is still the preferred method for a woman to carry just about anything.

ABOVE Women of all generations help prepare food, especially during a ceremony when many mouths need to be fed and when numerous offerings must be made.

BELOW Chillies, shallots and garlic are the basic ingredients of all Balinese dishes. These, and almost every other imaginable spice, vegetable and fruit, are readily available at public markets in each village and suburb.

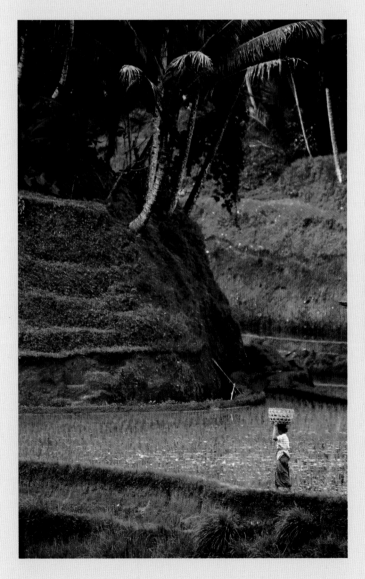

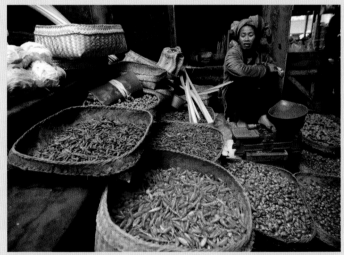

For example, menstruating females are usually temporarily banished from family compounds to live in special boarding houses because anyone associated with blood, including those with injuries, is deemed to be *sebel* or spiritually unclean. Women are often still exploited and undertake many of the most menial and lowest paid jobs, like carrying bricks at construction sites and planting rice. Where tourists will see women working *en masse* is at the village markets, which start well before dawn and often involve long walks carrying heavy baskets on their heads.

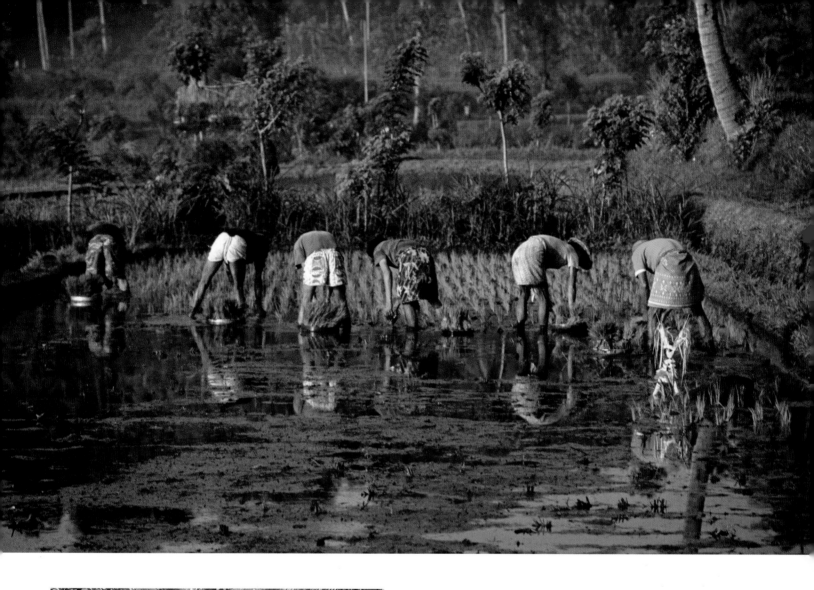

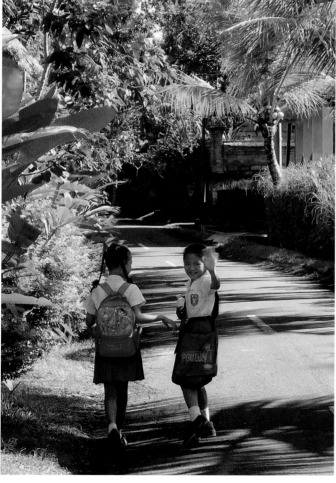

Dotted among the deliberately positioned temples, markets, *puri* (palaces) for nobility and *bale banjar* halls are family compounds in which most Balinese still prefer to live with their extended families. Designing compounds and homes often involves experts in *asta kosala kosali*, which, like the Chinese *feng shui*, ensures balance and harmony with the gods, nature and each person living there. So, compounds, homes and even rooms face *kaja* and not the demonic seaward direction of *kelod* (in great contrast to the preference of most foreigners for sea views).

In the southwest corner of the compound is the *angkul-angkul* entrance flanked with statues of gods, and the *aling-aling* wall that ensures privacy and deters demons (who can't turn corners) but is not lockable and therefore unwelcoming to guests. The compound is subdivided into three main areas: the *utama*, a sacred section facing *kaja* with rooms for senior family member(s) and a *sanggah* temple honoring ancestors in the northeast; a *nista*, an 'impure' area at the back towards *kelod*, where animals are kept and rice is stored in the southeast and food is cooked in the southwest; and *madya*, where ceremonies are undertaken in the eastern section, and most of the family eat and guests are catered to in the west.

LEFT Attendance at primary school is compulsory from about age six. All students must wear uniforms, which for these youngsters is red and white, the two colors of the Indonesian flag.

ABOVE Despite the advent of modern cultivation equipment, most rice across Bali is planted, harvested and threshed by hand because labor is much cheaper and more readily available than machinery.

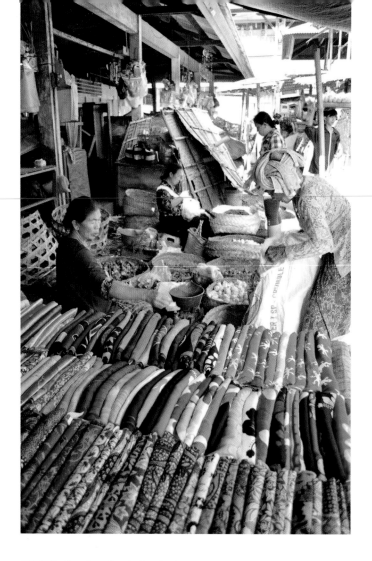

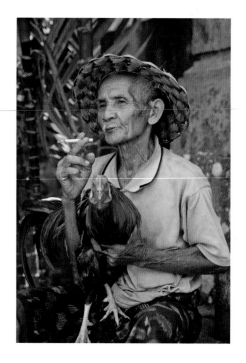

ABOVE No item for sale, whether food, clothes or baskets, at a public market like the Ubud Market has a fixed price. Everything is negotiable and haggling is part of the fun of shopping for locals and tourists alike.

ABOVE RIGHT Cockfighting is an ancient sport also undertaken to appease evil spirits during purification ceremonies. Although outlawed by the Indonesian government, it is still prevalent and a source of gambling.

BELOW Ducks are reared to feed on vermin that might damage the precious rice fields. In the process, they also fertilize the crops.

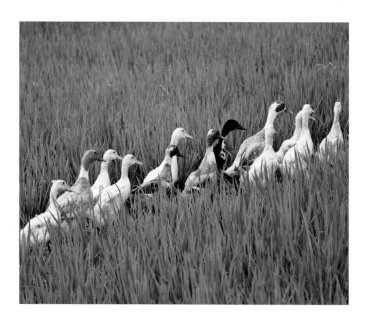

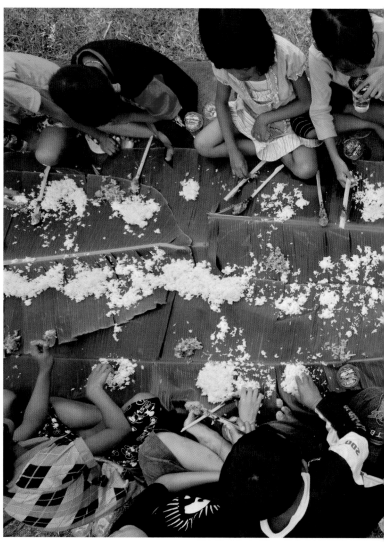

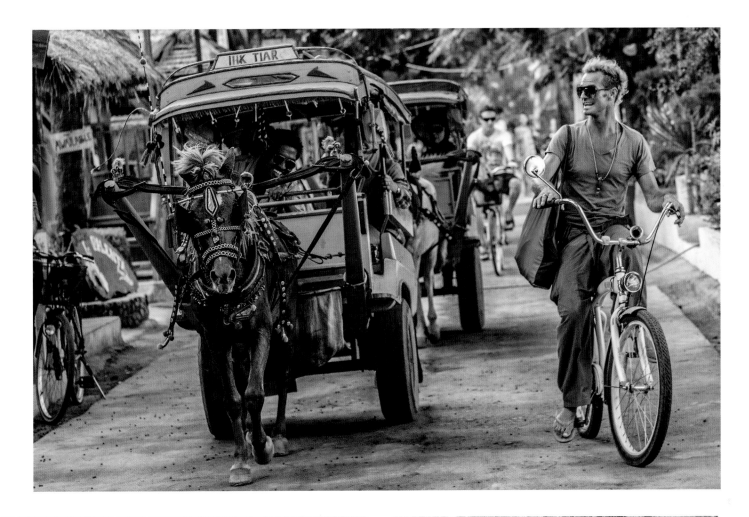

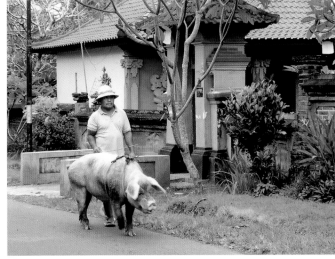

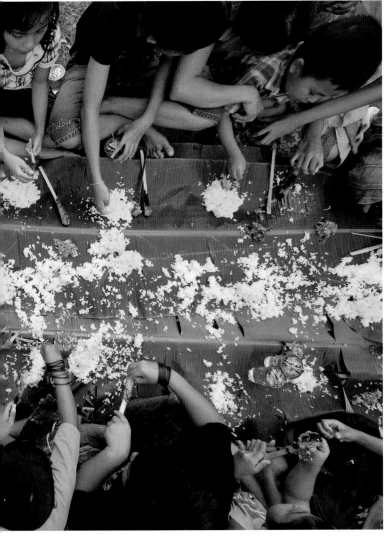

TOP The main form of transport on the trio of islands known as the Gilis off the coast of Lombok is the horse and cart called *cidomo*.

ABOVE Because Bali is Hindu rather than Muslim, rearing pigs and eating pork are not forbidden here. Most pigs end up as part of the traditional Balinese feast of *babi guling* (roast pig).

LEFT Children often eat communally, enjoying a handful of steamed rice with accompaniments such as *satay lilit* (meat with spices on a stick), while using a banana leaf as both table and plate. Here, a group of children gorge themselves during a temple festival, which often features rice and satay.

RIGHT When school or work has finished and the tide is out, soccer is frequently enjoyed on Kuta Beach.

BELOW As Bali is a small island, it's no surprise that fishing is a crucial industry. The daily catch is enjoyed by both locals and tourists.

OPPOSITE BOTTOM The delightful village of Jungutbatu on the island of Nusa Lembongan enjoys a spectacular location under the watchful eye of the Gunung Agung volcano on the mainland.

BOTTOM The Gili Islands off the coast of Lombok have become a hugely popular tourist resort area, with hundreds of hotels and restaurants. However, transportation to these islands is still primitive. Every-thing from potatoes and rice to building supplies is brought over from Lombok on small boats and laboriously unloaded, then transported to their destination by horse-drawn cart.

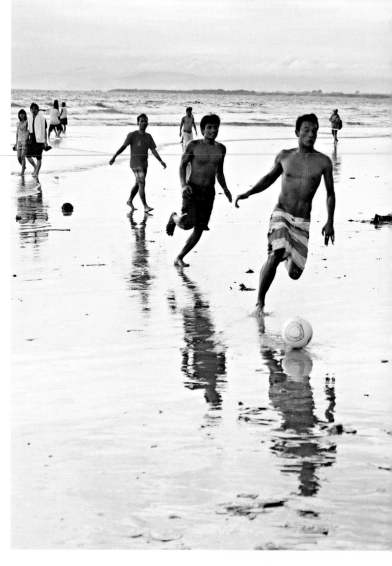

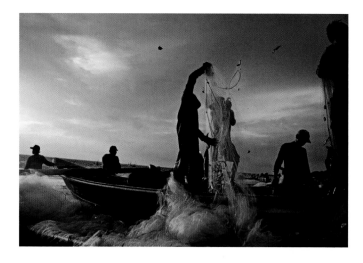

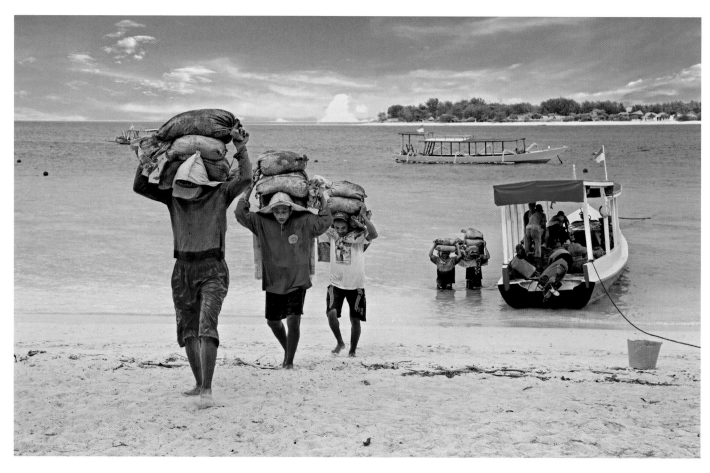

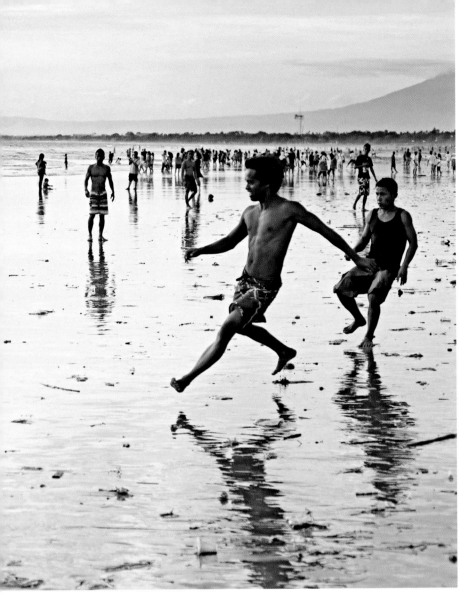

BELOW Both sides of the front of the fishing boats known as *jukung* are often plastered with eyes to repel evil spirits in the sea, where Balinese believe all demons reside.

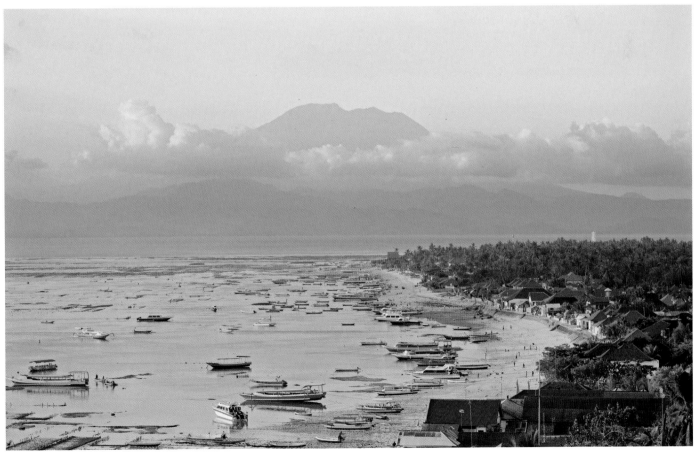

ORNATE TEMPLES AND RELIGIOUS CEREMONIES

The unique form of Hinduism observed by most Balinese unconditionally dominates their lifestyle and even influences modern-day business practices in a manner not always completely evident to most visitors.

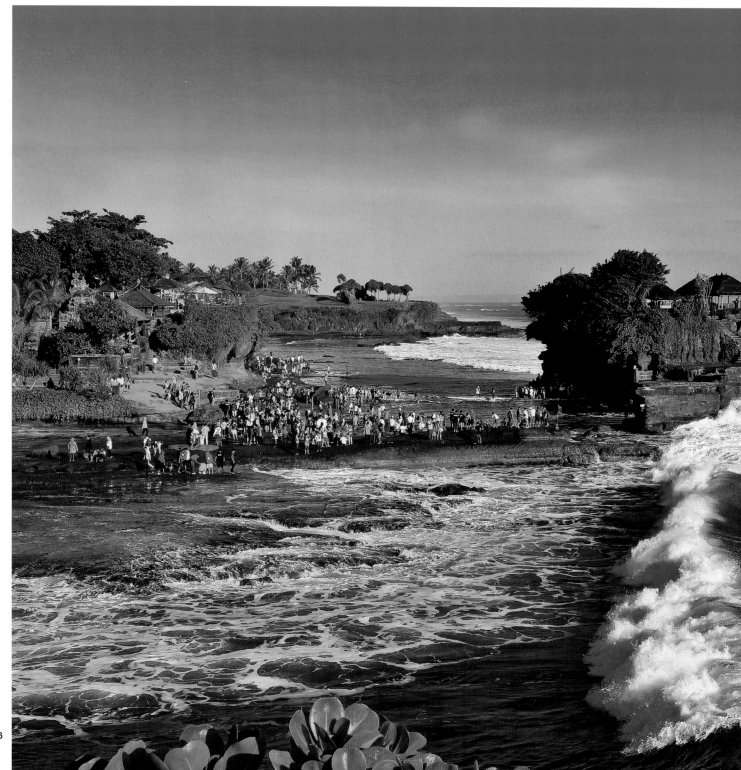

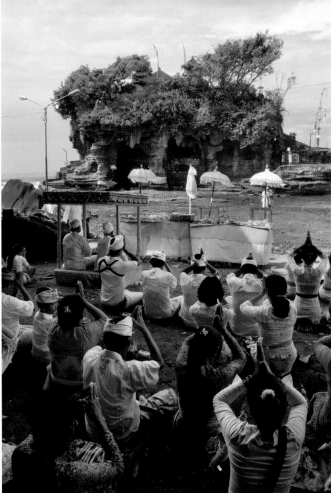

R eligion encompasses every single facet of Balinese life in obvious ways, such as temples and ceremonies, but also in art, medicine and architecture as well as the Balinese language, calendar and names. About 92 percent of the population of Bali, located amidst the world's most populous Islamic nation, practice Agama Hindu Dharma, sometimes still referred to as Agama Tirtha ('Religion of the Holy Waters').

Hinduism originated from India via Java, which ruled Bali a millennium ago. The Balinese version was formulated when priests and rulers from the powerful Majapahit Hindu kingdom that ruled Java and beyond fled to Bali in the 15th century as Islam encroached, and temples such as Pura Tanah Lot were built.

Nowadays, Balinese Hinduism embraces elements of Buddhism, which flourished in Bali during the 8th and 9th centuries, and animist beliefs that predate the introduction of Hinduism.

Like Hindus in India, Balinese believe in reincarnation and karma and worship the trinity of Brahma (the Creator of the Universe), Shiva/Siwa (the Destroyer) and Vishnu/Wisnu (the Protector). Each is a manifestation of the Supreme God of Sanghyang Widhi, which is a more recent appendage to Balinese Hinduism to comply with the Indonesian Pancasila national principle of worshipping 'One Almighty God'. Other fundamental differences to the Hinduism practiced in India are the numerous ancient indigenous beliefs, including black magic, and the adaptation of the religion to suit Bali's topography. For example, the Balinese believe that the gods reside in the mountains, particularly the revered and volatile Gunung Agung, and should be kept happy at every opportunity, while the demons dwell in the sea. Moreover, numerous spirits, whether *dewa* (male) or *dewi* (female), penetrate the physical world and also need to be appeased with innumerable shrines and frequent offerings.

The underlying philosophy is to seek a balance between the forces of good and order (*dharma*) and evil and disorder (*adharma*). This and other values and beliefs are amalgamated into Tri Hita Karana ('Three Causes of Happiness') that strive to unify and maintain harmony between humans and nature, between humans and God and the spirits, and among humans themselves.

LEFT No temple setting is more spectacular than that at Pura Tanah Lot, which faces the thunderous Indian Ocean. This rocky islet is, however, only accessible to Hindus and is unreachable by anyone at high tide.

ABOVE Tourists flock to photograph the Pura Tanah Lot from the mainland for its remarkable location while worshippers come in droves as it is one of the six highly revered cardinal temples on Bali.

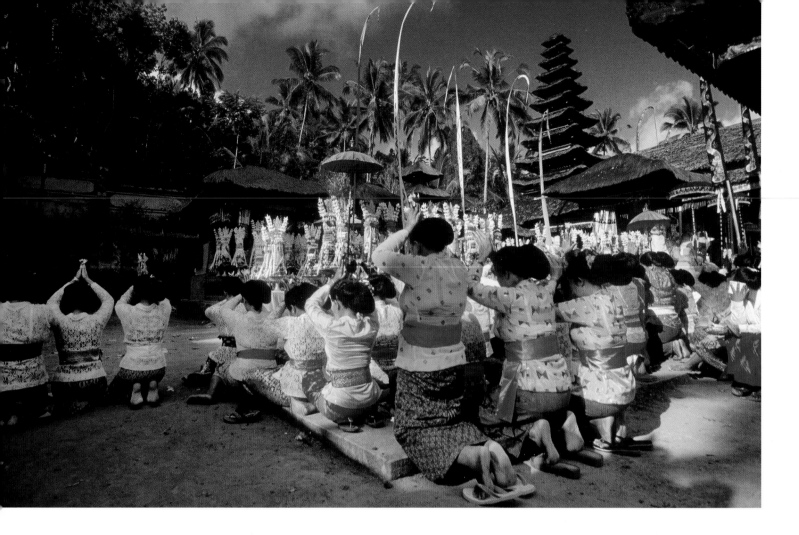

The religion dictates every personal event, such as marriage, as well as rituals for children, who are regarded as reincarnations of ancestors. For example, there are ceremonies at 42 days, when new mothers are allowed to return to the temples, and 105 days, when babies can touch the ground. Also, later in life and before marriage, teeth are evenly filed so that they are not pointy and resemble a demon's. The most important religious ceremony for the family is cremation. The local community helps construct and then incinerate a wooden tower before spreading the ashes out at sea in order to liberate the soul and allow it to enter heaven as part of the reincarnation process. Most events are dictated by the lunar *saka* or *sasih* calendar of 360 days or by the unique *wuku* or *pawukon* 210-day calendar used for festivals and choosing auspicious days for important events, such as starting a business and planting rice.

Hinduism in India strictly classifies people, for example, the *dalit* or 'untouchables', but the caste system in Bali is nowhere near as discriminatory nor as obvious to outsiders. The top three castes, whose members can trace their ancestors to the Majapahit rulers, are *brahmana* (the highest), *ksatriyasa/satriya* and *wesya*, although 90–95 percent of Balinese are *sudra* ('commoners'), also called *jaba* ('outsiders'). The only way a non-Hindu can easily identify a Balinese person's caste is by the prefix used for their complete name, such as Ida Bagus, a male *brahmana* name. Priests have a multitude of purposes and duties, particularly preparing for and presiding over temple ceremonies and family rituals. They are either *pedanda* high priests from the *brahmana* caste only or *pemangku* temple priests from any other caste, although many Balinese also consult *balian* (traditional healers) for spiritual as well as physical guidance and well-being.

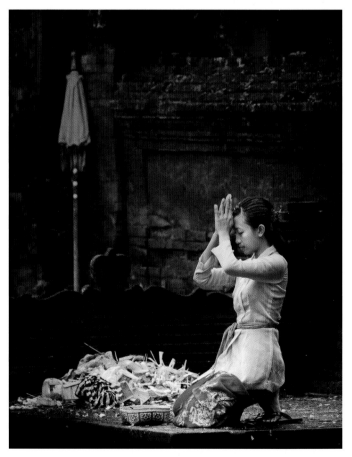

TOP Everything is symbolic and ritualized, from the number of roofs on the pagoda-style *meru* shrines to the position of hands and body when praying.

ABOVE Worshippers raise their hands above their heads when praying to a revered god within a temple. Hands positioned in front of the face indicate that one is praying to the ancestors.

The Balinese New Year

One of the most important days on the *saka* or *sasih* lunar calendar is Nyepi, the Day of Silence, which signifies the start of the Balinese Hindu New Year at the new moon in March or April. Everyone, including tourists, is confined to their homes or hotels and the streets are eerily deserted and dark so that evil spirits hovering over Bali will assume the island has been abandoned and will move on.

The aim of the day before Nyepi is to cleanse Bali of demons so that the next year can start afresh. Colossal offerings (*tawur agung*), created to placate the demons and purify areas of evil influences, are placed at crossroads. Massive, and often outrageously shaped effigies of demonic monsters (*ogoh-ogoh*), which take weeks to construct, are paraded around the streets by young men. Animal sacrifices and mock exorcisms are also undertaken by priests to appease the evil spirits. During the evening, there is organized chaos as masses of people yell, carry flame torches, let off fireworks and bang pots to scare off and expel the demons, and the numerous *ogoh-ogoh* are burnt.

In distinct contrast, Nyepi, which lasts 24 hours from 6 am, is a day of complete silence and time for reflection, prayer and inactivity, which includes tourists. Special police ensure that everything, including the airport, is closed (although hospitals and hotels stay open); that the streets are empty (except for ambulances); and that no electricity or lights are being used. The day after (*ngembak nyepi* or *ngembak geni*) is celebrated with various rituals, including a kissing and water-throwing ceremony in Denpasar, and roads become even more jam-packed than normal as people visit families, friends and temples.

Tourists are expected to comply with all regulations. It can be inconvenient with no shopping, surfing or clubbing, but hotels remain open and staff will arrange meals for guests.

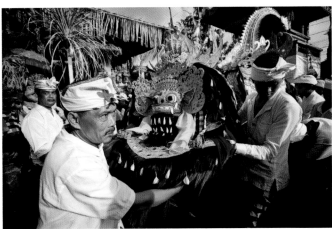

TOP Elaborate offerings made of cloth and bamboo leaves are regularly placed on shrines in family compounds and around the rice fields to appease the gods.

BELOW LEFT The *banten tegeh* offerings carried to the temple on festival days can weigh up to 20 kg, with the size and contents depending on the importance of the ceremony.

ABOVE The Barong is a benevolent figure in Balinese religion, used like a Chinese lion or dragon dance to chase away evil spirits and bring good fortune.

BELOW Monstrous effigies called *ogoh-ogoh* are hand-crafted by dozens of men for weeks leading up to the Balinese New Year celebrations before being engulfed in flames within minutes.

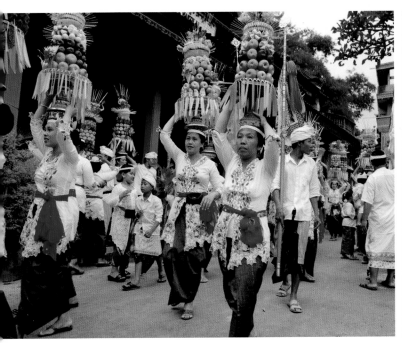

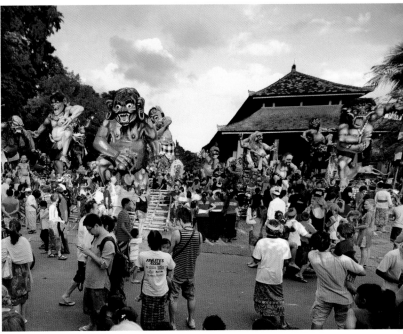

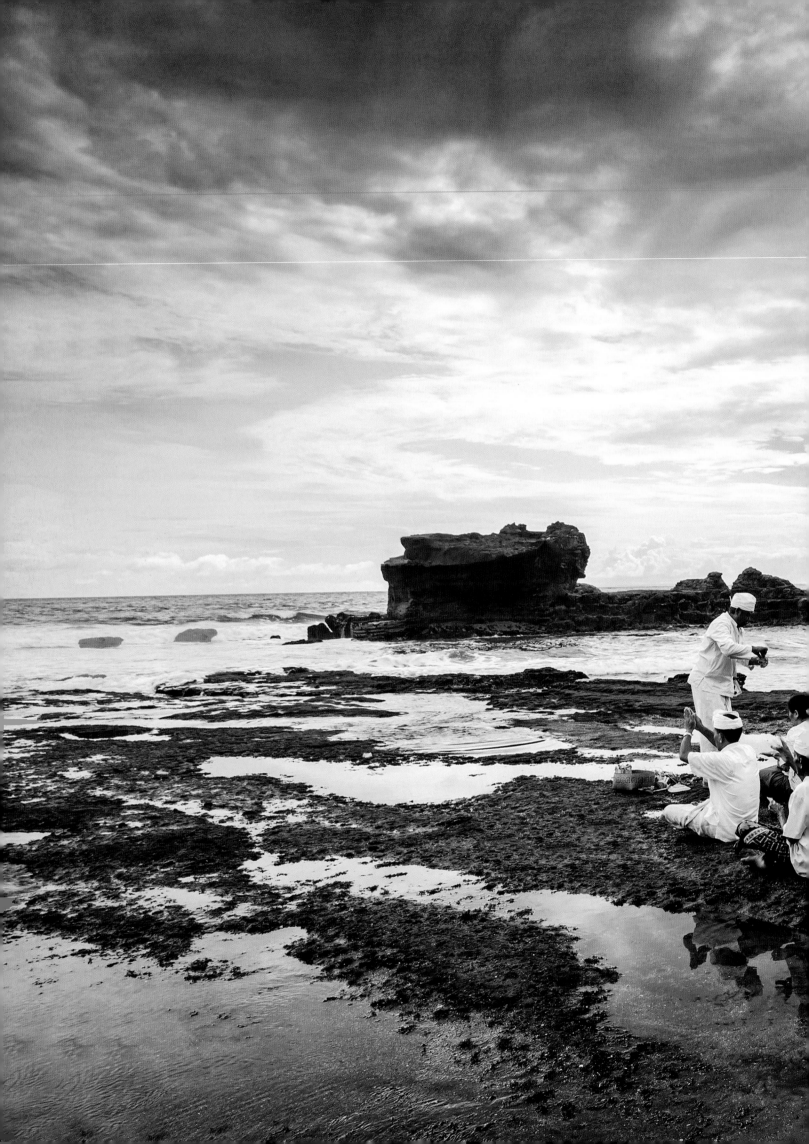

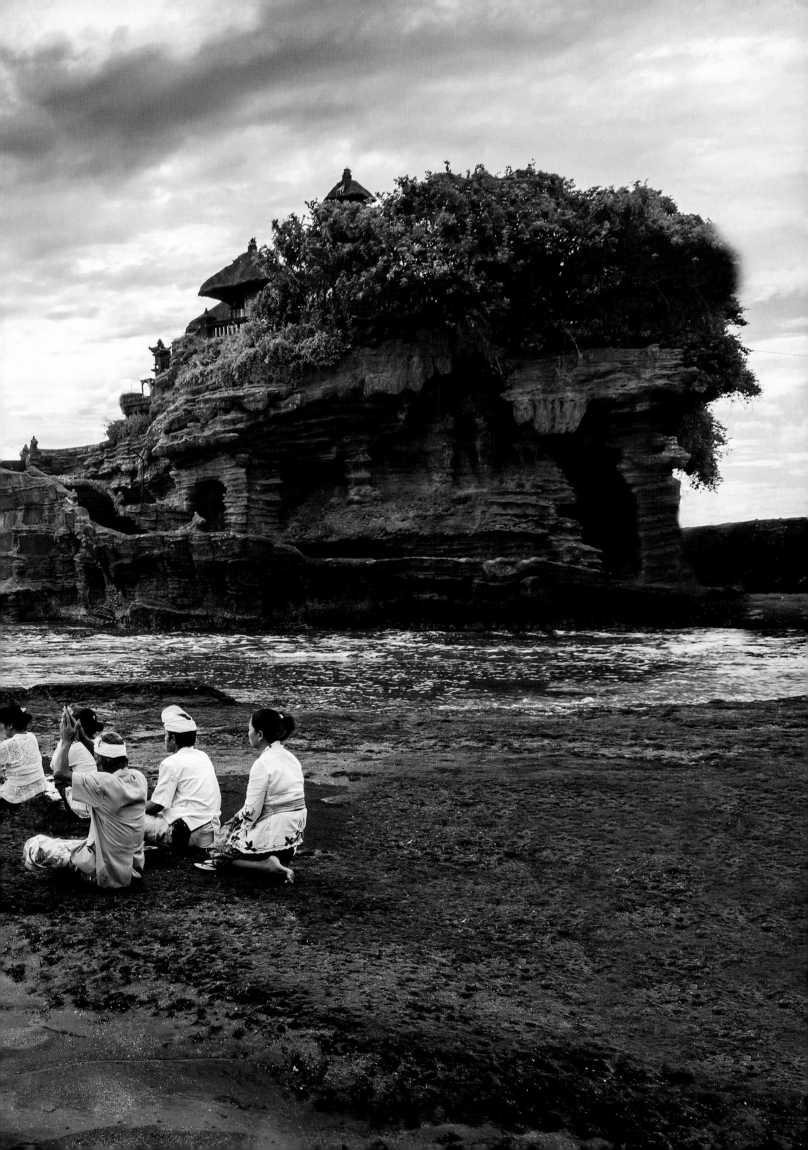

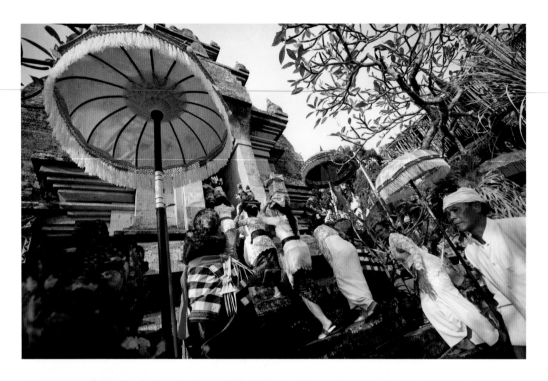

PREVIOUS SPREAD A temple priest known as a *pemangku* will often guide and bless worshippers, even if the temple itself, at Tanah Lot, is inaccessible because of high tide.

LEFT Many temples are often, by definition, perched along hills, mountains and volcanoes. Invariably, attendance involves a lengthy walk, often followed by a strenuous climb through the *gapura* or gateway.

BELOW Traditional dances and shows, such as fire breathing, are still performed, if mainly for the benefit of fee-paying tourists.

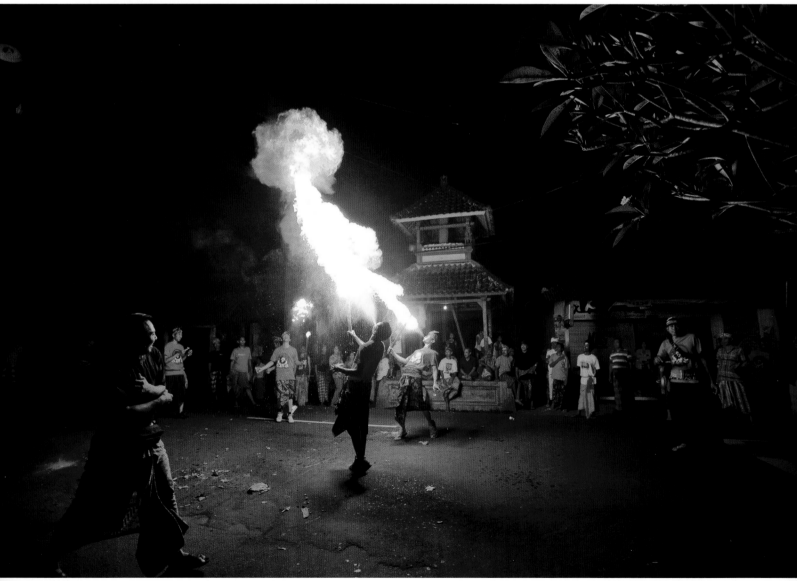

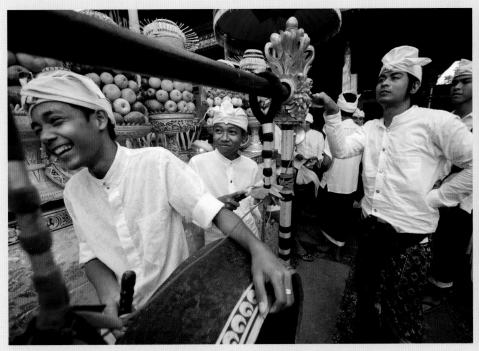

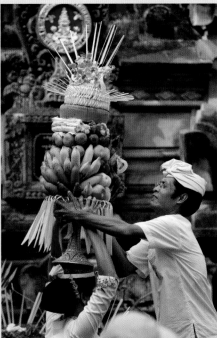

Ceremonial Outfits and Temple Etiquette

To please the gods during temple ceremonies, Balinese Hindus dress up in their finest outfits according to traditional customs. Men wear *kamen* sarongs, short-sleeved shirts or jackets and white head-cloths called

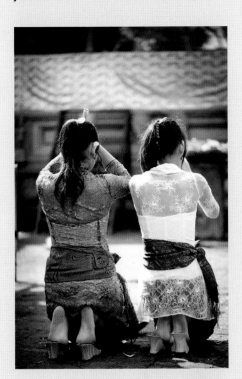

ABOVE Rules about the position of the body and hands are strictly adhered to while praying at temples.

udeng. Women also appear resplendent in their colorful *kebaya* blouses and *kamen* sarongs with cloth belts (*selempot*). Foreigners are welcome to observe ceremonies but not participate unless specifically invited. If so, they're expected to wear appropriate ceremonial attire and make a small donation to help with the significant costs of maintaining the temple and holding the ceremony. When visiting temples, tourists must wear a sarong and, if possible, a temple sash (*selendang*) as a sign of respect. These can be borrowed at major temples. A temple is not only a place of worship but a sacred building. Some rules are obvious, for example, never enter if a sign forbids non-Hindus; always remain quiet and distant; and be sensible about filming, for example, don't use a flash. Others are less so: never walk in front of anyone praying or position yourself higher than a priest. Also, women who are pregnant, menstruating or have given birth within the previous 42 days, as well as anyone grieving, bleeding or sick, is forbidden to enter because they are spiritually unclean (*sebel*).

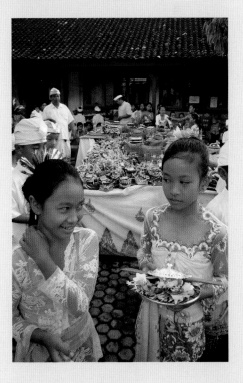

TOP LEFT Each village funds its own orchestra or *gamelan*, including massive bronze gongs, which are used during temple ceremonies and family rituals.

TOP RIGHT Women often walk vast distances to ceremonies carrying weighty offerings called *banten tegeh* on their heads, but need some help loading up.

ABOVE During ceremonies, boys and girls of all ages are happy to dress up in traditional attire and help make offerings beforehand.

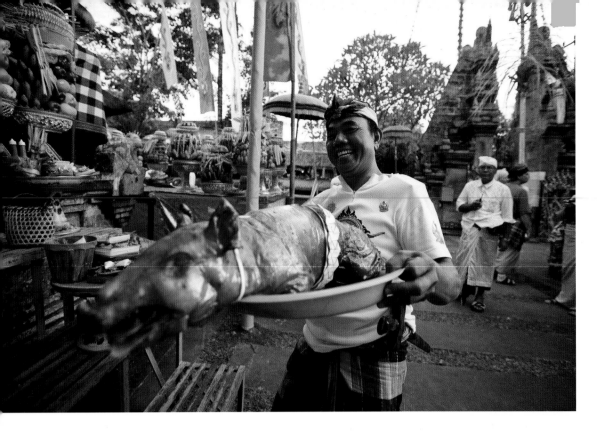

LEFT Because of the expense, a whole roast pig is usually reserved for special temple ceremonies. The cost and the cooked meat are often shared by several families.

BELOW To ensure the soul's proper release and reincarnation, cremations are lavish affairs that can take years to save for and organize. The ceremony usually involves hundreds of people.

Temples and Temple Ceremonies

Balinese are villagers at heart, so hundreds of villages are spread across the island. Places like Ubud, for example, are really an amalgamation of a dozen or more villages. Each village has at least three types of *pura* (temple): the *pura desa* (village temple), also called the *pura agung*, which is located in the village center and created to appease spirits that protect the villagers; the *pura puseh* (temple of origin), positioned in the direction of *kaja*, which is closest to the mountains and home of the gods, and dedicated to Brahma, Creator of the Universe; and the *pura dalem* (temple of the dead), situated in *kelod*, nearest to the sea where demons live, and used for cremations. Nine of these temples are sacred enough to be revered by all Balinese Hindus, not just local villagers, among them Pura Besakih, Pura Goa Lawah and Pura Luhur Ulu Watu. Others are also particularly valued because of their dedication to specific spirits, historical importance or nomination as official state temples.

Temples are typically fronted by a *candi bentar* (split gate) which leads to one or two outer courtyards with several *bale* (open-air pavilions) for resting, cooking and preparing for ceremonies, as well as a *kul-kul* tower with a drum used to announce events. Through another ceremonial gate is the sacred inner courtyard with small shrines dedicated to village elders and lesser gods, and several tall *meru* shrines, shaped like pagodas, with thatched roofs of an odd number up to eleven, depending on which deity and mountain the *meru* is dedicated to. Given the Balinese passion for, and skill in, carving and painting, temples are ornately decorated, with every chiseled gate and sculptured roof carrying meaning and purpose.

Each of the temples in every village is celebrated on the anniversary of its founding (*odalan*), usually according to the *wuku* Balinese calendar, which is shorter at 210 days. On holy days also, such as the major Galungan and Kuningan festivals, and for personal rituals, particularly cremations, families visit

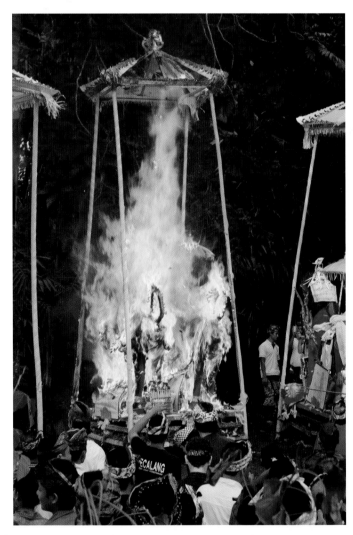

every temple they're associated with, thus attending ceremonies takes up a significant proportion of their time and income.

For each ceremony, temples are decorated with colorful *batik* and shrines are wrapped in yellow and white cloths, while enormous offerings are made to satisfy the spirits who

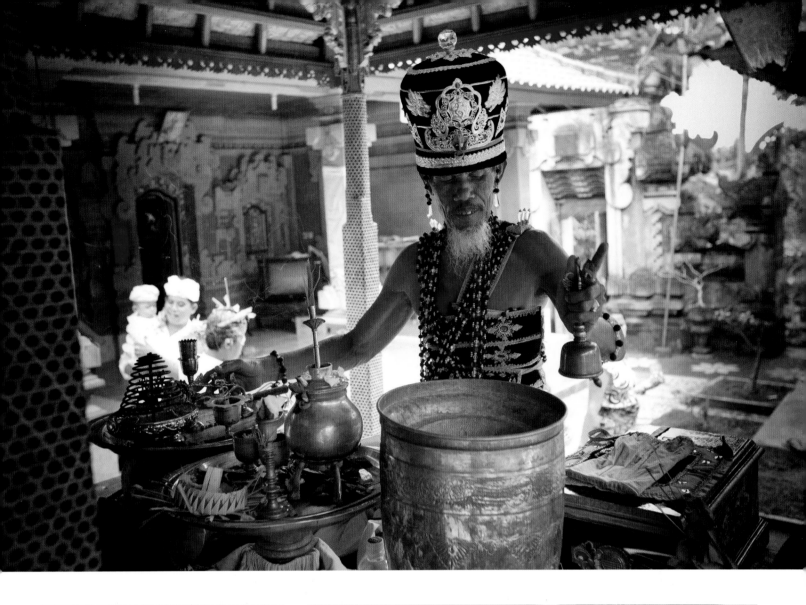

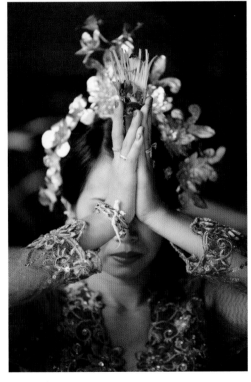

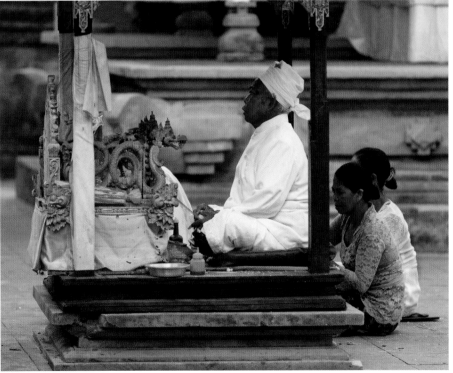

ABOVE Fingers and palms are always firmly clasped together when praying, and hands are briefly raised above the head during moments of particularly deep spiritual connection.

ABOVE The temple or high priest performs a spiritual purification of the household and is always seated on a platform raised above the level of the worshippers.

TOP Special holy men are called upon to perform sacred rituals in family compounds, such as when a child's teeth are filed.

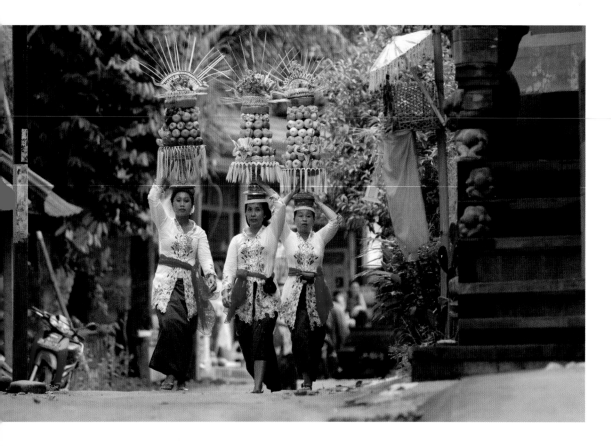

then grant happiness and health to the families. Ceremonies last all day, often several days, and involve much eating, ritualized dancing and, of course, worshipping, praying and reflecting under the guidance and blessing of the *pedanda* (high priest) or *pemangku* (temple priest).

Tourists often stumble across ceremonies while traveling about or even sitting on a beach in Kuta. Otherwise, visit a major temple (particularly during full moon), look for signs stating hati-hati ada upacara agama ("be careful, there's a religious ceremony"), or ask locals. The best temples to visit for their setting and piety are Pura Besakih, the vast sacred 'Mother Temple'; Pura Ulun Danu Beratan, nestled along- side a crater lake at Candikuning; Pura Tanah Lot, perched on an islet surrounded by other cliffside temples; Pura Pasaran Agung, along the isolated slopes of Bali's highest peak; and Pura Taman Ayun in Mengwi, surrounded by a moat. But don't forget that temples are not tourist attrac-tions, they are sacred buildings sometimes permanently closed to non-Hindus. And please don't begrudge payment of entrance fees that help offset the enormous cost of maintaining temples and holding ceremonies.

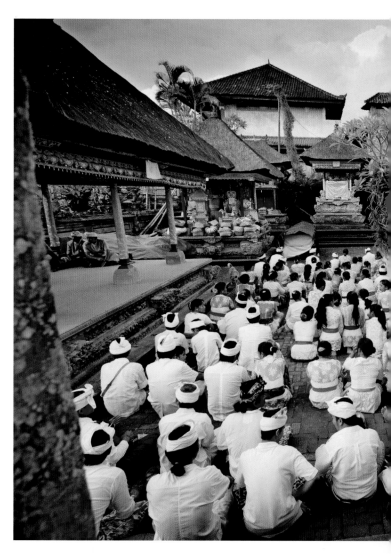

ABOVE The size and height of these *banten tegeh* offerings, which are layered with fruit, cakes and flowers, depend on the importance of the occasion.

ABOVE RIGHT During the Nyepi New Year festival, huge effigies are carried through the streets before being burned during elaborate ceremonies.

RIGHT There are strict rules about where and how men and women pray, but while waiting for ceremonies to begin, friends and families can mingle and relax, especially after carrying the huge *banten tegeh* offerings.

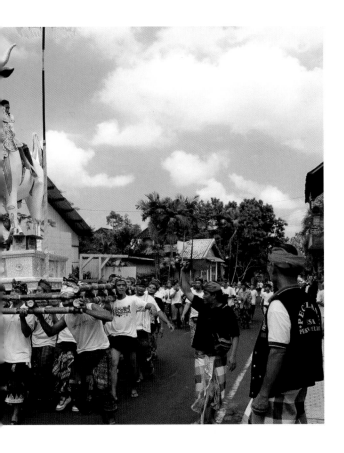

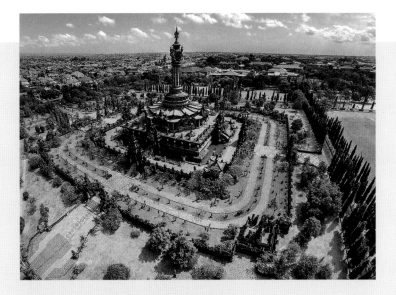

Other Religions on Bali

The dominant minor religion on Bali is Islam. Muslims are descendants of Javanese who ruled and then fled to Bali from the 14th century, or are more recent job-seekers from across the world's most populous Islamic nation. Sizable Muslim communities are located in the west, close to Java, and at Candikuning, while seafaring Buginese from Sulawesi and elsewhere across the archipelago have settled in Jimbaran and along the northern coast. Buddhism thrived on Bali during the 8th and 9th centuries and is still a dominant element of local Hindu rituals and philosophies, but the only evidence of Buddhist veneration these days is the monastery at Banjar, near Lovina. Christians in Denpasar are mostly descendants of Chinese settlers, while some expatriates worship at the elegant Protestant St Mikael's Church at Seminyak. In the far west, two remarkable villages are successful examples of missionary zeal: Belimbing Sari is home to a large Protestant community where the church features a *kul-kul* drum, used at Hindu temples to make announcements, instead of church bells; and, five kilometers away, Palasari boasts a massive Catholic church with spires resembling pagoda-style *meru* shrines, also found in Hindu temples. The most admirable example of religious harmony on Bali, if not Indonesia, is at Benoa village on the northern end of Tanjung Benoa, where a Chinese temple, mosque and Hindu temple coexist peacefully.

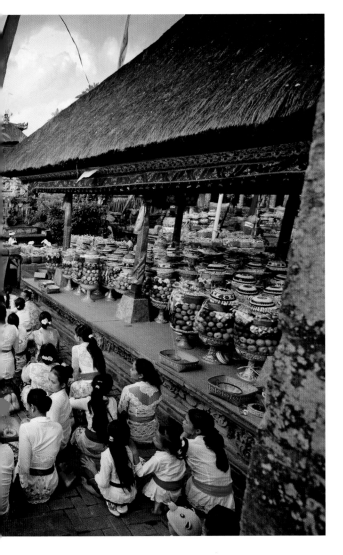

ABOVE The Bajra Sandhi monument in Denpasar, Bali, contains 33 dioramas depicting the people's journey over the years of the island's illustrious history.

RIGHT Some Western residents and Balinese of Chinese background are Christians and worship in a handful of churches spread across the island.

Artful Offerings to the Gods

An integral element of the Hindu religion and, therefore, Balinese way of life, are offerings (*banten*) to the gods. Typically, a family may spend half their income and vast amounts of time assembling gifts to thank the favorable gods and entice them to join in the ceremonies, or to appease the demons in order to maintain universal harmony and good fortune for the family. The most common offerings are the *canang* (*sari*) trays made from coconut leaves and attractively packed with rice, morsels of food and flowers, which represent Shiva, the Destroyer of the Universe. Every day, *canang* are placed with burning incense, signifying Brahma, the Creator, at household and temple shrines and in front of shops, offices and homes, and then sprinkled with Holy Water symbolizing Vishnu, the Protector. Generations of women spend days before religious festivals creating huge numbers of diverse offerings, including the exquisite meter-high pyramids called *banten tegeh* that burst with flowers, rice cakes and fruit. Men happily involve them-selves in cockfighting to offer blood to the demons, and help craft the *penjor* that decorate village streets during major festivals, particularly Galungan. Under these arched bamboo poles, a colorful *lamak* mat is placed. A symbolic *sampian*, shaped like a *canang*, dangles from the tip.

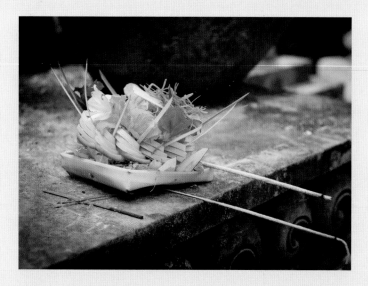

ABOVE Laid every day along streets outside homes, shops and offices, *canang* offerings are made from coconut palm leaves and contain rice, flowers and maybe crackers and slices of fruit.

BELOW A sizable portion of the family income is used to create *banten tegeh* offerings, which comprise mostly fruit, such as *jambu* and *salak*, as well as more commonly known apples and bananas.

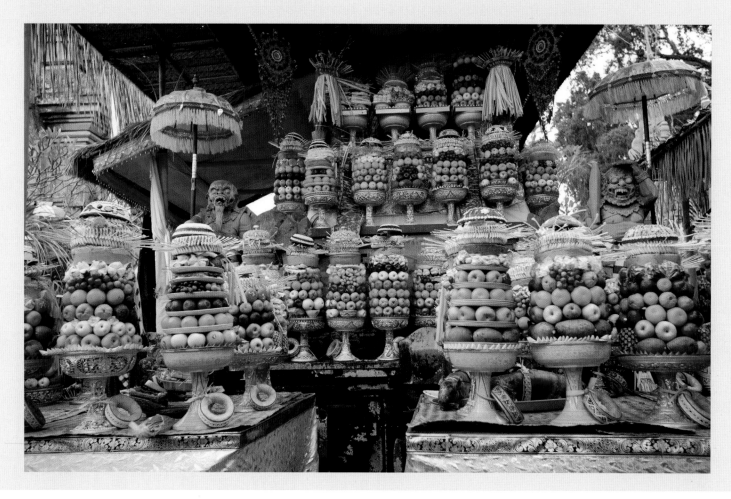

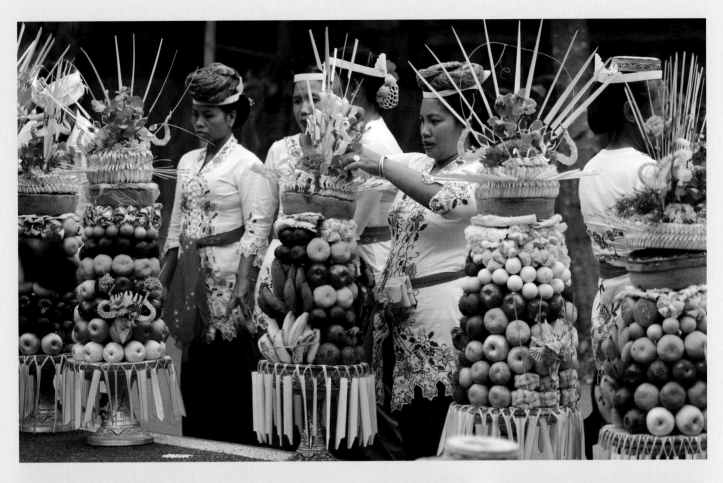

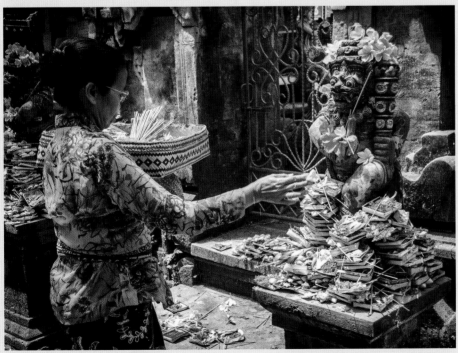

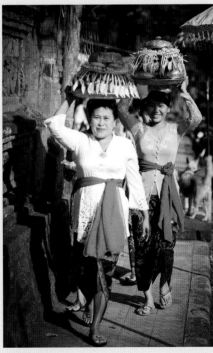

TOP Contents of these enormous *banten tegeh* offerings are layered upon a *dulang* pedestal tray with a spike at the center to help keep everything stable.

ABOVE LEFT No offering or communication with the gods is complete without presenting flowers, lighting a stick of incense and sprinkling the offering with holy water.

ABOVE RIGHT When attending temple ceremonies, women always wear elegant *kamen* sarong-style skirts, *baju kebaya* blouses and the obligatory waist sash.

The Traditional Market

Although mini-marts seem ubiquitous, and a few shopping malls have sprung up in the cities and tourist areas, most Balinese still shop at a *pasar umum* (public market). Market traders are almost always women, who don't shy from rising before the roosters and transporting hefty bundles on their heads. Partaking in the *banjar* village association and playing in a *gamelan* orchestra are predominantly male domains, but markets are an essential chance for women to socialize, earn money and buy food that's fresh and goods that comply with *adat* (traditional) customs.

Daily markets are sometimes makeshift, such as the one that operates near 'bemo corner' in Kuta between about 5 am and 8 am, or housed in a permanent structure like at Sanur. Some villages may only have markets every three days, on set days each week or at night (*pasar malam*). Others specialize, such as Pasar Kumbasari in Denpasar, which sells souvenirs and clothes, Pasar Burung, also in Denpasar, for birds and other caged animals, and at Candikuning, where traffic jams are created as drivers stop to buy rare delights like strawberries.

Some markets close, or the best produce is already bought, by the time tourists even contemplate breakfast. This is to ensure that food doesn't rot in the heat and because traders often have other duties, such as cooking and tending to animals and rice fields. As well as fruit, vegetables, meat, clothes and household goods, ingredients for ceremonial offerings and *canang*, small trays woven from palm leaves, are sold. Impromptu fish markets (*pasar ikan*) are often positioned alongside roads within minutes of fully laden boats landing, for example, around Amed, while fish is put on ice all day at the extensive market at Jimbaran. The largest, oldest and most chaotic produce market is Pasar Badung in Denpasar, while the market at Semarapura is relatively spacious and clean, and the one in Ubud is convenient.

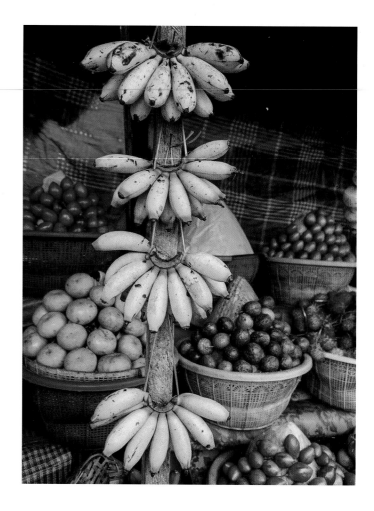

ABOVE Some of the more unusual fruits often not found outside of Asia include *salak*, with its brown snake-like skin, and *rambutan*, with a hairy red covering.

BELOW LEFT Some market stalls also sell flowers and petals that can be added to the ubiquitous trays of *canang* offerings.

BELOW Shopping is not always a chore. It's also a time to gossip. And bargaining is a way of life for all buyers and sellers.

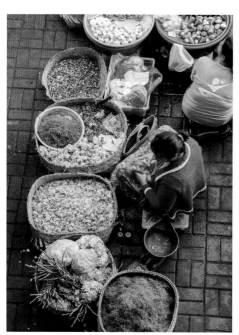

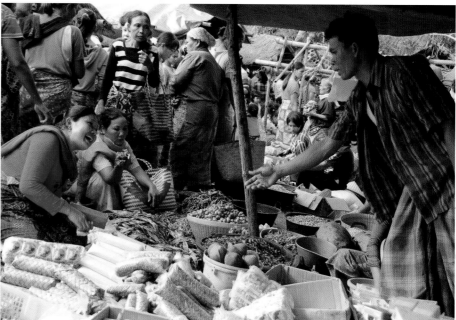

Traditional Healers and Herbal Treatments

A traditional healer called a *balian*, or *dukun* elsewhere in Indonesia, is often the first port of call when a Balinese becomes sick, not only for medical purposes but also spiritual reasons, such as contacting deceased family members while grieving. The 8,000 or so *balian* have learnt their trade from officially studying ancient texts for years or through divine intervention. Treatments include massaging to restore internal harmony, applying pastes, and prescribing drinks formulated from various herbs and plants. Other healing processes may be painful (being poked with a stick), unpleasant (being basted with spit) or unusual (the *balian* may drift into a trance).

As Ubud becomes an increasingly fashionable destination, especially following the popularity of the movie *Eat. Pray. Love*, foreigners are also seeking spiritual guidance and medical treatment from *balian*. However, most therapies and remedies are rigidly linked to religion and of negligible benefit to non-Hindus. Also, most *balian* work in family compounds,

which are difficult to locate, won't deal with Westerners because of the linguistic and cultural divide, and rarely relate to Western concepts of speed and privacy. If an appointment has been made, the same rules apply as visiting a temple: wear a sarong and don't sit higher than the *balian*. Menstruating and pregnant women will not be treated.

Traditional *jamu* medicines come in all kinds of pills and powders for every conceivable physical ailment and emotional malady, and are often sold in liquid form by *jamu* ladies, especially around the markets. Dressed in a ceremonial-style blouse and skirt, these women laboriously drag a very heavy basket laden with bottles across their shoulders. Consumers state their illness, for example, ulcer, virus or infection, or wishes, such as beauty, a youthful appearance or fertility, and the *jamu* lady offers a brightly colored concoction prepared from herbs, flowers, minerals, plants, bark and even animal parts, all usually sweetened with honey.

TOP Traditional *jamu* can be bought from specialty stores or from ladies who wander the streets carrying baskets filled with bottles of brightly colored concoctions.

ABOVE Tourists can also seek spiritual, emotional and physical treatment by visiting a traditional healer.

AN EXOTIC AND LITTLE KNOWN CUISINE

Although ostensibly not as exotic as Thailand or Vietnam, the food in Indonesia is appetizing, the array of spices, vegetables and fruits used astounding, and it does vary substantially across the archipelago.

Like its culture and language, Indonesian cuisine is also a mouth-watering mix of foreign influences: noodles and *fu yung hai* (sweet-and-sour omelette) from China; *gulai* curries from India; *rijsttaffel* ('rice table') smorgasbord created by Dutch colonialists; and, from the Arabian Peninsula, *sate* (satay) and *martabak* (stuffed sweet or savory pancakes).

Balinese food differs because it includes pork, which is *haram* (forbidden) for Muslims throughout Indonesia, and the spices, garlic, ginger and chillies are blended to create unusual flavors and contrasts. Beef is rarely eaten because of Hindu philosophies, and other red meats are expensive, so fish and chicken are more common. Vegetables normally used but rarely seen in the West include stringy *kangkung* water spinach, while fruits such as papaya are often included in vegetable dishes that are generally boiled in coconut milk. And, naturally, almost everything is served with rice.

The family kitchen is often sparse, with just a gas stove, several woks and a mortar and pestle for grinding peppercorns, ginger and garlic, among others, to create the zesty *basa gede* paste used in many dishes. Household meals as well as offerings to the gods are normally prepared after an early morning visit to the market so, when hungry, family members eat cold but fresh morsels of meat/fish and vegetables with maybe a hard-boiled egg, *krupuk* crackers or *tempe* fried soybean cake, all with rice and *sambal* chilli paste.

There's somewhere to eat on and between almost every street corner. These include *kaki lima* portable food carts that sell two or three items, often pre-cooked; *lesehan* cafés, where guests sit on mats or in a *bale* (open-air pavilion); *warung* food stalls with bench seats and a limited selection of Indonesian food; and *rumah makan* ('eating house') or *restoran* with menus often featuring Western meals.

And a few tips: Balinese habitually eat dry rice-based meals with their right hand, although cutlery is always available. Chopsticks are rare, and normally used for noodles in better restaurants. If there's no menu, check the wall or awning for pictures or words and point. If asked into a home, wait to be invited before eating, take some rice first and then small amounts of meat and vegetables using the right hand, and leave a little on the plate and in the glass.

A Feast of Babi Guling

ABOVE *Babi guling* is best enjoyed at restaurants that specialize in the dish, although it is often possible to order it at other places by giving 24 hours' notice.

Arguably, the tastiest Balinese dish is *babi guling* (roast pig), enjoyed by Hindus in direct contrast to Muslims for whom pork is *haram* (forbidden). It's best at speciality *warung* (food stalls) in Gianyar, recognizable by signs of a pig with a pole extending from both orifices, or at cafés along the main road north to Singaraja, via Candikuning, which cater for day-trippers from Denpasar. But the most convenient spot for tourists is probably Ubud, particularly the three Ibu Oka outlets still regarded as *the* places to pig out. At Ibu Oka's, pigs are about 18 months old, although other places commonly use animals as young as four months, which are conveniently smaller and cheaper. The pigs are slaughtered, skewered with a spit and their insides stuffed and skins basted until yellow with a spicy combination that includes turmeric, chillies, garlic and ginger, although the exact ingredients used at Ibu Oka's are a secret. The animals at Ibu Oka's are laboriously rotated by hand above a wood-fueled blaze in a scorching furnace for up to five hours from 5 am until the skin is crispy brown and the flesh is tender and succulent. For Balinese, pigs are very expensive, about 1 million rupiah or US $100, so they're bought for very special occasions only or shared by families, but five to seven large pigs are roasted each day and devoured by tourists among the three Ibu Oka restaurants. Usually eaten without cutlery and always served with rice, *babi guling* is often accompanied by spicy sausage made from innards and blood, crackling skin and *urab* or green vegetables boiled in coconut milk.

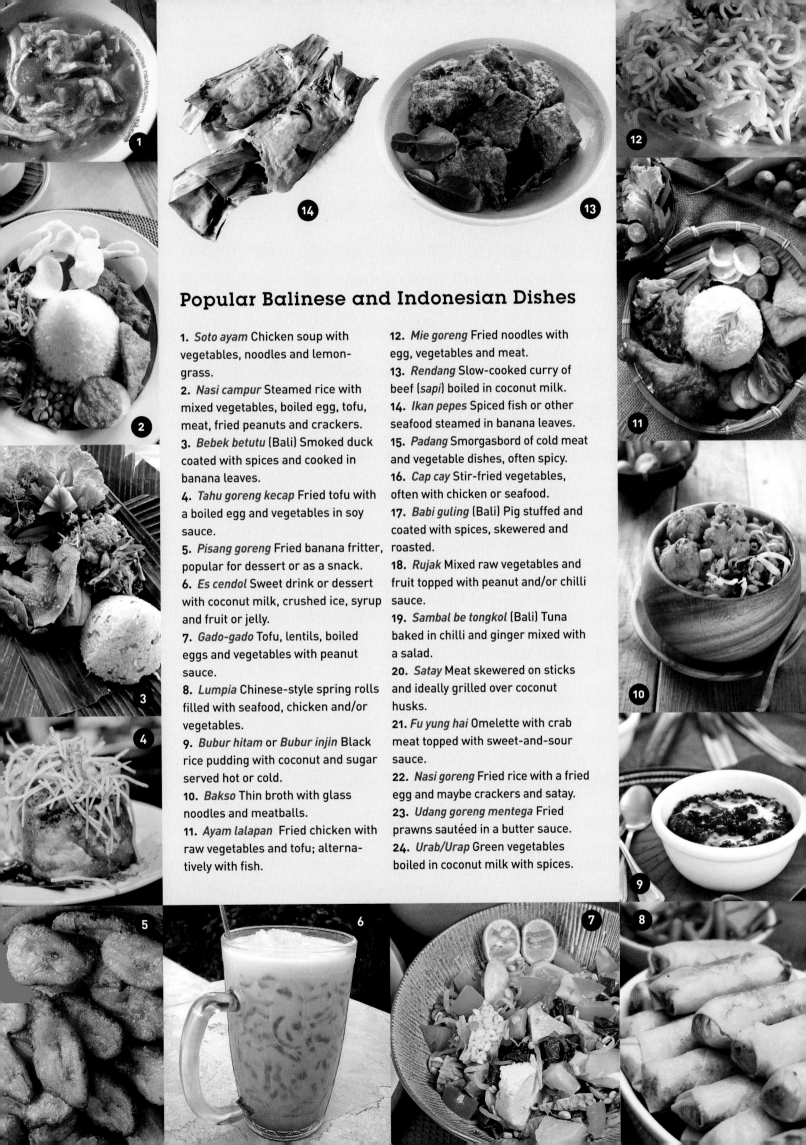

Popular Balinese and Indonesian Dishes

1. *Soto ayam* Chicken soup with vegetables, noodles and lemongrass.

2. *Nasi campur* Steamed rice with mixed vegetables, boiled egg, tofu, meat, fried peanuts and crackers.

3. *Bebek betutu* (Bali) Smoked duck coated with spices and cooked in banana leaves.

4. *Tahu goreng kecap* Fried tofu with a boiled egg and vegetables in soy sauce.

5. *Pisang goreng* Fried banana fritter, popular for dessert or as a snack.

6. *Es cendol* Sweet drink or dessert with coconut milk, crushed ice, syrup and fruit or jelly.

7. *Gado-gado* Tofu, lentils, boiled eggs and vegetables with peanut sauce.

8. *Lumpia* Chinese-style spring rolls filled with seafood, chicken and/or vegetables.

9. *Bubur hitam* or *Bubur injin* Black rice pudding with coconut and sugar served hot or cold.

10. *Bakso* Thin broth with glass noodles and meatballs.

11. *Ayam lalapan* Fried chicken with raw vegetables and tofu; alternatively with fish.

12. *Mie goreng* Fried noodles with egg, vegetables and meat.

13. *Rendang* Slow-cooked curry of beef (*sapi*) boiled in coconut milk.

14. *Ikan pepes* Spiced fish or other seafood steamed in banana leaves.

15. *Padang* Smorgasbord of cold meat and vegetable dishes, often spicy.

16. *Cap cay* Stir-fried vegetables, often with chicken or seafood.

17. *Babi guling* (Bali) Pig stuffed and coated with spices, skewered and roasted.

18. *Rujak* Mixed raw vegetables and fruit topped with peanut and/or chilli sauce.

19. *Sambal be tongkol* (Bali) Tuna baked in chilli and ginger mixed with a salad.

20. *Satay* Meat skewered on sticks and ideally grilled over coconut husks.

21. *Fu yung hai* Omelette with crab meat topped with sweet-and-sour sauce.

22. *Nasi goreng* Fried rice with a fried egg and maybe crackers and satay.

23. *Udang goreng mentega* Fried prawns sautéed in a butter sauce.

24. *Urab/Urap* Green vegetables boiled in coconut milk with spices.

PAINTINGS, TEXTILES AND WOOD CARVINGS

Bali's arts and crafts are unique and so, too, are the island's architecture, dance and religion. Galleries, museums and souvenir shops across Bali are crammed with paintings, jewelry, textiles and carvings of wood or stone that often blend traditional themes dating back centuries with Western influences generated by the modern-day tourist trade.

For centuries, most Balinese art was created to decorate palaces for the nobility and temples for the gods. Large works hung on walls or were crafted as series of panels, often portraying scenes from the *Ramayana* and *Mahabharata* Hindu epics with characters depicted like *wayang kulit* shadow puppets. This classical design is often labeled the Wayang Style or Kamasan Style after the village near Semarapura where similar work is still created for tourists, not temples.

Unfortunately, most examples of this form of art faded over time or were destroyed during battles between rival kingdoms and against Dutch colonialists, and by the wrath of the gods through earthquakes and eruptions. Probably the finest and most accessible examples, albeit greatly restored and repainted, are the panels along the ceilings of reconstructed buildings in the water palace at Semarapura.

It wasn't until a handful of European artists settled in Ubud and, to a lesser degree, Sanur during the 1930s that local artists were convinced to paint on canvas portraits of ordinary Balinese people and landscapes of everyday village life. Local artists were also given superior brushes, paints and canvases on which they incorporated their own classical styles with those introduced by the Westerners. Most notable was the extraordinarily talented I Gusti Nyoman Lempad, who was also an architect and sculptor. His work can be appreciated at the Pura Taman Saraswati temple in Ubud, among other places.

Concurrent to the Ubud Style but without Western influences, indigenous artists in Batuan, between Sanur and Ubud, developed individual methods and techniques. These often encompassed dramatic and contrasting black-and-white images, and sometimes

merged active scenes of village life with the 'peculiar' activities of the occasional foreigners then trickling to Bali. After World War II, the Young Artists movement also developed in Ubud as artistic creativity using vibrant colors progressed with a flourish previously hindered by a lack of equipment and encouragement, not by an absence of talent and ideas.

Artists once 'worked' for the gods, but they now do it for the money. Art nowadays is mostly based on what tourists like and buy, often with minimal creativity and little originality. Now common is an amalgamation of various styles, classic and modern, European and Balinese, that incorporate an inordinate diversity of activities, sights, themes and characters cluttered amongst a dense setting, for example, a forest, often using shades of one color, such as brown or green.

The foreigners who settled in Bali during the 1930s quickly convinced local artists and elders about the importance of artistic conservation, so cooperatives were established to foster local art and museums were built to preserve it. Other than the splendid collection at the Museum Pasifika in Nusa Dua, the best is on display at Ubud. Three outstanding museums feature works by foreign artists, such as Walter Spies, and Balinese, such as Lempad, and paintings in the pre-colonial classical style: the Museum Puri Lukisan; Agung Rai Museum of Art (ARMA); and Neka Art Museum. Modern Balinese art can be admired at the Ganesha Gallery in the Four Seasons Resort, Jimbaran; the Gaya Gallery in Ubud; and at Biasa Art Space in Legian, which also helps restore and conserve art that inevitably gets affected by the tropical environment.

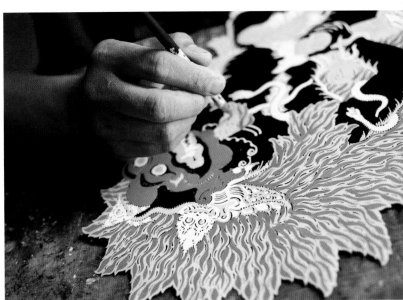

LEFT Many modern Balinese paintings share a deliberately cluttered style that portrays numerous aspects of village life.

ABOVE Balinese art continues to thrive, if only for the tourist market, but sometimes still incorporates themes and traditions dating back many centuries. Here, an artist puts the finishing touches to a *wayang kulit* shadow puppet.

Balinese Textiles and Wood Crafts

Previously created to appease the gods, carvings and woven cloths are now mostly crafted to please the tourists, but the traditional methods used and the cultural and religious significance attached still remain. Almost no one leaves Bali without buying a souvenir, and among the fake designer sunglasses and pirated DVDs is a multitude of crafts synonymous with Indonesia and unique to Bali. The best places to admire and acquire a range of quality mementoes are the streets of Jalan Raya Seminyak and Jalan Laksmana in Seminyak and Jalan Hanoman in Ubud.

Stone carvings that decorate palaces and temples with faces of demons and statues of protective spirits, particularly on the *candi bentar* split gate entrances, are usually produced from *paras* volcanic rock. The main road through Batubulan, between Sanur and Ubud, is choked with Buddha images and characters from the Hindu epics, but their size and weight preclude much interest from tourists so these statues maintain their traditional design and purpose. Elaborate wood carvings, often with evident Chinese influences and supernatural elements, adorn most roofs and doors and are especially ornamental on the *bale* open-air pavilions dotted amongst family compounds and temple courtyards. Popular wood-crafted souvenirs include *wayang kulit* shadow puppets, which are also made from buffalo hide, at Tegallalang near Ubud, and *topeng* masks, as seen in traditional dances, at Mas, also located between Sanur and Ubud.

Many of the patterns and fabrics employed for weaving and the old-fashioned methods using looms are also found elsewhere in Indonesia. The most elegant of Bali's three authentic styles of *ikat* cloth, in which threads are dyed before they are woven, is *songket*. Often worn during ceremonies and dances, *songket* is hand-woven from cotton or silk and features unpretentious designs but bright colors using gold or silver threads. More common is *endek*, which can be admired at workshops in

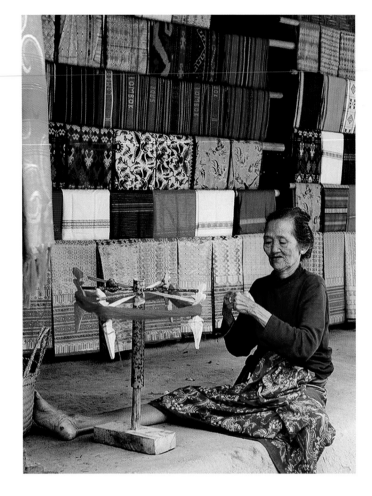

ABOVE Although much of the fabric sold in markets to tourists is made in factories, sometimes in Java, traditional methods of weaving are still common in the villages.

BELOW LEFT The type of *ikat* cloth known as *songket* is very expensive and only worn on special occasions, such as temple ceremonies.

OPPOSITE ABOVE This painting *Blick von der Hohe*, (View from Above), 1934 was created by German artist Walter Spies who was incredibly influential in Bali and many Balinese artists have imitated his style.

BELOW The *kamen* sarongs worn around the waist by Balinese women are always colorful and intricately patterned.

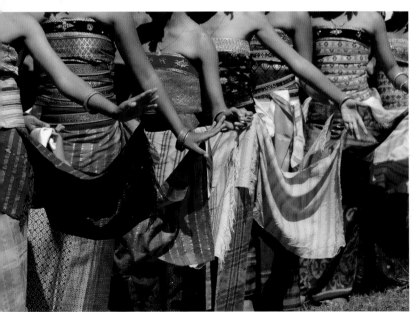

Bali's Influential Foreign Artists

Although flourishing on Bali for centuries, paintings were mostly created to recount historical tales and decorate palaces and temples. Late in the 19th century, renowned Western artists such as Gaugin incorporated Asian symbols and themes, prompting other foreign artists to settle in Ubud during the 1920s and 1930s (also to escape the Great Depression). Two Europeans who encouraged local artists to produce and sell paintings of Balinese people, landscapes and village life were the Dutchman Rudolf Bonnet and the German artist, musician and writer Walter Spies, who was repatriated but died in 1942 when a Japanese submarine torpedoed his boat. They formed the Pita Maha artists' association in 1936 to promote and conserve Balinese arts and crafts, which culminated with the founding of the Puri Lukisan Museum in Ubud. Other artists settled in Sanur, such as Mexican writer and anthropologist Miguel Covarrubias and Belgian impressionist Adrien Jean Le Mayeur, who married a 15-year-old Balinese Legong dancer 40 years his junior and whose home is now a museum. Art-istic creativity again peaked in Ubud after World War II when Dutch artist Arie Smit developed the Young Artists movement by encouraging children to create colorful and spontaneous portrayals of village life, and when the unconventional Spaniard Antonio Blanco settled with his Balinese wife, whose nude portraits are displayed at the eponymous museum.

Sidemen, but the sacred double ikat *geringsing* takes months to create and is unique within Indonesia, and probably Southeast Asia, to the traditional Bali Aga village of Tenganan.

The method of creating *batik* by dipping the cloth in dye and decorating it with colorful patterns using dots and melted wax has been recognized on UNESCO's Cultural Heritage List. The word *batik* also describes the vivid shirts that are the Indonesian national costume for men. Popular and functional, especially among female tourists, are the cotton wraparound sarongs useful for ensuring modesty when swimming and entering temples. Balinese women also spend considerable time and money making or buying refined ceremonial attire, such as *kebaya* blouses of lace or cotton.

For centuries, baskets assembled from vines, bamboo, palm leaves and rattan have been used for carrying and storing. They cost nothing to make and are durable but also disposable, so they're particularly suitable for religious offerings. Hand-woven baskets are also utilized to steam and store rice, entrap shellfish and transport competitors for cockfighting. Authentic and inexpensive baskets, clothes and fabrics can be found at markets in Ubud and Denpasar.

Once exclusive to nobility, silver and gold are still crafted by specialist clans for ceremonial jewelry and traditional *kris* daggers, and ironsmiths continue to manufacture bronze mallets and gongs for *gamelan* orchestras. Souvenirs are available in specialty stores at Ubud, in and around the markets in Denpasar, and at family-run workshops along Celuk, between Sanur and Ubud.

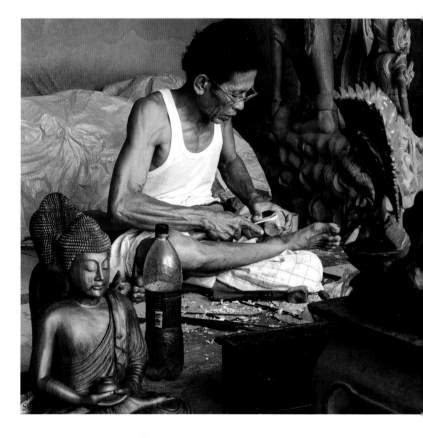

ABOVE Intricate wood carvings, whether produced for religious purposes or tourists, can take days or even weeks to create using traditional tools and methods handed down through the generations.

FABULOUS SPECTACLES FOR GOD AND MAN

Performances of music and dance are as much a genuine part of Balinese culture as they are requisite items on tourist itineraries. Stumbling across or being invited to attend something authentic at a temple ceremony or family ritual is very rare, but dances, such as the celebrated Legong, or music like the renowned gamelan, even if enhanced or truncated for tourists, are no less majestic.

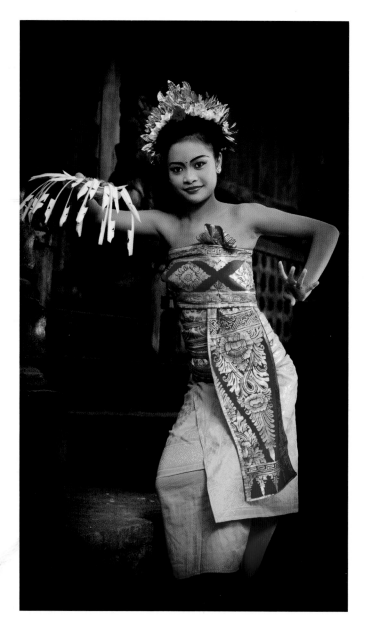

For more than a thousand years, dances have retold the epic tales of Balinese history and Hindu religion, while music has always been an essential component of village ceremonies. Both are now major tourist attractions, of course, and attending at least one performance of traditional dance and/or music is almost obligatory. A dozen or more varieties are staged every evening at numerous temples, palaces and museums across Ubud. Details of these are available from the tourist office and hotels.

The term *gamelan* is used to describe the instruments, the collective orchestra and the types of metallic sounds that are synonymous with Bali, although *gamelan* is played throughout Java, albeit more slowly and quietly. A diverse variety of *gamelan* orchestras use up to 50 instruments each, including hand-made xylophones lined with bronze disks and bowls, as well as drums, gongs and bamboo flutes, each with religious and cultural significance. Every village boasts at least one *gamelan* group, which practices regularly, performs during religious ceremonies and family rituals, and accompanies traditional dances and *wayang kulit* shadow puppet shows presented for tourists.

While most dances feature women and girls, such as the Legong, three are solely male domains. The most renowned is the hypnotic Kecak that involves trances, chants and fire walking. Another is the Baris, in which small groups of men flamboyantly dressed as 'warriors' guard their 'king'. It's energetic and entertaining as the 'warriors' glare, pose, stalk and engage in 'battles' with real or imaginary shields and weapons, such as lances, arrows and traditional *kris* daggers. Often performed in temples with a *gamelan* orchestra even more cacophonous than usual, the Baris is rarely seen independently by tourists but often performed among a collection of other dances.

The third is the ancient Topeng mask dance, in which each actor wears a mask called a *topeng*. Some of these masks, especially those worn by the clowns, are designed to allow the

OPPOSITE Dancers are trained from an early age and can become renowned, with the chance to train others when they get older or to perform across the world.

RIGHT Drums, flutes and metallic xylophones are integral parts of the *gamelan* orchestra whose performances are necessary for all temple ceremonies on Bali.

BELOW The all-powerful Barong is a benevolent creature who protects communities from the ravages of disease or misfortune.

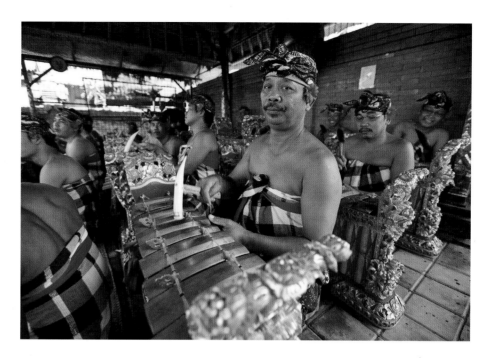

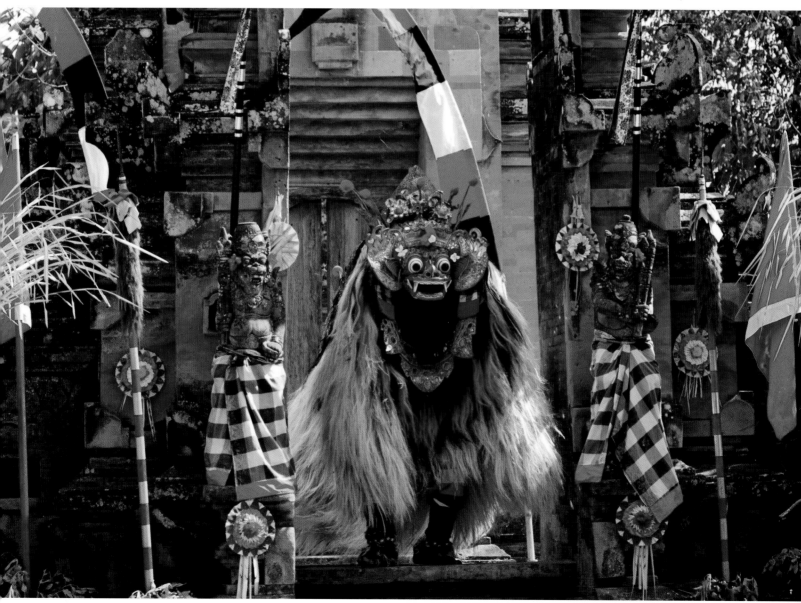

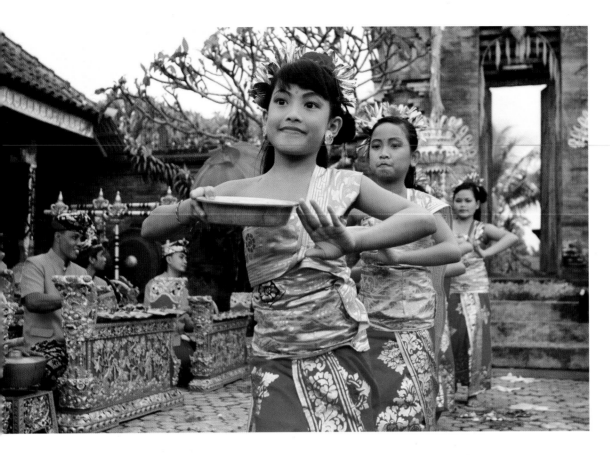

LEFT There are about eight different versions of the Legong. The purest form is performed at temple ceremonies by young girls in costumes, and have over 20 parts, each of them named.

BELOW LEFT Part of a Legong dancer's ritual is to apply thick makeup before donning a costume with layers of tightly wrapped, gold-threaded cloth and a headdress topped with flowers.

BELOW RIGHT Performing the Legong requires extraordinary dedication and discipline from an early age as each dancer jerks her neck, flutters her eyelashes and flicks her fingers with precision.

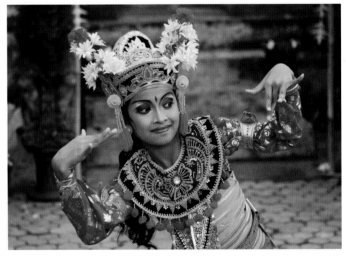

characters to speak and produce humorous noises as part of the narration. Relating a myriad of Balinese legends and stories about the trials and tribulations of their kings, this dance is often performed at religious festivals and family rites-of-passage, such as cremations and tooth-filing. The grotesque masks and comical antics are relished by Balinese children who don't realize they're also receiving lessons in morals and philosophy.

As popular as the Legong and Kecak among tourists and locals is the Barong and Rangda, an entertaining dance about the eternal battle between good and evil that's still traditionally enacted in villages to exorcize demons. The main characters are Barong, a lovable and cheeky part-lion part-dog, with the front and back played by two men, who is the protector of the village, and Rangda, an evil, ugly witch who likes to lurk around graveyards and eat children. Other performers carrying *kris* daggers rush to the aid of Barong whenever it seems to be losing,

but Rangda causes these men to go into a trance, often genuine during village performances, and they stab themselves instead. There's plenty of action and the universal theme is easy to follow.

There are dozens of other lesser known but entertaining dances, including the more modern Joged or Joget. Sometimes performed on small stages in restaurants, a female dancer 'searches' for a 'husband' among the audience and then flirts with him on stage to the usual embarrassment of the man and guaranteed amusement of his friends. Another flirtatious dance is Janger, in which rows of exquisitely dressed girls and an equal number of boys face each other, often forming a square. They sing, dance, flirt and flutter fans in sequence as part of an old-fashioned courtship ritual.

And in a different vein is the Wayang Kulit shadow puppetry that has entertained tourists for decades and mesmerized Balinese for centuries.

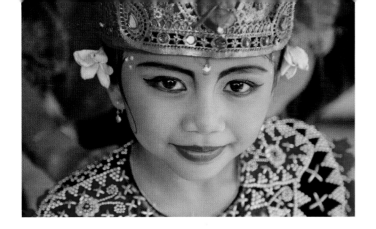

LEFT The *Legong* and other traditional dances are learnt and often performed by girls before they become teenagers.

BELOW Most Balinese girls learn to dance. If taught inside a temple, they must wear sarongs and temple sashes around their waists.

Learning to Dance the *Legong*

The elegant but complex Legong is probably the most popular dance for tourists. It relates one of eight stories, primarily the kidnap by King Lasem of Princess Rangkesari who is inevitably rescued by her brother Prince Daha and his army. It probably originated from the ancient spiritual Sanghyang Dedari dance, but was subsequently adapted with various storylines. A performance commences with a short but vital introductory dance by a *condong* servant who passes hand-held fans to the two incoming *legong* dancers. They perform synchronized, often mirrored movements in which every subtle jerk of the wrist, flutter of the fingers and darting of the eyes is highly symbolic. Both are swathed in identical gold-thread fabrics with gilded crowns of flowers and are heavily made up.

Girls, not women, are chosen to study the Legong because their formative muscles and joints can be flexed like gymnasts to an extent that older children cannot, particularly creating over-arched backs so their buttocks and breasts protrude. (Many older professional dancers seem almost deformed from bending at impossible angles when young.) Prepubescent girls are selected because they haven't menstruated and become *sebel* (spiritually unclean). Another likely but unsavory reason is that in the past young girls were preferred by lecherous and polygamous kings. *Legong* dancers often learn their craft from five years old, perform from about eight, and traditionally retire when they reach puberty. Some then pass on their vast knowledge, but limited years of experience, to students. A few become so renowned that pupils travel across Bali to learn from an eminent tutor.

Dances performed for tourists feature young women, not girls, because of logistics: the late starting times, length of show and preferred longevity of performers. While professional Legong dances are regularly staged in Ubud and truncated versions at restaurants in tourist centers, the most authentic place to admire young girls learning and performing the Legong is at Peliatan village in Ubud.

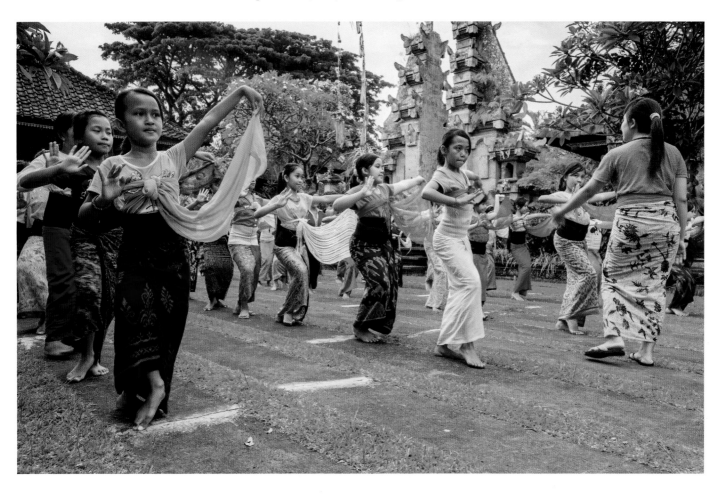

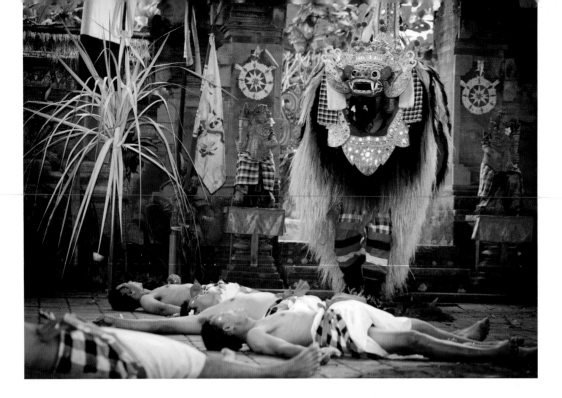

The Dramatic *Kecak* Dance

Walter Spies, a German artist and musician living in Ubud during the 1930s, is accredited with conceiving the modern form of the powerful Kecak dance, although the exact nature of his contribution is debatable. As a musical advisor to a German film, *Island of Demons*, he extracted the choral sections and fire walking elements from a hypnotic Sanghyang dance, performed for centuries in Bali to exorcize demons and prevent epidemics. Spies then blended in tales from the Hindu epic *Ramayana*, such as the kidnapping of Princess Shinta and her rescue by Prince Rama and his brother Laksmana with the aid of the Monkey God, Hanoman.

With choreography from a renowned Balinese exponent of the Baris dance, the newly created and named Kecak dance enjoyed immediate success, although the exact location of its origin, whether at Bona, near Gianyar, or Bedulu, closer to Ubud, remains a source of contention.

During the performance, up to 50 bare-chested men of all ages wrapped in sarongs of black and white, which symbolize evil and good, respectively, sit in a shadowy circle around a bonfire, usually at night. With flailing arms, they shout, clap and chant using a chak-a-chak sound in impressive unison as the prince and princess, and other characters with evil intent, come and go. Because the chanting apparently sounds like monkeys, and Hanoman is represented, it's sometimes called the Monkey Dance.

Unusually, a *gamelan* orchestra is not used because the chanting itself is the musical accompaniment. The performance climaxes as the men drift into simulated trances, which enable them to walk, admittedly very timidly, across hot coals quickly strewn across the dirt floor, which is why it's also occasionally dubbed the Fire Dance. The most dramatic settings to witness this extraordinary spectacle are the cliff-side amphitheaters at the Tanah Lot and Ulu Watu temples during sunset.

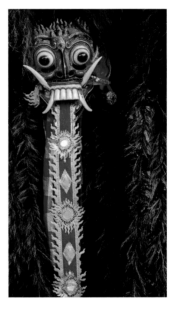

ABOVE The Topeng is a fanciful dance in which numerous male characters wear masks while weaving ancient stories with current issues that reinforce communal morals.

RIGHT The Kecak, which can involve up to 50 bare-chested men in black and white sarongs, is performed almost solely for the benefit of tourists and is particularly dramatic at the Pura Luhur Ulu Watu temple.

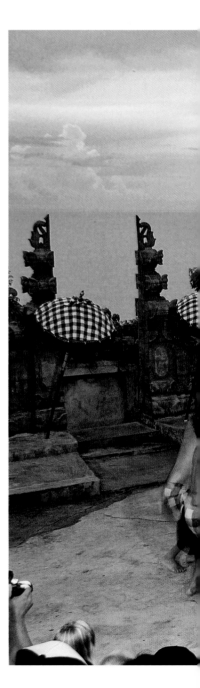

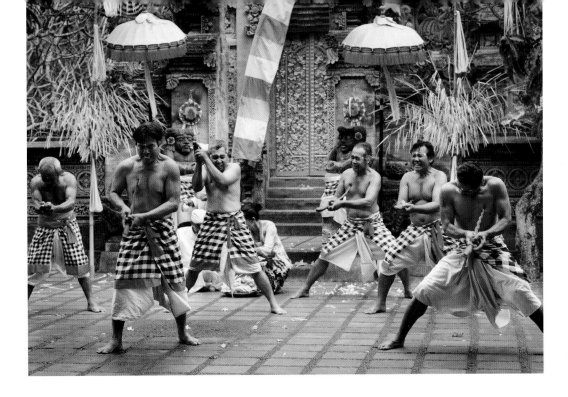

LEFT A part of the Barong and Rangda dance that is quite intense, even when simulated, is the ceremonial stabbing with *kris* while the dancers are in a trance imposed by the evil Rangda.

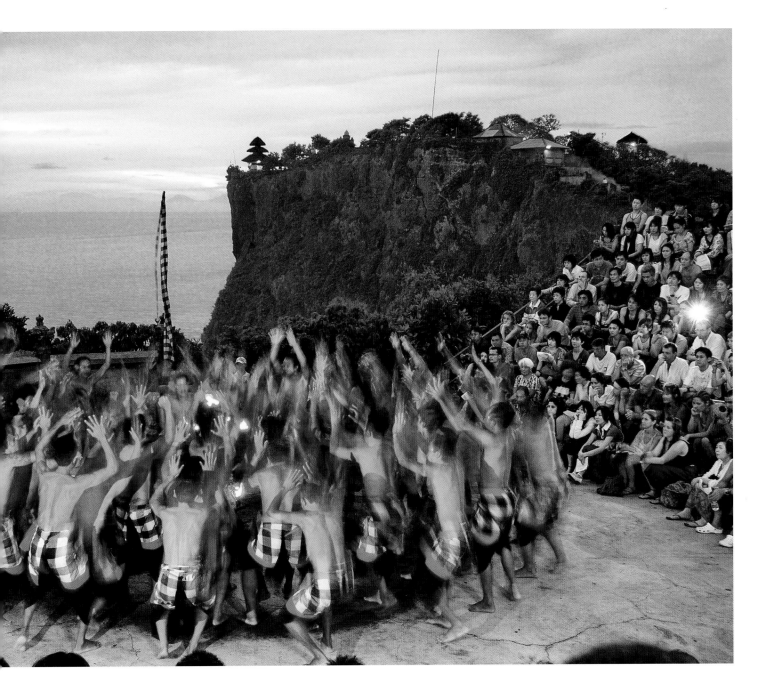

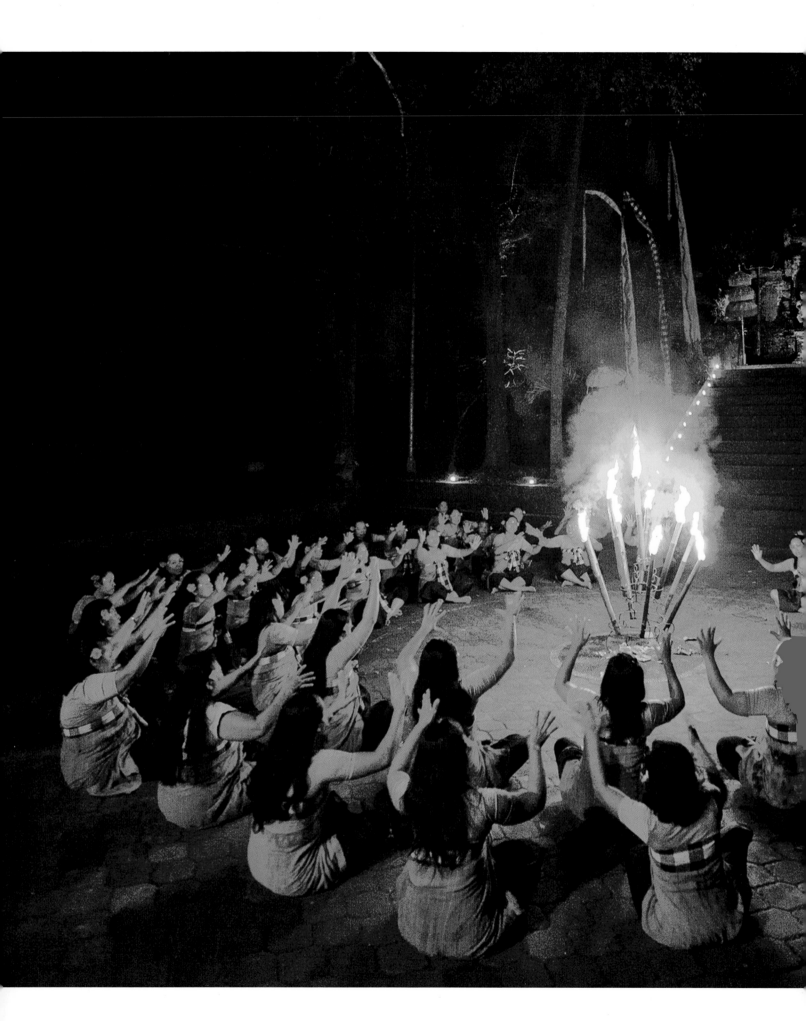

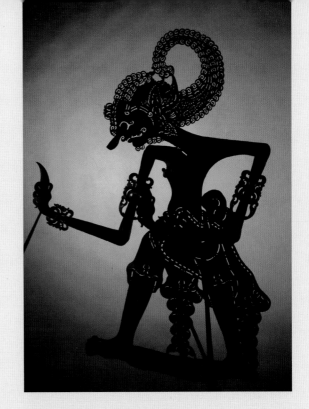

The *Wayang Kulit* Shadow Puppet Play

Taken from the Javanese word *wayang* ("shadow") and Indonesian word *kulit* ("skin"), this ancient form of slapstick puppetry is still performed throughout Java and Bali. Up to a hundred characters are paraded by the *dalang* puppeteer across a white screen lit from the back with a flame or, more recently, an electric light bulb, to create shadows for the audience. The highly trained *dalang* must provide an intricate balance of humor, tradition and style, and also know the exact positioning of the characters, be able to adapt the storyline to include local issues, and possess a vast repertoire of voices that speak and sing in Indonesian, Balinese and Javanese. Formal performances are accompanied by a four-piece *gamelan* group, but others may use taped music. Puppets are shaped from flat buffalo or goat hide, painted with individual costumes and manipulated by rods carved from buffalo horn and attached to the 'body' and 'arms'. Plots are improvised but based around the *Mahabharata* and *Ramayana* epics, and include an assortment of demons and gods as well as gallant heroes, vulnerable heroines and mischievous clowns who all fight, fall in love and get into trouble. But, inevitably, good triumphs over evil. Traditional performances last many hours, and for most tourists the language, symbolism and themes will be incomprehensible, so watching the excitable audience of Balinese may be more fun. But truncated versions are performed for the benefit of tourists.

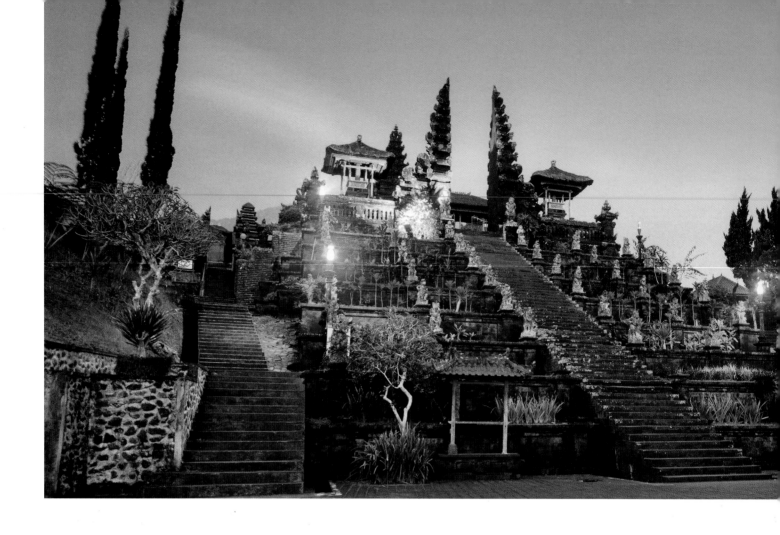

BALINESE ARCHITECTURE

FROM THE SACRED TO THE MUNDANE

Of all the images so readily identifiable with Bali, from rice terraces to traditional dances and religious ceremonies, the most unique is probably its architecture, noticeable from the moment visitors arrive at the airport.

Every carved door and sculptured gateway throughout the island has meaning, and even a building's layout, position and system of measurement are symbolic, all designed to gratify the gods far more than the residents, and to ensure maximum harmony for those living and working inside. This is markedly apparent for the two most significant structures in Balinese life: the temple and the family compound.

Before a temple or home is constructed and decorated, or even a village is established, positions have to be aligned to ensure unity among the three realms of the spirits, man and nature according to the principles of *asta kosala kosali*, very like *feng shui* in China. Often with the assistance of an *undagi* specialist, an architect-cum-priest, structures are placed along the axis

between *kaja*, towards the mountains, and *kelod*, towards the sea, and designed to symbolize the universe or human body. The roof is thus heaven or the head, the rooms are the earth or torso, and the floor is the underworld or feet. Then, every centimeter of each door, pillar, roof and window beam is intricately carved with the faces and symbols of specific demons, gods and evil spirits to safeguard the building against malevolent intruders from the spiritual world.

The most obvious and accessible examples of traditional architecture are the temple and household entrances and the *bale* open-air pavilions dotted among temple grounds and family compounds. The main entrance to a temple's outer courtyard is marked by a free-standing *candi bentar* split gate with two

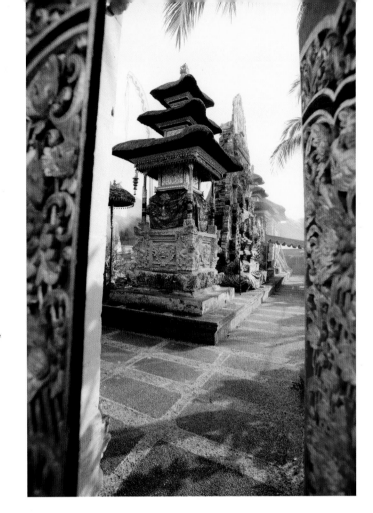

LEFT The 'Mother Temple', Pura Besakih, is a classic example of traditional architecture. At the top of the steps is a split gate *candi bentar* entrance flanked by *bale piasan* pavilions.

RIGHT Temple compounds are dotted with meru shrines that have 3, 5, 7, 9 or 11 roofs depending on the holiness of the god the temple is dedicated to.

BELOW LEFT Every element within a temple or family compound, whether carved from wood or stone, has a symbolism designed to please the gods and placate the demons.

BELOW RIGHT Within every temple compound large bale pavilions are built for non-religious purposes, such as meeting and storage, while smaller bale piasan structures are created for the placement of offerings.

OVERLEAF Perched high along the slope of Bali's most revered mountain, Gunung Agung, is Pura Besakih, a complex of 22 temples and the most sacred on the island.

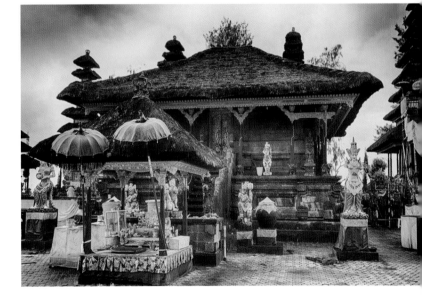

unconnected triangular pillars, often carved as mirror images, which symbolize a division between the positive and negative forces of the material world. To the inner and most sacred courtyard is a ceremonial gate called *kori agung* reserved for priests. This entrance, which is enclosed within a wall and can be locked, is surrounded with intimidating carvings of *boma*, a hideous god that helps repel evil spirits with its gigantic mouth and elongated fingers.

The only way into a family compound is through an *angkul-angkul*, which is flanked by statues of welcoming gods and recesses for offerings, covered with a thatched roof, and usually built higher than the wall which surrounds the compound. A few meters inside, the confronting *aling-aling* wall discourages evil spirits but not guests of the material world who are always welcome, and ensures privacy but not necessarily security because it often can't be locked. Normally seen within the grounds are a *sanggah*, a miniature temple dedicated to the ancestors of the occupants, a *natah* courtyard where children play and chickens roam, and a *lumbung* used to store rice, grain and other foods.

The *bale* pavilions are not only traditionally designed and built but also functional. Wide, gutterless roofs of *alang-alang* elephant grass are firmly thatched and angled to protect against torrential rain; platform bases are raised high in the event of flooding; an absence of walls provides maximum ventilation; and wooden components are not nailed but fitted very tightly with pegs to allow them to sway, not crumple, in case of earthquakes.

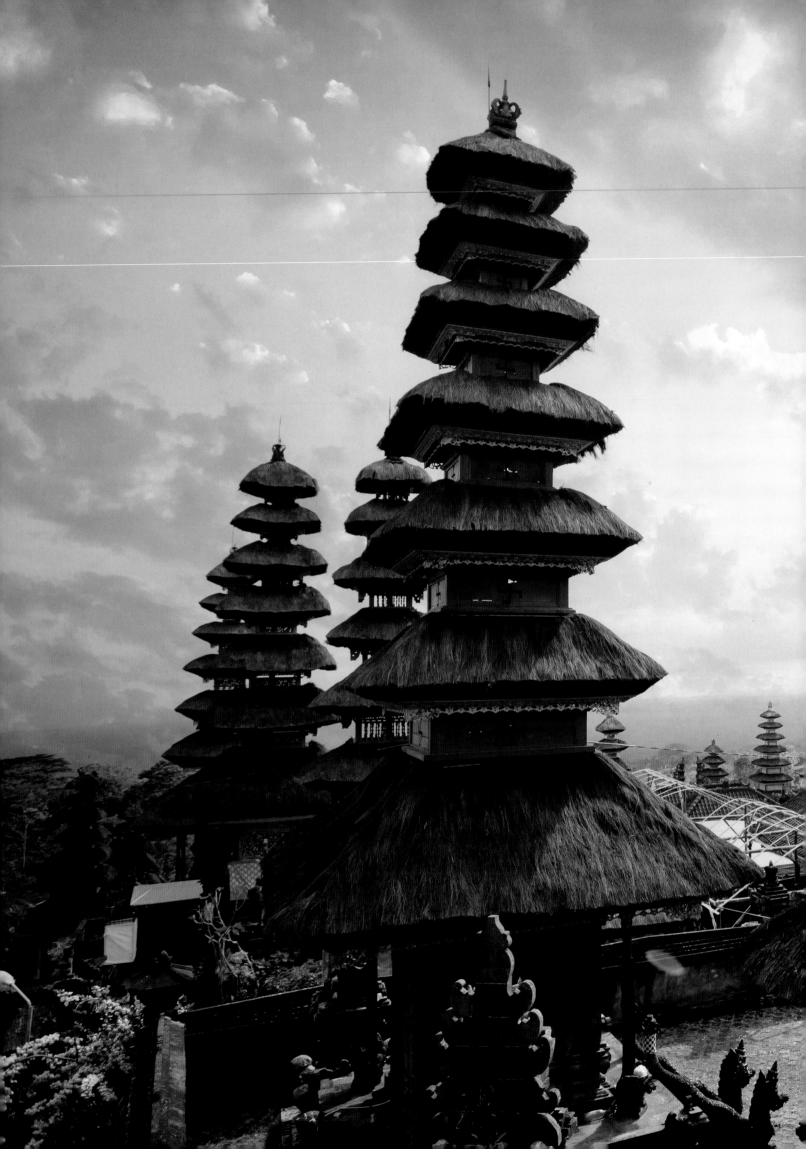

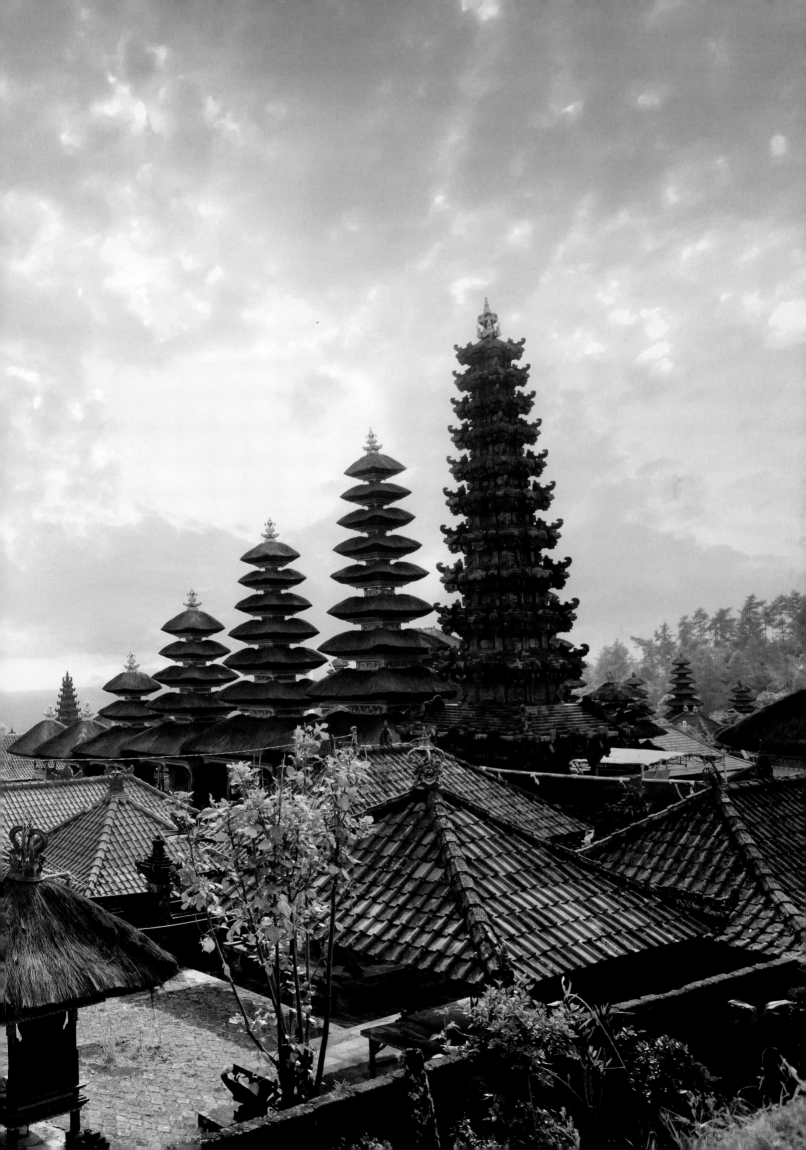

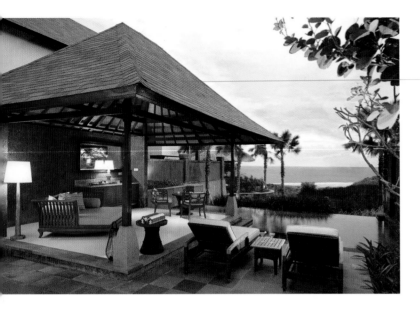

The Modern 'Bali Style' Resort

As tourism boomed, Balinese architecture, one of the most distinctive elements of the island's unique culture, inevitably became influenced by comparatively rich Westerners living on Bali and adapted by foreign companies with access to better materials and equipment. Decades ago, luxury hotels, such as the Tandjung Sari at Sanur and the Oberoi at Seminyak, were built along the lines of a Balinese village and family compound, with traditional-style accommodation of thatched roofs connected by stone paths among gardens dotted with palm trees, shrines and sculptures.

This modern Balinese architectural style was more recently expanded and adapted by luxury hotels to include open-air reception areas shaped like a *wantilan*, normally used for village meetings; a *candi bentar* split gate entrance usually only seen in temples; separate rooms and villas modeled after *lumbung* barns typically used to store rice; and thatched *bale* open-air pavilions normally used for meetings and storage in temples but now positioned alongside swimming pools.

Soon enough, all this architectural wonder moved offshore as workshops along the bypass roads in southern Bali began to export *bale* and sculptures to hotels and villas in Europe, Australia and the Caribbean. Some Balinese farmers now

ABOVE Open-air thatched roof *bale* pavilions, like this one at Grand Nikko Bali, are a common feature of the modern Balinese resort style of architecture.

BELOW The modern Balinese style also includes open-plan rooms with raised ceilings to allow warm air to escape, and sliding doors to allow breezes in and to maximize the views.

OPPOSITE LEFT Common in bedrooms and lounge areas are mosquito nets, which are more than just decorative, and open-air seating pavilions that take full advantage of the views.

OPPOSITE RIGHT Particularly popular among luxury hotels around Ubud are the infinity pools that appear to connect seamlessly with the surrounding landscape.

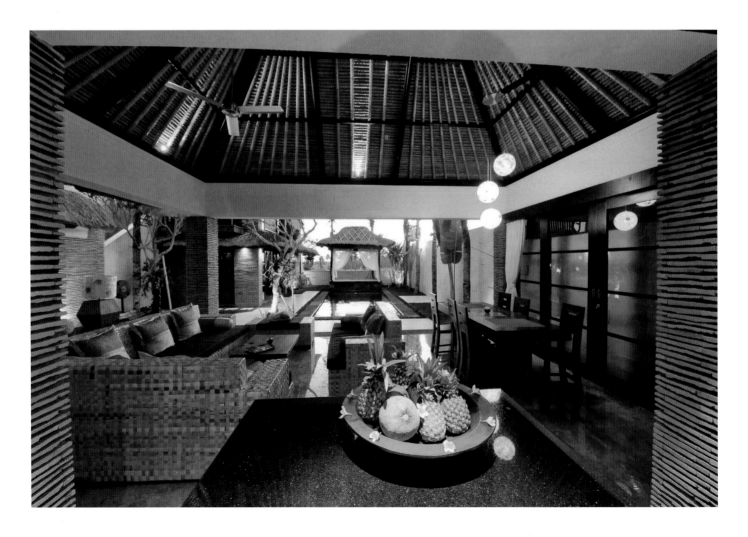

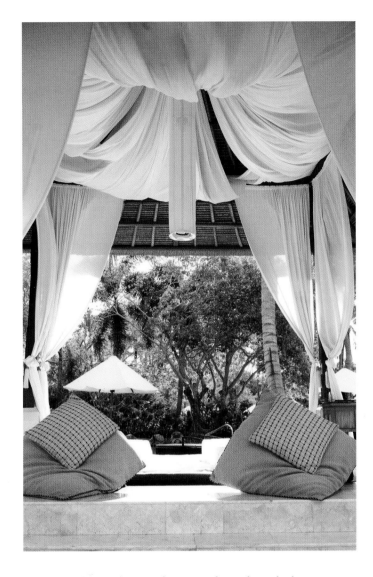

some not indigenous to Indonesia; outdoor showers with no roof but plenty of foliage; front doors facing rice fields rather than the main road; and those infinity-style pools with edges that seem to connect seamlessly with the landscape. These villas and hotels are inevitably built among, and with extended views of, rice fields and jungle-clad ravines, which means they are being built further and further away from the main tourist centers.

Some of the most awarded luxury hotels with modern Balinese design include the Oberoi in Seminyak, the Amandari in Ubud, the Hanging Gardens not far from Ubud and the Amankila near Candidasa. Other hotels that more truly resemble a Balinese village are the Ida Beach Village at Candidasa and the Tandjung Sari at Sanur, where rooms are within walled 'compounds', hidden by dense foliage and connected by stone paths.

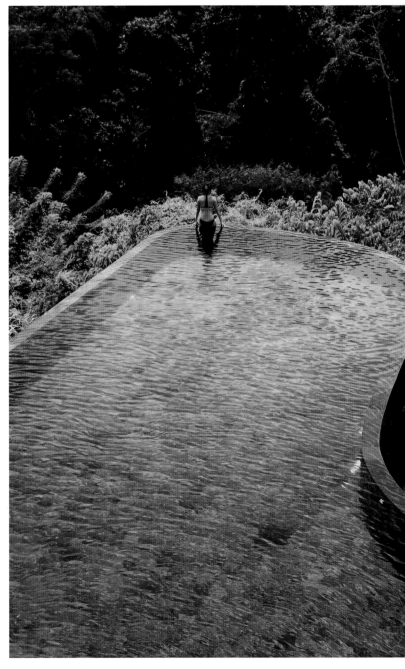

prefer to cultivate the more lucrative *alang-alang* elephant grass for thatched roofs of villas and poolside *bale* than grow rice, while 'Balinese' sculptures are often mass produced in factories across Java.

Ironically, the so-called 'Balinese style' of architectural design currently sought by hotels in Europe, resorts elsewhere in Asia, and private villas across the Indonesian archipelago, are rarely used by the Balinese themselves. The Balinese prefer instead to utilize their precious land for building what's important and necessary, such as shrines for worship and barns for storage, rather than for opulent gardens and swimming pools. And no Balinese would ever position any door or window to face the 'impure' sea, which is home to evil spirits, whereas, of course, Westerners pay over-the-top prices for anything that can offer envied sea views.

These days, the term 'Modern Balinese Architecture' is used to describe the design of private villas and upmarket hotels that offer open-air lounge rooms, *bale* pavilions and common courtyards, but it also incorporates elements not typical at all of the island: sliding doors and windows, which do allow breezes and maximize views but affect privacy; ponds with fish and ornate water features; expansive lawns flanked by tropical plants,

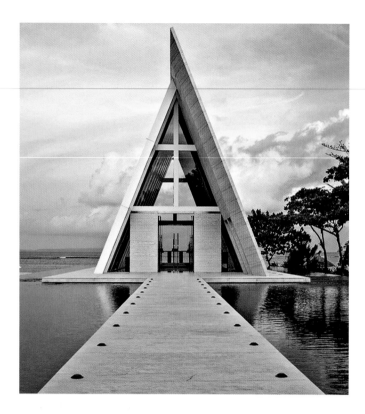

LEFT Modern wedding chapels, such as this one at the Conrad Bali, have sprung up in luxury hotels to cater to foreigners who wish to get married in exotic Bali.

BELOW LEFT At the end of the breakwaters that help secure the sandy beaches at Sanur are open-air *bale* pavilions with traditional curved roofs, designed for sitting to enjoy the views and sea breezes.

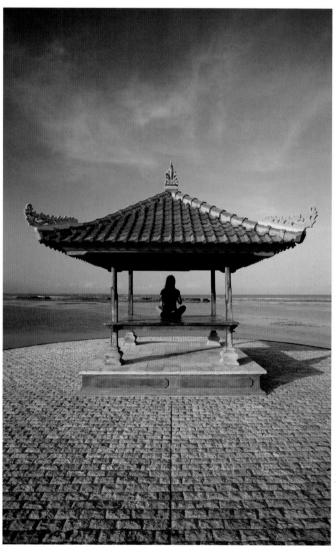

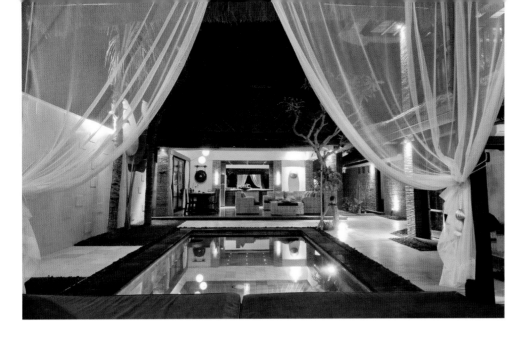

LEFT Many private villas position a small plunge pool in the courtyard outside the bedroom, just next to the lounge area.

BELOW Many modern hotels feature open-air bars and restaurants with spectacular views and breezes as well as infinity pools. One of the most spectacular is the Bulgari Resort shown here.

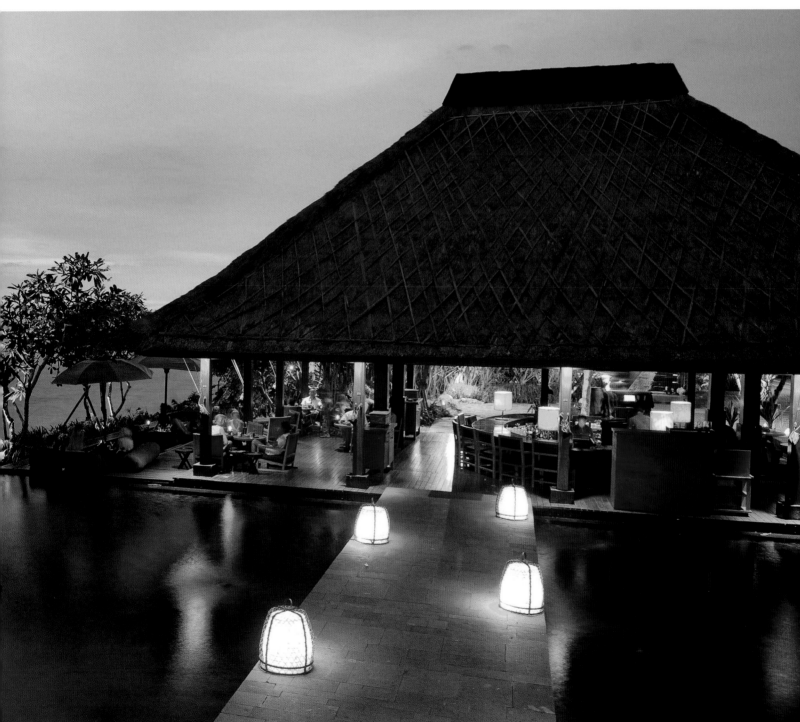

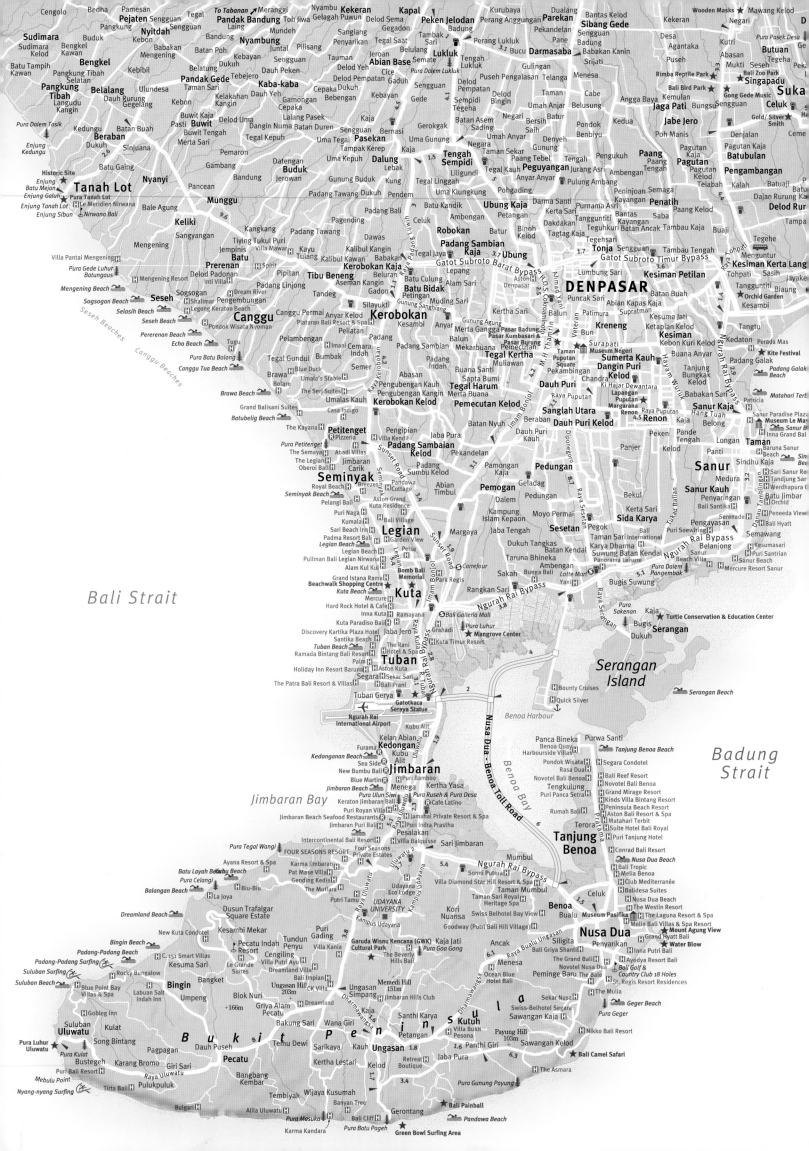

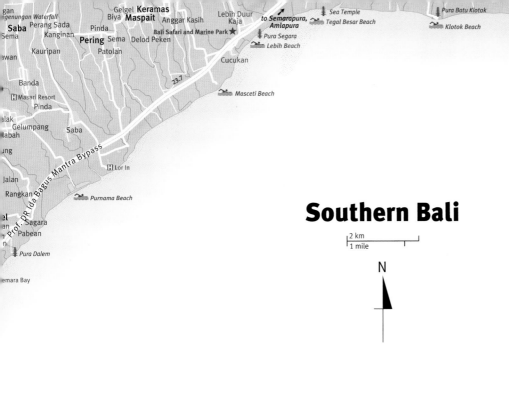

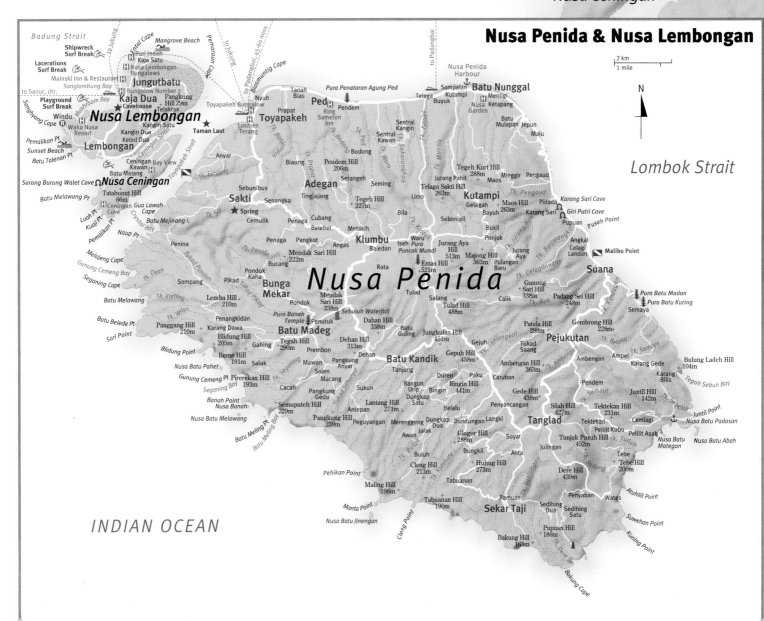

PAGES 64–5 A golden sunset at Kuta Beach on Bali's southwestern shore. Once a sparsely populated village, Kuta was 'discovered' by Australian and American surfers in the 1950s and today is the most famous beach on the island.

BELOW Soil around the numerous volcanoes on Bali is particularly fertile for cultivating Bali's most essential crop, and the slopes are ideal for creating spectacular rice terraces.

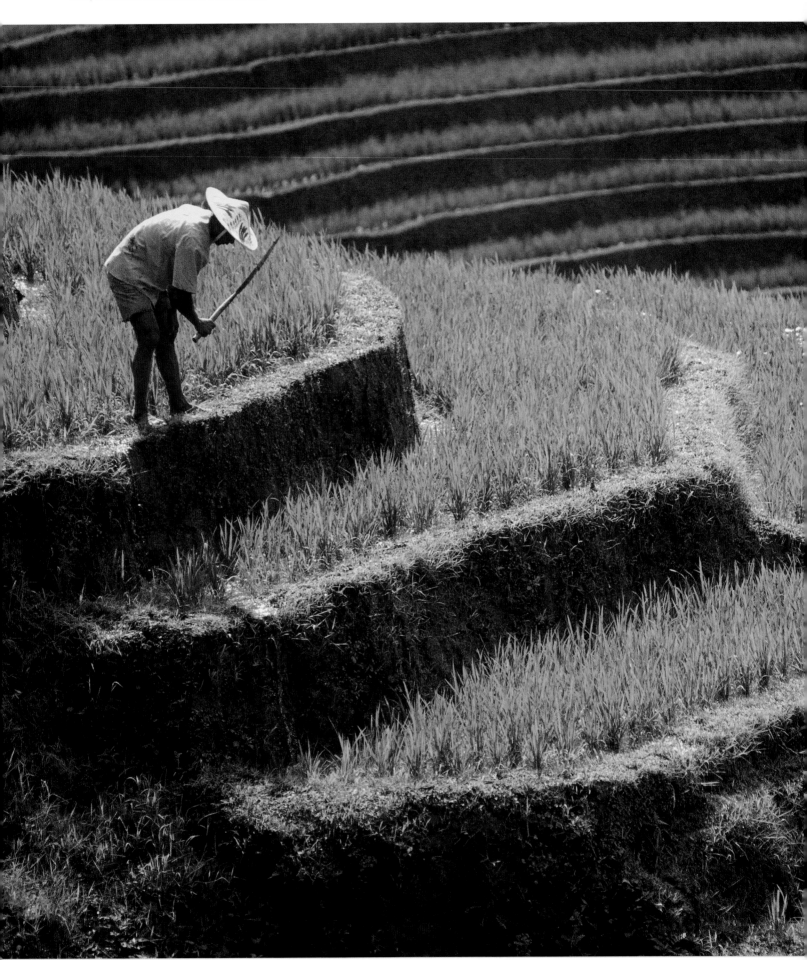

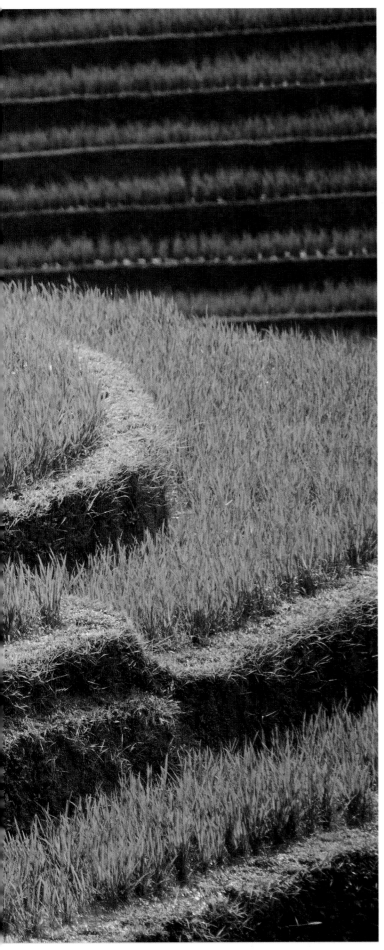

THE "REAL" BALI EXPERIENCE

Bali is compact but maps can be deceptive. Traveling often takes longer than expected because of the traffic, especially in the south, and the mountainous terrain, (particularly between Denpasar and Singaraja). Your choice of base will depend on your interests, your desire to be among, or to avoid, the crowds, and the amount of time and money at your disposal.

The places mentioned below provide all the usual tourist facilities, such as banking and Internet, and Western-style accommodation and restaurants, although some have far more than others and a few have little or no shopping or clubbing, a negative for some visitors. Each is linked by tourist shuttle buses, and renting a car or motorbike or chartering either with a driver is usually easy to organize, but public transport is often very limited and taxis non-existent away from the south.

Many choose Kuta/Legian because of its reputation, proximity to the airport and range of excellent facilities, although Tuban and Seminyak nearby are more spacious and quiet. Sanur doesn't provide the same quantity of shops and clubs or the famed sunset but is delightfully relaxed, and Jimbaran boasts a sublime beach that paradoxically doesn't attract the crowds found on the other side of the airport. To avoid the hordes, hawkers and traffic, try Nusa Dua, while just north, Tanjung Benoa, a likable cross between Kuta and Nusa Dua, is the epicenter for water sports.

Almost everyone includes Ubud in their schedule, but those interested in culture and a far more authentic 'Balinese experience' often stay nowhere else. The east coast is increasingly accessible from the south and popular because of its numerous temples, palaces and beaches. The major bases in the east are Padangbai, a village and departure point for boats to Lombok and the Gili Islands; Candidasa, a beach resort without a real beach; and Amed, an isolated string of fishing villages, ideal for scuba divers. The antithesis to the hedonistic south is Lovina along the north coast where the laid-back village vibe and host of nearby attractions offset the deplorable black sand beaches.

SUN, SAND, SEA AND SURF

The vast majority of visitors to Bali base themselves in the south. About 500,000 Balinese live in the capital Denpasar, while resident expatriates are scattered across the Bukit Peninsula, the bulbous bottom of Bali, and beaches north of Kuta. Although the crowds and traffic can be overwhelming at times, this region offers some of the world's most enticing surfing beaches and famed tangerine sunsets.

Most visitors are attracted by the proximity to the airport as well as the most comprehensive array of facilities on the island, which range from surfer homestays built in the 1970s to five-star resorts featuring lagoon-sized swimming pools with waterfalls, and from familiar fast food outlets to upscale bistros on the beach. The popularity of this area never wanes, but among the malls, massages and madness there are elegant temples, traditional markets and even a world-class art museum.

The epicenter for hedonism is Kuta, unapologetically brash and intense, where the streets are often more crowded at midnight than midday. The celebrated combination of sand, sea, surf and sunset can be relished anywhere along the coast, from Petitenget in the north to Tuban (also called South Kuta) near the airport. Amidst the mega malls and monolithic resorts, however, a village still survives: traditionally clad ladies busily prepare for ceremonies in family compounds; a market sprawls across the road near 'bemo corner' at dawn, then disappears before the traffic becomes too intolerable; and the Pura Batu Bolong temple sits incongruously only meters away from the unmistakable 'golden arches'.

Further north, Legian is more spacious than Kuta and thus preferred by families and older visitors. The pleasant beachside walkway, popular with cyclists and mostly devoid of vehicles, is lined with charming restaurants offering perfect views of those perfect sunsets. There's also more room on the sand to relax and

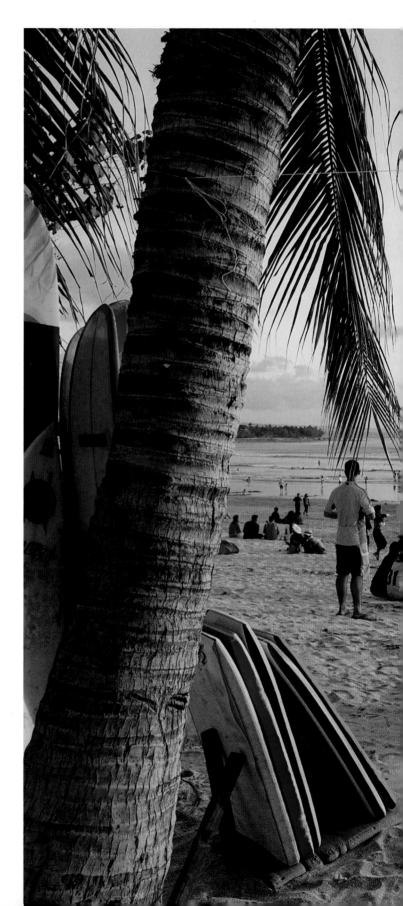

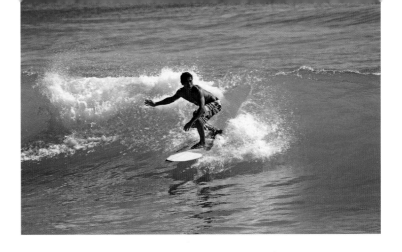

RIGHT The southern coastline of Bali offers a range of surfing conditions to satisfy anyone, from beginner to expert.

BELOW The beach at Kuta is renowned for its surf but enjoyed by anyone who likes the sea, sand and technicolor sunsets.

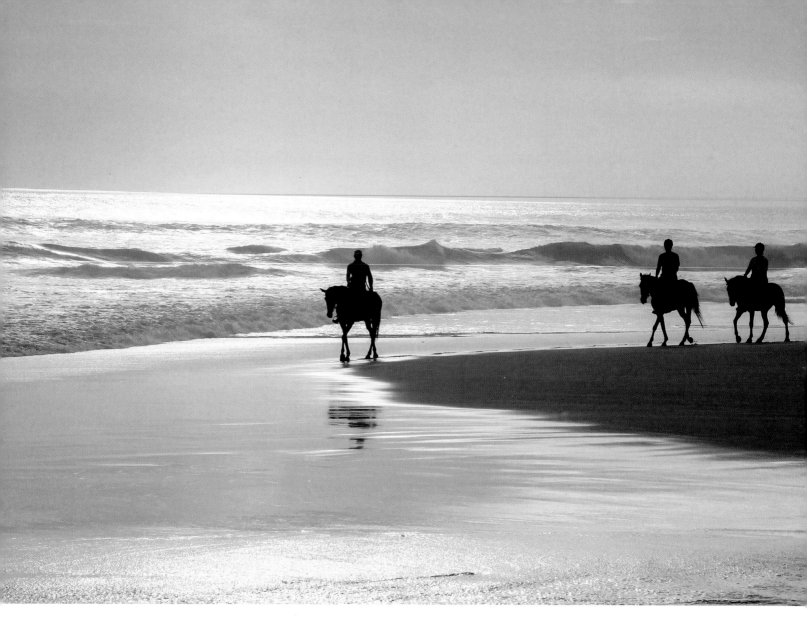

spread out a towel, and the main road no longer parallels the beach, so it's infinitely quieter.

Seminyak used to be *the* haven for expatriates, who have now started moving north as tourists advance from Kuta and Legian. Now Seminyak resembles the beaches further south, with massive resorts and crooked streets jammed with traffic and crammed with boutiques. The sand becomes increasingly gray, but a definite draw card is the handful of cafés with beanbags strewn across the beach in preparation for the sinking of the sun. And tucked away between construction sites is the elegant Protestant church of St Mikael.

Some expats have now escaped further north to Petitenget. Among the villas and boutiques are the striking 16th-century Pura Petitenget temple and some rare pockets of rice fields, accessible by bicycle along tranquil village lanes. The beach is still wide, although the sand is even grayer and the waves just as menacing, and continues north through Canggu and beyond, but development is hindered by poor access and unappealing black shores.

Somehow, Sanur still retains a village atmosphere, with a produce market, temples and beaches popular with locals from Denpasar, especially on Sundays. A beachside walkway lined with cafés, souvenir stalls and hotels stretches the entire length of Sanur from the makeshift 'port' for boats to Nusa Lembongan

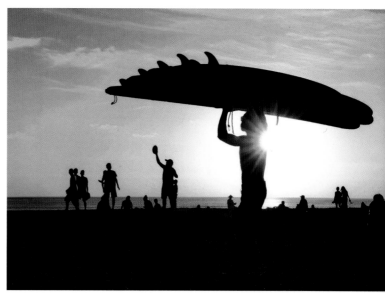

TOP Horse riding along the beaches north of Seminyak is popular and also provides a chance to visit remote villages and see some remarkable landscapes.

ABOVE When the sun sets, surfers hit the bars and locals renting boards pack up for the day.

OPPOSITE ABOVE The moving Bali Bomb Memorial in downtown Kuta lists the names of all those who died in the tragedy of 2002.

RIGHT Whenever there's a lull in business selling drinks or touting for taxis, locals often begin an impromptu game of soccer.

The Infamous Bali Bombings

One year, one month and one day after the attacks on the World Trade Center in New York, Bali suffered its own catastrophe. Late on a steamy Saturday night, 202 people in and around the Sari Club and Paddy's Bar in Kuta were killed and hundreds more injured. It was the worst single attack against Australians anywhere since World War II and the most devastating terrorist attack on Indonesian soil. Only three years later, as tourists had started trickling back to Bali and the economy was slowly recovering, another bomb exploded on Jimbaran Beach as tourists enjoyed a seafood dinner at sunset. Another 20 were killed. Both attacks were the work of Jemaah Islamiah (JI), which has become impotent following the subsequent arrest, imprisonment and execution of the perpetrators. JI had hoped to start a holy war, and it was probably only the imploring of Hindu priests for Balinese to undergo rituals and make offerings to the gods that avoided bloody revenge against local Muslims. Along Jalan Legian, the poignant Bali Bomb Memorial lists those who died, which includes 38 Indonesians. The owner of the empty space where Paddy's Bar once stood wants to develop the site but others wish to create a 'spiritual garden' (see www.balipeacepark.com.au).

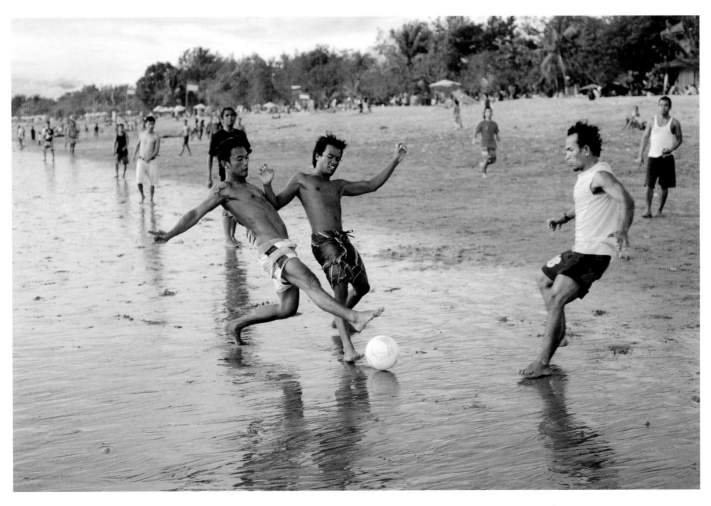

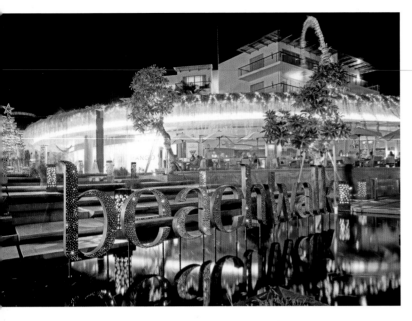

to the mangroves in the south. It passes the Museum Le Mayeur, with distinctive works of art by one of Sanur's earliest foreign settlers, and the Inna Grand Bali Beach Hotel, the first and only multistory building on Bali. (Horrified elders immediately introduced regulations to prohibit further construction anywhere on the island taller than a palm tree.) Other attractions nearby include the Bali Orchid Gardens; Pulau Serangan island, home to the Turtle Conservation and Education Center and the revered Pura Sakenan temple; and the impressive Mangrove Center.

Sanur blends seamlessly into Denpasar, the chaotic capital. Most Balinese can't find much to recommend in their *ibu kota* ('mother city'), but worth a peek are the Museum Negeri Propinsi Bali and, opposite, the Taman Puputan square, a rare oasis of greenery. In utter contrast to the mall in Nusa Dua and the boutiques of Seminyak are the frenzied Pasar Badung produce market and the adjacent Pasar Kumbasari art and clothing market. Pasar Burung, which trades in a peculiar variety of caged animals and birds, is fascinating although a little disturbing.

Enjoying a seafood dinner at a café on the beach during sunset at Jimbaran is almost obligatory, but the town and its comparatively undeveloped crescent of white sand have more to offer. The produce market is regarded as the finest in southern

ABOVE The new Beachwalk Shopping Center dominates the main road bordering the beach in Kuta and offers an enormous range of shops and cafés as well as entertainment for the kids.

BELOW Along the beaches of Kuta, Legian and Seminyak, locals set up makeshift stalls renting surfboards and selling drinks for the enjoyment of all visitors, not only surfers.

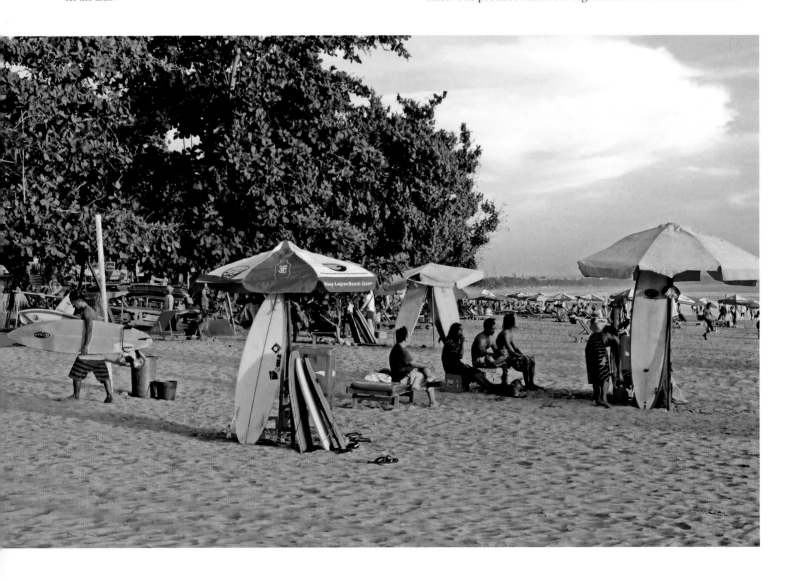

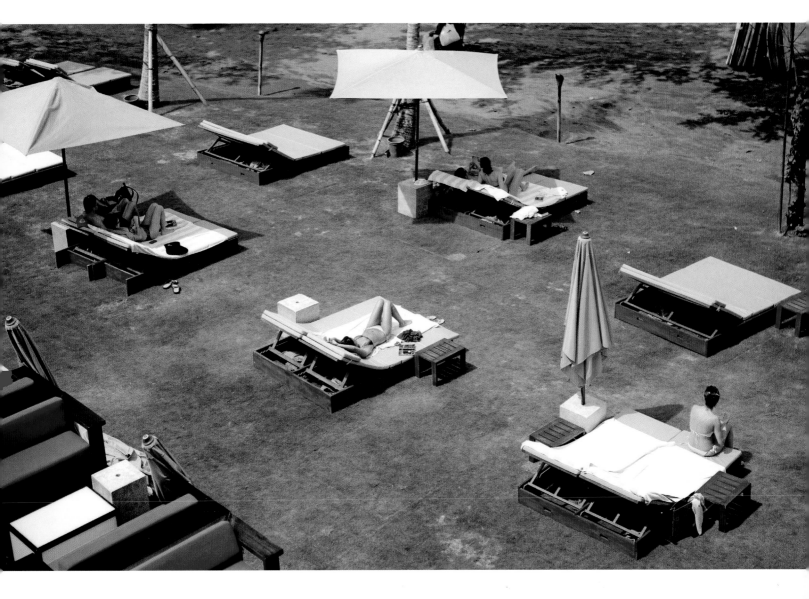

ABOVE Luxury resorts line the beaches of Seminyak and Petitenget and usually provide lawns for sunbathers, who prefer them to the gray volcanic sands.

RIGHT Quirky thatched roof restaurants and villas are found scattered amongst the luxury hotels, shopping malls and temples of Seminyak and Petitenget.

BELOW Enjoying a traditional Balinese massage is almost obligatory for every visitor, whether on the beach or in an open-air pavilion at a hotel.

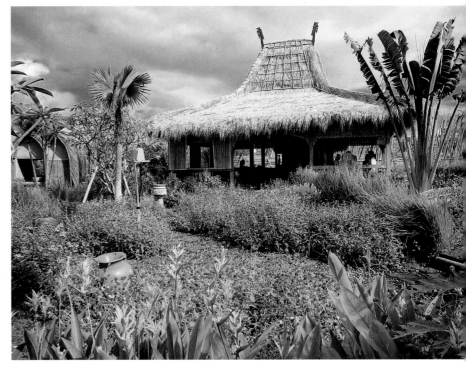

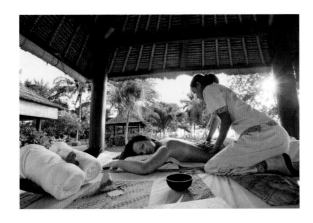

Tanah Lot Temple

Pura Tanah Lot is a sacred *sad kahyangan* temple dedicated to one of the six major geographical features of Bali, in this case the sea, and also one of the island's most popular and crowded tourist attractions, especially during the famed sunset. Built some 500 years ago by a Hindu priest fleeing Java and Islam, it's dedicated to the Goddess of the Sea who protects Bali from plagues and other destructive forces that originate from the ocean. Tanah Lot, which appropriately means 'Temple of the Land in the Sea', is perched on top of a rocky islet about 100 meters offshore. Until a century ago, it was connected to the mainland. Most of the temple, including the much-photographed pagoda-style *meru* shrines with three and seven tiers of thatched roofs, has been rebuilt and reinforced with concrete to combat inevitable erosion. Only accessible to Hindus and unreachable by anyone at high tide, it's 'guarded' by *ular suci* (holy snakes) that reside in holes along the lower edges of the islet. Cliffside paths lead to other temples less revered but equally astonishing, such as Pura Batu Bolong, nestled on a promontory with a gaping arch below and overlooking another treacherous wave-swept beach.

BELOW Worshippers on the rocky islet where the temple is located sometimes have to wait for the tide to recede before they can walk back to the shore.

RIGHT One of the most sacred temples for Balinese and also most often photographed by tourists, Tanah Lot clings to an outcrop of rocks along the roaring coastline of the Indian Ocean.

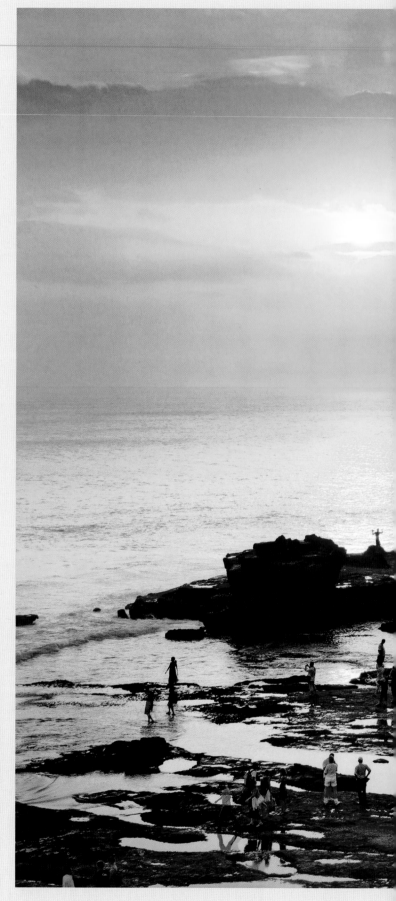

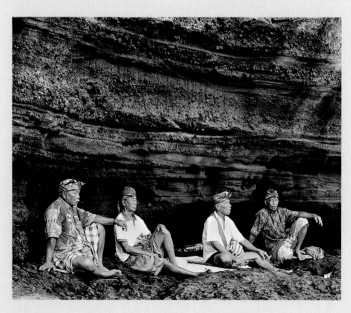

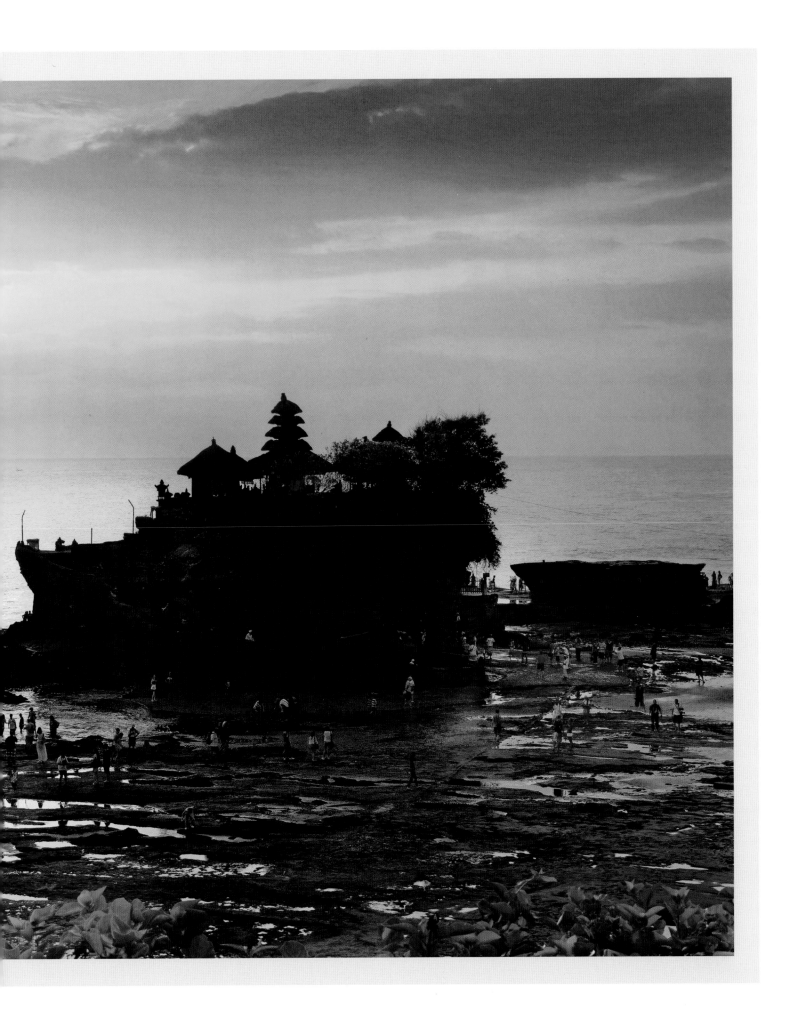

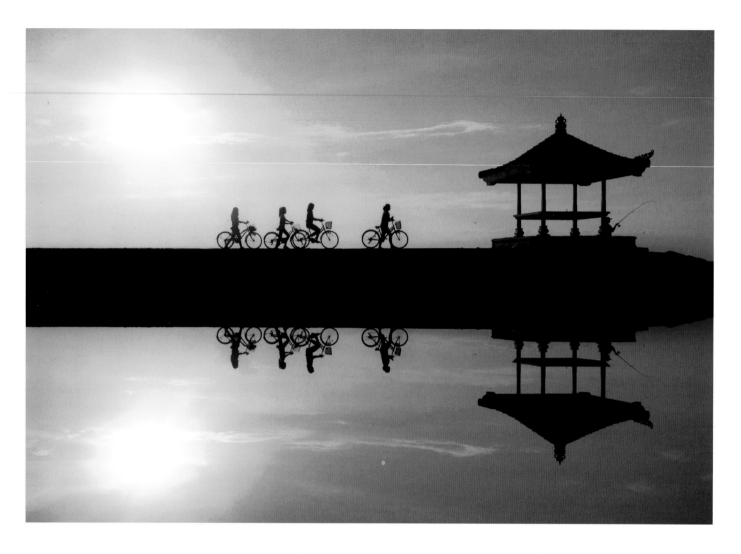

TOP Cycling is a rare joy, often relished along breakwaters that help and conserve eroding beaches like Sanur Beach.

ABOVE Every morning, beaches used by the luxury hotels in Nusa Dua are fastidiously cleaned and raked, with lounge chairs and umbrellas set up for sunbathers.

Bali and the 18th-century Pura Ulun Siwi temple features an unusual layout, while the fish market is particularly hectic at dawn and photogenic during the late afternoon when boats venture out once more.

Nusa Dua is a gated compound of resorts with features unheard of elsewhere in southern Bali: broad footpaths, negligible traffic and zero hawkers. All the beaches are superb and accessible from the promenade that stretches 7 km north to Tanjung Benoa. Nusa Dua, which means 'two islands', lends its name to the twin headlands shaped like islands and topped with temples. Another attraction, besides golfing and shopping, is the splendid Museum Pasifika with its extensive collection of works from across the Asia-Pacific region.

Tanjung Benoa is positioned along the extended 'thumb' of Bukit Peninsula. Foreigners rarely venture to the likable village at the tip that boasts an admirably harmonious cluster with a Chinese temple, mosque and Hindu temple. Some of the beach is molded with breakwaters that create protected curves of white sand, so swimming is wonderful and every conceivable water sport is available.

The peninsula's coast is peppered with luxurious villa complexes and divine cliffside surfing beaches, such as Padang-Padang, which are mostly accessible by steep steps along isolated

RIGHT Frequent sea breezes on Sanur Beach ensure that kite flying remains a popular pastime among Balinese youth.

BELOW The most revered volcano on Bali, Gunung Agung, often soars above the clouds and can be seen as far away as the beaches of Sanur on a clear day.

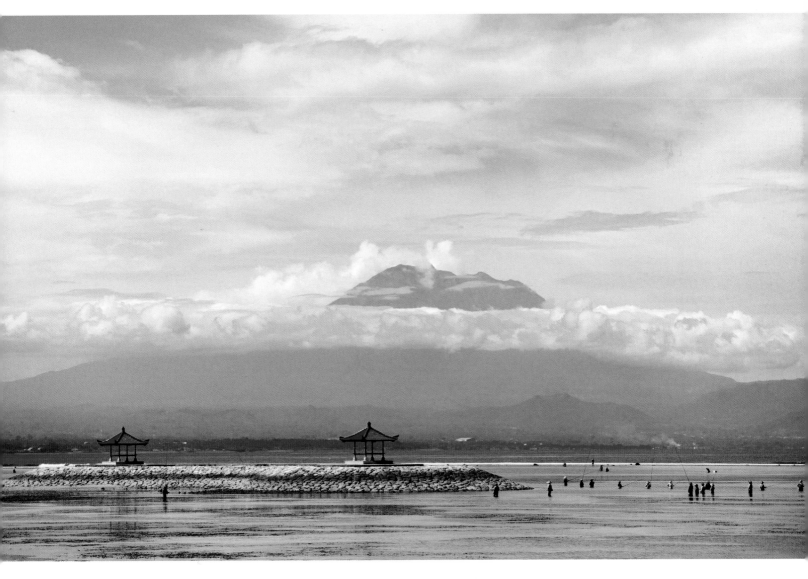

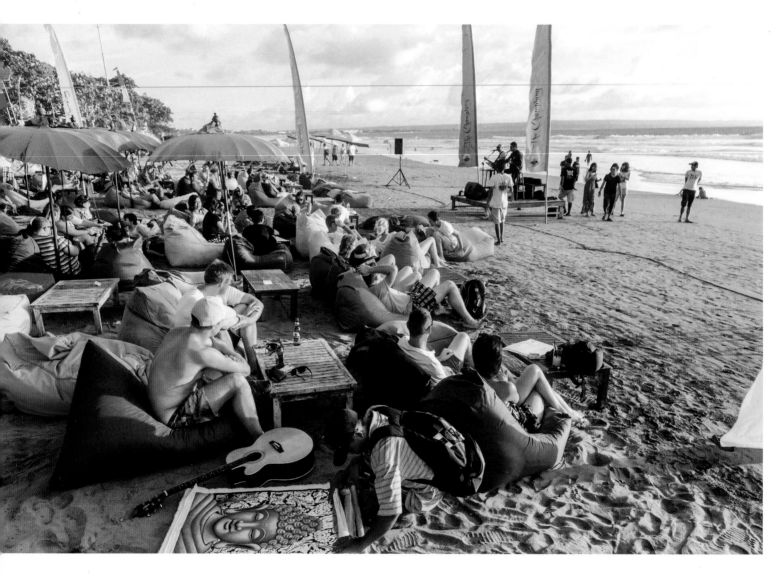

ABOVE As the sun sets at Seminyak, beanbags are strewn across the sand by local cafés, so visitors can enjoy a drink and meal and, later, revel in some live music.

RIGHT The tourist beaches, such as Seminyak″s, boast some of the most magnificent sunsets on earth.

OPPOSITE Luxurious resorts like the Ayana Bali have recently sprouted along the rocky cliffs of Jimbaran, offering sublime views and occasional snatches of white sand.

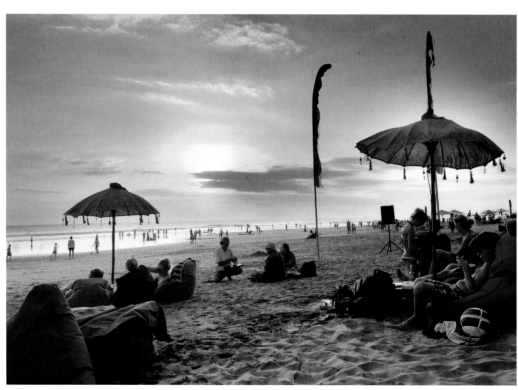

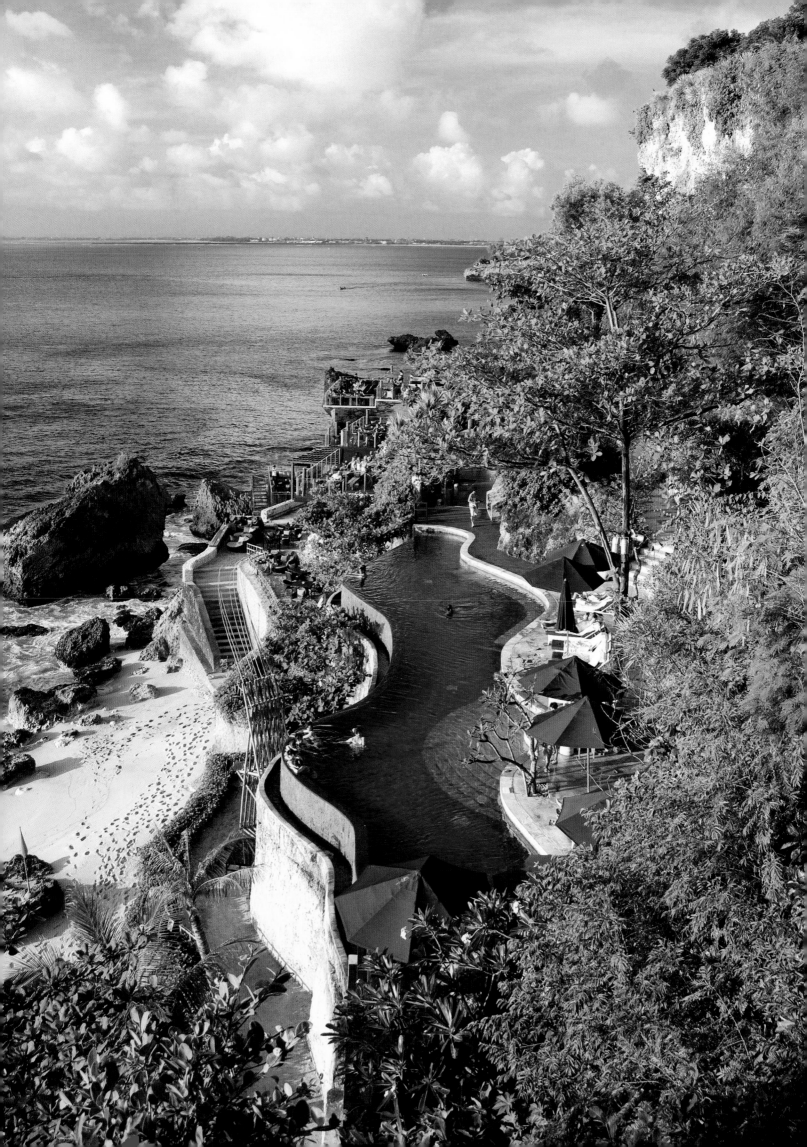

roads. At the far southwestern edge, poised above the Indian Ocean, is Pura Luhur Ulu Watu, a highly revered clifftop temple. The only attraction in the scrubby interior is the massive Garuda Wisnu Kencana Cultural Park.

Every conceivable type of accommodation is available across southern Bali, including at the surf beaches, although the choice at Jimbaran is surprisingly poor. Taxis are available at all major tourist centers (only in Jimbaran during the evening), but are rare elsewhere. Public transport is no longer reliably available except in Denpasar, but shuttle buses connect Sanur and Kuta with all the main tourist hubs across Bali. Renting a car or motorbike, or better still, chartering one with a driver, is easy to arrange anywhere except the southern Bukit Peninsula, but keep in mind that the traffic around this region is truly horrendous.

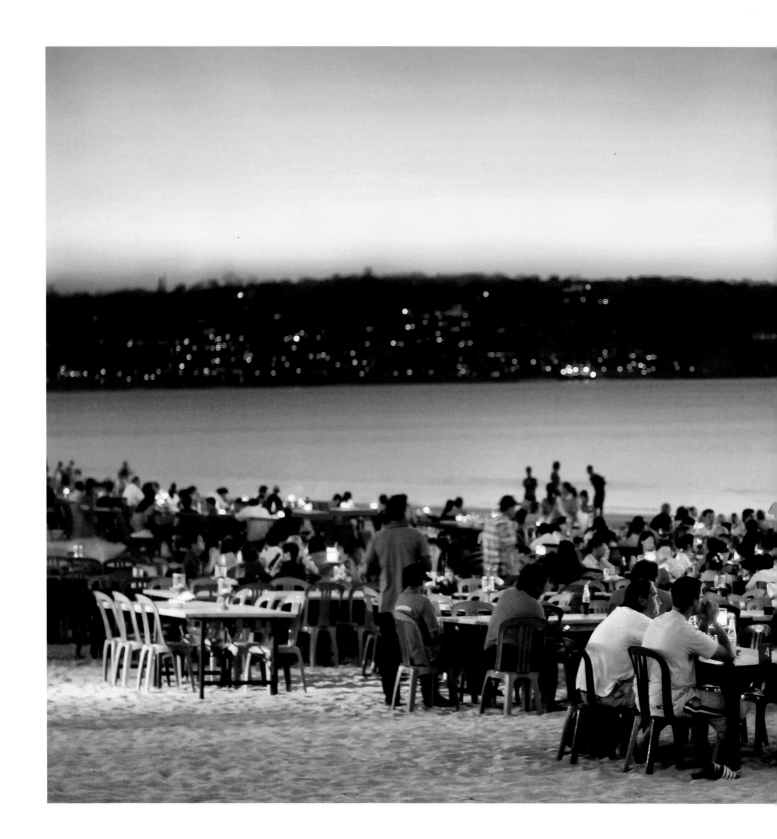

BELOW Obligatory for most tourists is a seafood dinner along the gorgeous crescent of white sand at Jimbaran, followed by traditional dances, wandering musicians and fireworks.

RIGHT The Garuda Wisu Kencana Cultural Park with its massive statue of Garuda, the Hindu sunbird.

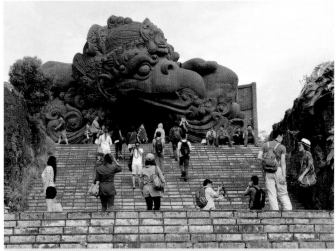

The Garuda Wisnu Kencana

In the middle of the bulbous Bukit Peninsula is the cultural park of Garuda Wisnu Kencana (Golden Garuda Vishnu), known locally as GWK. Another potential white elephant, built with good intentions to showcase Bali's culture and art but with little foresight, this complex has been under development and construction for over 20 years and looks no closer to comple-tion than it did a decade ago. Much of its 250 hectares has been hewn from solid rock, with lawns and avenues flanked by square 'islands' of remaining lime-stone about 50 meters high and extended roads lined with massive animal statues.

GWK offers the usual tourist attractions, more often enjoyed by Indonesian tourists than West-erners, such as cultural shows and traditional dances, including the fascinating Kecak dance of fire walking and hypnotic chanting, in an impres-sive amphitheater; a couple of classy restau-rants offering buffet lunches; and monstrous shops selling every conceivable type of souvenir. But for most the main appeal are the statues of its namesake: Garuda, the mythological sunbird atop a hill, and Wisnu/Vishnu, the Hindu God of Life, made of bronze. Yes, GWK is incomplete, often deserted and all rather artificial, but it's worth visiting if you're in the area for the sheer grandiosity and certainly for the vistas of southern Bali but also for watching Indonesian tourists enjoying themselves.

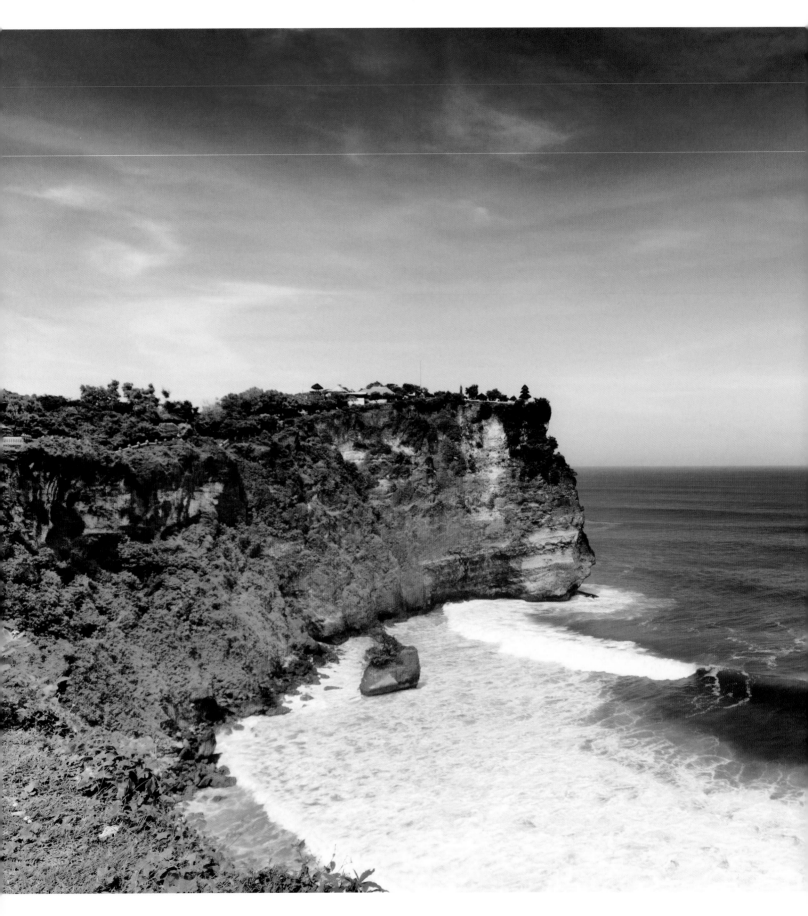

ABOVE Perched on a rocky outcrop along the thunderous Indian Ocean, Pura Luhur Ulu Watu temple is one of the most visited by Balinese for its holiness and by tourists for its location.

OPPOSITE TOP While the temple itself at Ulu Watu is not nearly as impressive as at Tanah Lot, the Kecak dance at sunset is well worth the visit due to its spectacular clifftop setting.

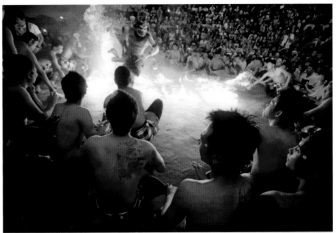

Pura Luhur Ulu Watu Temple

Perched atop a rocky promontory along the south-western edge of Bukit Peninsula, Pura Luhur Ulu Watu is immensely popular for its divine setting 80 m above the pounding waves of the Indian Ocean. The low-key atmosphere, with almost no stalls, cafés or hawkers, also adds to the laid-back charm. Probably constructed about 1,000 years ago by a Hindu priest fleeing Java, Ulu Watu is one of Bali's most revered temples and, like Tanah Lot, is dedicated to the gods of the sea. The present structure was recreated by another revered priest in the 16th century and features three courtyards representing spiritual, human and demonic spheres, although most of the complex has been renovated extensively in recent years because of erosion and lightning strikes. Unusually, the *candi bentar* split gate at the outer entrance features carvings shaped like wings of the mythical Garuda, while the arched gateway further inside is guarded by statues of Ganesha, the elephant-headed god. The innermost courtyard, with the photogenic triple-tiered thatched pagoda-style *meru* shrine is off limits to non-Hindus, however. Another primary reason for the temple's popularity is the Kecak dance held in a cliffside amphitheater at sunset. This dramatic, entertaining show features hypnotic chanting, fire-walking and characters representing the eternal struggle between good and evil.

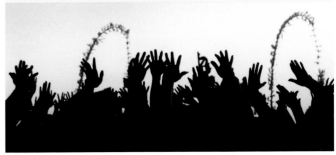

BELOW The best swells in Bali, like this one at Ulu Watu, originate from the Indian Ocean, but the locations of the best breaks vary across the coastlines depending on the season and prevailing winds.

RIGHT Old-style long boards are making something of a comeback at Kuta Beach because they are easier for beginners to use in the gentle waves found here.

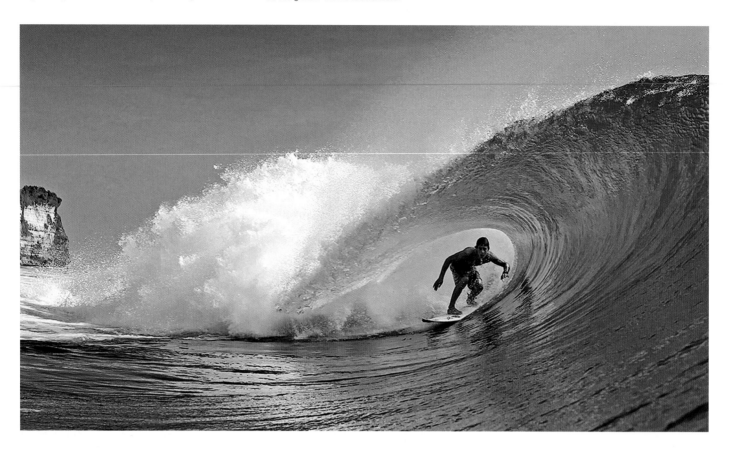

SURFING IN BALI

A SURFER'S LIFE IN PARADISE

It was really the surfers who 'rediscovered' Bali in the late 1960s after the volcanic eruption and political upheavals earlier that decade, and they've been coming in droves ever since. Conditions and winds do vary, but the best swells crash into the southern coasts from the Indian Ocean in the dry season, from April to October.

The less experienced, and those just as interested in the après-surf entertainment, tend to stick to the beaches from Tuban, near the airport, to Kuta, and a few kilometers further north to Petitenget. Strong but predictable breaks are located only meters offshore, and shacks offering all the essentials—rentals, repairs, beer and massages—are dotted along the palm-choked sands. Lessons are also available along these beaches and, importantly, lifeguards are usually present.

The more dedicated and proficient head to beaches along Bukit Peninsula, the island's bulbous bottom. Homestays, and even expensive hotels catering to nostalgic 'beach bums' from the 1960s, are sprouting up at places like Padang-Padang, Bingin and Ulu Watu, not far from the renowned temple. Although only accessible along treacherously rocky steps from isolated bumpy lanes, waves can still get crowded. Some spots along the peninsula, such as Nyang-Nyang, are kept secret among diehards for fear of overdevelopment, because sublime sites like Echo Beach and Suluban are now overflowing with villas and boutique restaurants where non-surfers have the apparent cheek to also enjoy the beaches, views and sunsets.

So, to *really* get away from the masses, surfers now flock to Nusa Lembongan, off the southeast coast of Bali, where breaks are 200 meters or more offshore and mostly only accessible by chartered boat. Other popular surfer hangouts yet to become commercialized, despite their proximity to Kuta, are along the inner southwest coast, such as Balian and Medewi.

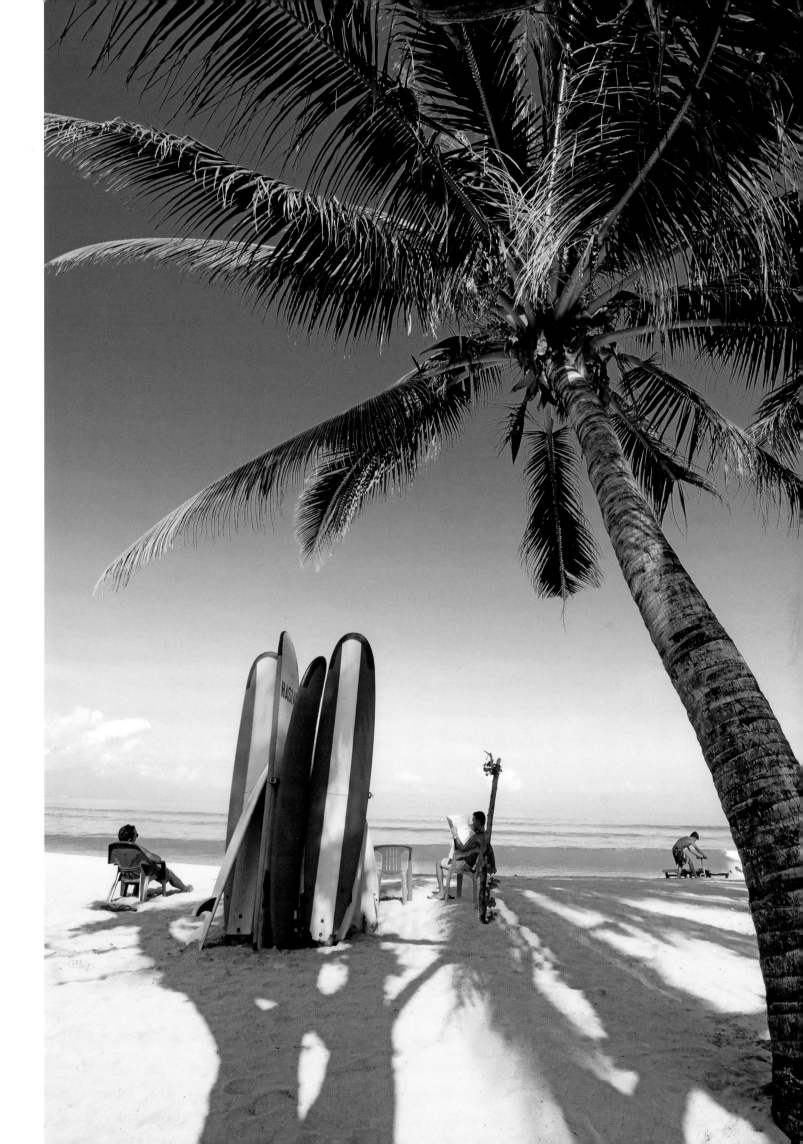

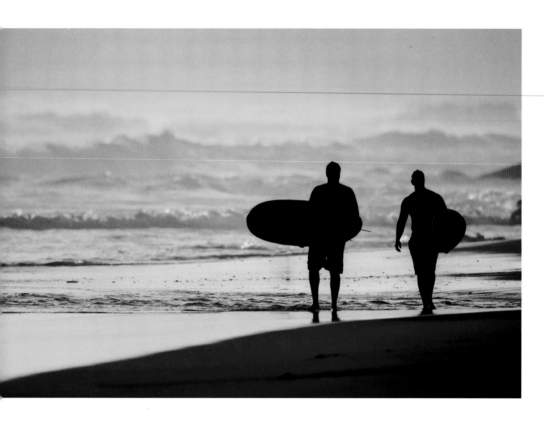

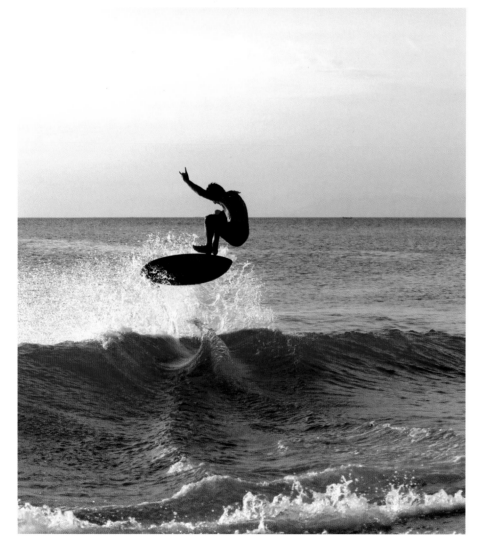

ABOVE LEFT As the sun sets, surfers head back to their homestays or hotels to enjoy the evening entertainment on offer and, no doubt, share stories about the waves.

LEFT Surfers flock to Bali from all across the world to revel in the variety of waves on offer, including just meters from Dreamland Beach.

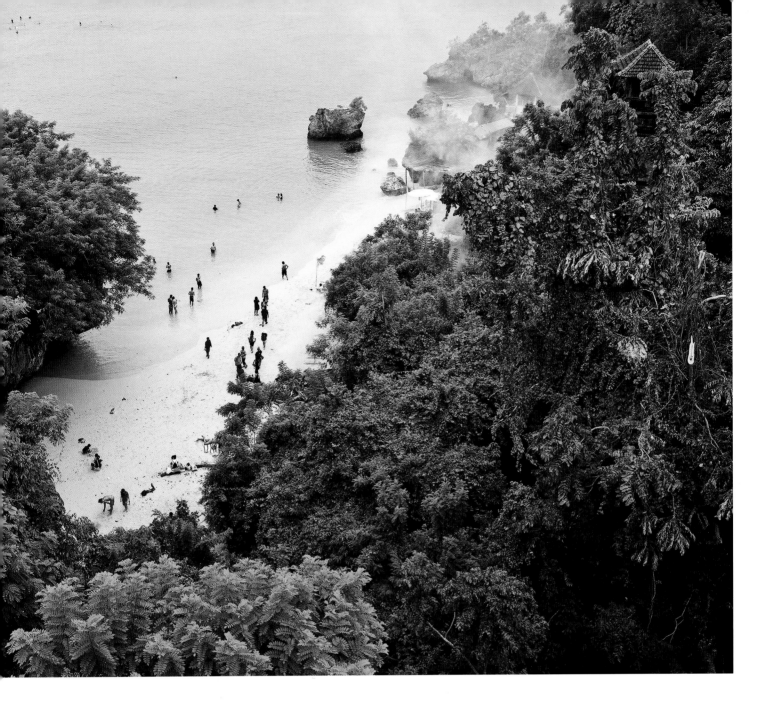

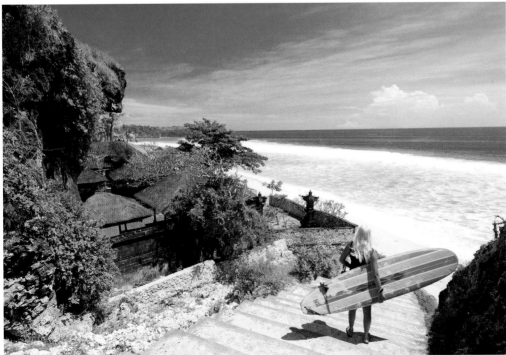

ABOVE Surfers often have to travel to remote regions along the inner southwest coast and the southern peninsula to find the biggest waves and smallest crowds. Padang-Padang is one of Bali's most famous surfing spots.

LEFT Particularly popular among the more experienced are the breaks along the Bukit Peninsula where bungalows, bars and surf shops have sprung up catering to foreign surfers.

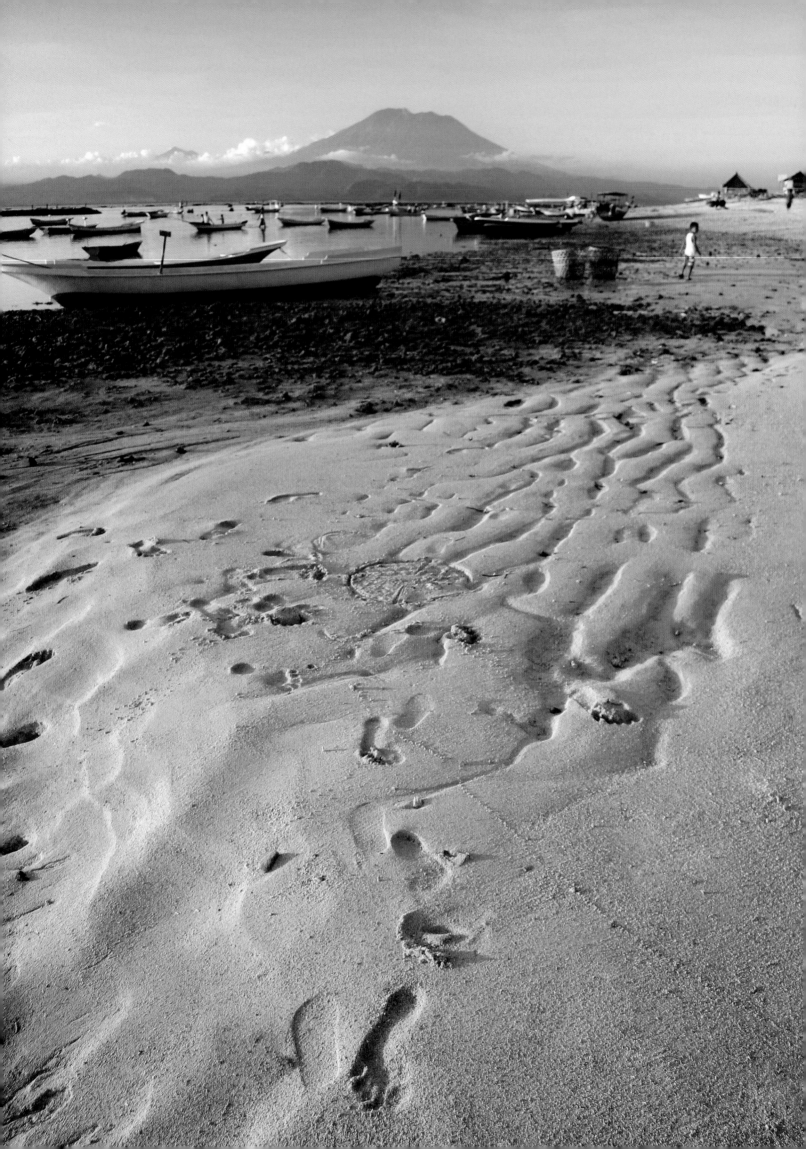

RECALLING THE BALI OF OLD

With more than 17,000 islands sprinkled across the Indonesian archipelago, it's surprising how few belong to the province of Bali. Equidistant from the beach resort of Sanur and the village hub of Padangbai is a trio of enticing islands: Nusa Lembongan, the closest and most developed for tourism; Nusa Penida, by far the largest; and Nusa Ceningan, squeezed in between.

Easily the most popular of the three islands is Nusa Lembongan, where only motorbikes, a few pick-up trucks and some hardy tourists on bicycles ply the roads through the two villages and across the hilly interior. Most tourists stay at the village or beach at Jungutbatu or at Mushroom Bay with its superior beach offering sheltered swimming and superb snorkeling. Other spots may have enticing monikers, such as Dream Beach and Sunset Beach, but the undertows are only slightly less terrifying than the waves.

Despite this, most of the attractions on the island are on or below the water. Every day, cruisers dock at offshore pontoons or unload passengers at Mushroom Bay so that day-trippers from the Bali mainland can revel in a variety of water sports, while locally based surfers and scuba divers charter boats to some of the finest breaks and reefs in Indonesia.

The only road along the north provides dramatic panoramas of the Gunung Agung volcano on Bali. The road finishes at Mangrove Beach, a departure point for boat trips, where there are far more mangroves than beach. The eastern road veers through uninhabitable mangrove forest, which appears remarkably eerie at high tide, to a rickety wooden suspension bridge. Barely wide enough for one motorbike, the bridge connects Nusa Ceningan, the sparsely populated little sister island with pot-holed roads and villages lined with coconut palms.

Maybe 15 times larger than Lembongan, the pre-colonial penal colony of Penida is only now being developed for tourism, albeit slowly. As well as world-class diving sites, Penida boasts more attractions than Lembongan, such as the Pura Penataran Agung Ped temple, set in a pond and greatly revered by worshippers from as far as Bali; the sacred Gua Karang Sari cave, also called

LEFT Although tourism has become a significant source of income on Nusa Lembongan, fishing and harvesting seaweed are still the predominant industries.

RIGHT As more tourists head to Nusa Lembongan, luxury villas have sprouted up in places like Mushroom Bay and Sunset Beach.

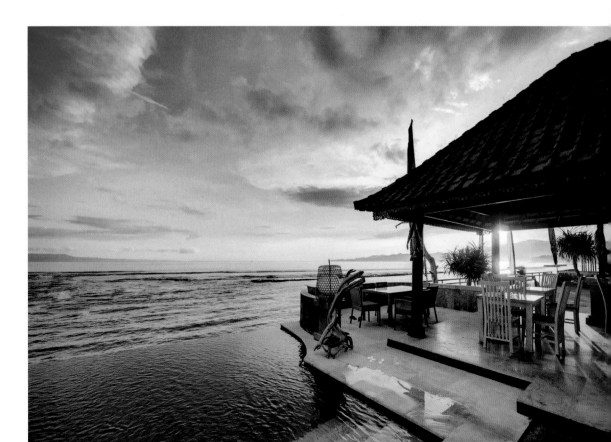

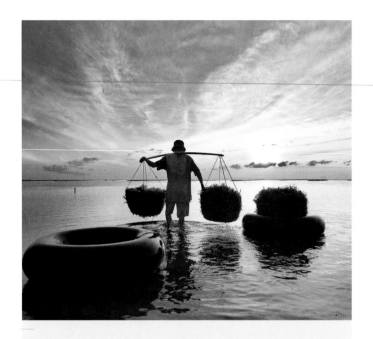

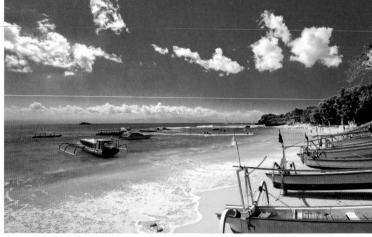

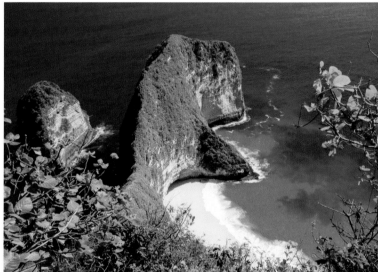

Seaweed Farming

Where Bali has not been blessed with consistent rain and arable land, such as at Bukit Peninsula and Nusa Lembongan, villagers must often eke out a subsistence living from what's under the water, primarily *rumput laut* (seagrass), used as a gelling and thickening agent, such as carrageenan, for meat and dairy products, including ice cream, and cosmetics. But it's an extraordinarily laborious process. Allocated seaweed farms along the shallow waters are dotted with bamboo poles linked with ropes along which fully grown seaweed is attached. The nutritious waters allow offshoots to grow rapidly, which are then transplanted and later harvested every four to six weeks. The seaweed is loaded onto shoulder-snapping baskets and lugged onshore, usually by men, for sorting, usually by women, according to the two varieties: the edible green *cottonii* and red *spinosum*. It's then laid out to dry on massive blue-and-white tarpaulins along the sand and, ironically, covered during rain before being transported to processing factories on Java. Farmers are paid about USD$0.50 cents per kg and produce 500 to 800 kg per month. Despite the increasingly lucrative tourist industry, about three-quarters of the population of Nusa Lembongan island are still involved in, or rely on, seaweed farming. The best place to observe the cultivation process is alongside the sheltered, shallow waters that separate Nusa Lembongan and Nusa Ceningan.

Giri Putri, which is actually a 200-meter-long tunnel; and the undeveloped beach at Crystal Bay. Along the roads hugging the cliffs are occasional weaving workshops and viewpoints with jaw-dropping vistas, especially from Pura Banah temple. Also, Penida, as well as the Taman Nasional Bali Barat national park, is where efforts continue to preserve the endemic but extremely endangered Bali Starling.

Lembongan offers a wide range of places to stay, but accommodation on Penida is basic and scarce on Cenigan. Other facilities, such as Internet and banking, are limited on all three islands. Public boats are not recommended, so take a speedboat from Sanur to Jungutbatu on Lembongan or Penida. The only way between Lembongan and Penida is to use the public boat or charter something. Remember that the seas are always rough and jetties are non-existent, including at Sanur. There are no cars on Lembongan, but vehicles can be chartered with a driver around Penida, where public transport is mostly limited to between Toyapakeh and Sampalan.

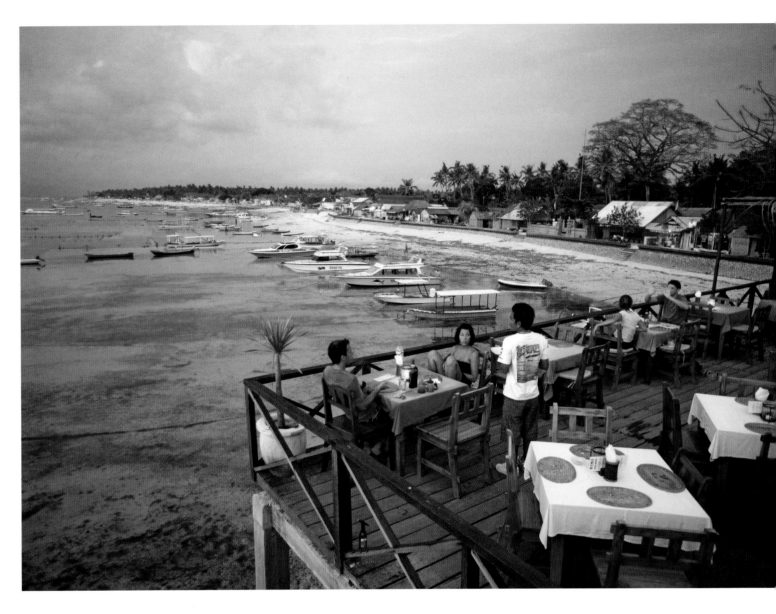

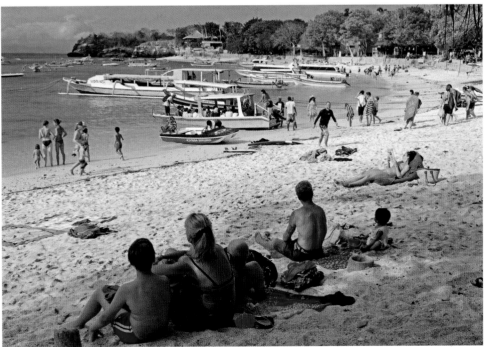

ABOVE The shores along the edges of southern Jungutbatu on Nusa Lembongan are dotted with villas and upmarket hotels offering superb views and dining options.

LEFT The beach at Mushroom Bay is the best on Nusa Lembongan. It's mostly devoid of fishing boats and has no waves or undertows, so it's safe for swimming and snorkeling.

OPPOSITE TOP LEFT Along the coastlines of Nusa Penida and Nusa Lembongan, where rain, arable land and even tourists are scarce, seaweed cultivation is a major industry.

OPPOSITE TOP RIGHT The beaches on Nusa Lembongan look superb but some are dangerous for swimmers because of high waves and strong undertows.

OPPOSITE CENTER The rocky limestone outcrops and tiny bays are sublime around Manta Bay on Nusa Penida.

SEEKING SANCTUARY IN THE HILLS

The spiritual, cultural and artistic heartland provides the best of what Bali has to offer except, of course, beaches, but these are only an hour away to the east and south. And the choices in and around Ubud are almost overwhelming: the finest selection of arts and crafts to buy from innumerable galleries or admire at world-class museums; an inordinate range of traditional dances and music performed in temples and palaces; a variety of courses in cooking, crafts and language; and visits to nearby rock-hewn monuments and sacred springs.

Although understandably popular, especially with day-trippers from the south, it's surprisingly easy to escape the hordes in Ubud. Visitors can stay in bungalows dotted amongst duck-filled rice fields or at family-run homestays in traditional compounds bursting with shrines and chickens. Add in the fresh air, countryside walks and yoga/meditation centers, and it's no wonder so many choose to base themselves entirely in the bucolic town.

The central landmark is the produce and souvenir market, an absorbing, sprawling mass of stalls and ladies with baskets selling everything from chillies to chimes, bananas to bangles. Ubud is actually a collection of villages, such as Penestanan and Nyuhkuning, each with its own personality and, often, specialty, such as yoga (Penestanan) and wood carving

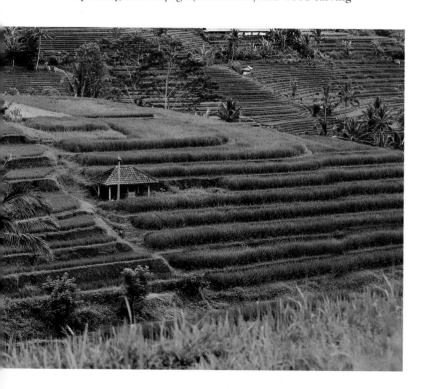

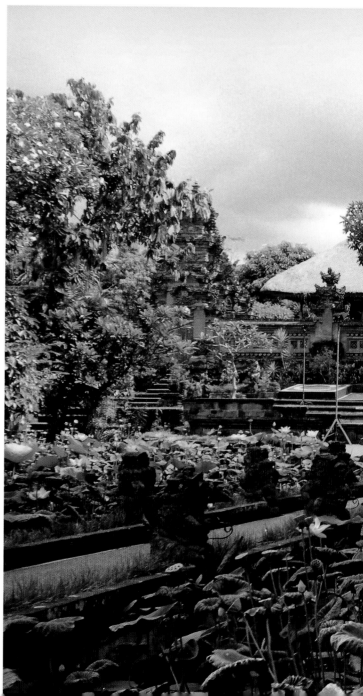

RIGHT Ubud is an increasingly popular place for Westerners to stay and unwind, and ideal for anyone keen to learn about meditation and yoga.

BELOW The majestic Pura Taman Saraswati temple, only meters from the main intersection in central Ubud, is home to traditional dances every evening, although the temple at the back is closed to foreigners.

OPPOSITE BELOW Rice fields and terraces are still found around Ubud, although not along the main roads where tourist resorts, shops and restaurants have taken over.

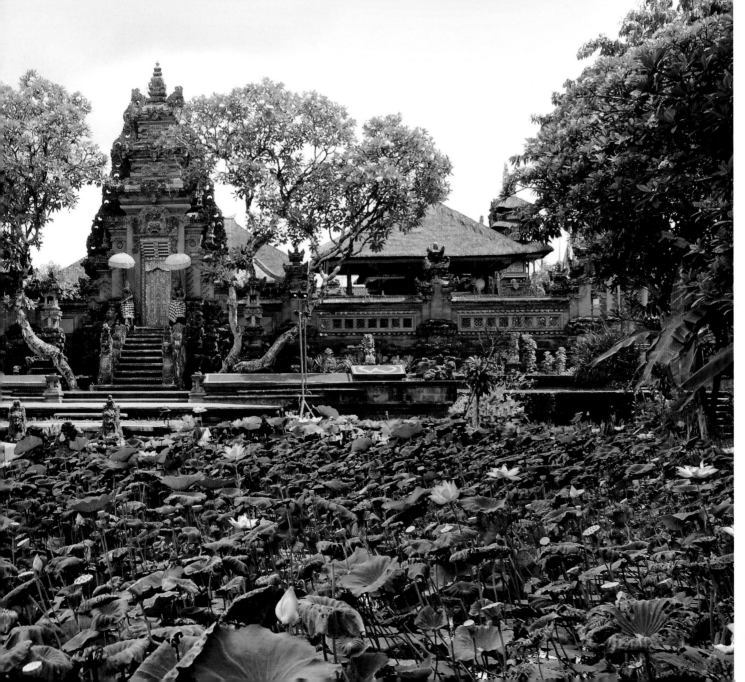

RIGHT For many, a major attraction in Ubud is the chance to try authentic Indonesian cuisine from around the archipelago and Balinese dishes from around the island itself.

BELOW The main streets of Ubud are dotted with trendy cafés offering world-class coffee and a selection of cuisines from around the globe.

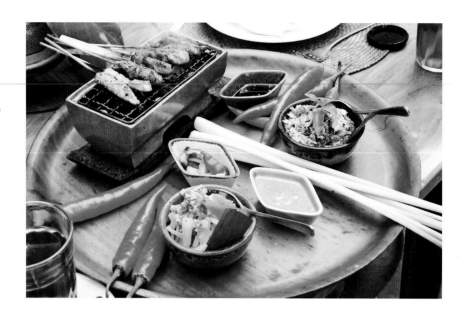

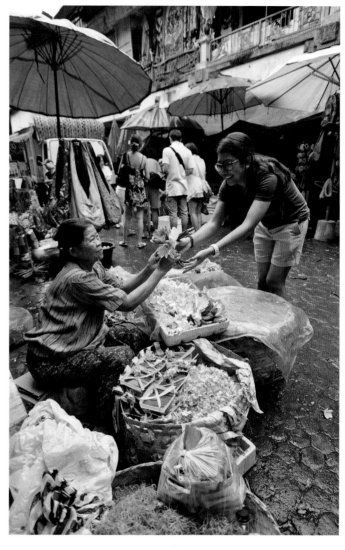

TOP Many restaurants in Ubud, such as Bebek Tepi Sawah, offer superb ambience with traditional Balinese-style décor and walls lined with artwork that is often for sale.

ABOVE The souvenir market in the center of Ubud and the lanes leading to it are choked with stalls selling every imaginable memento.

ABOVE RIGHT Shopping at the Ubud Central Market is an experience, and bargaining is expected.

RIGHT The main streets of Ubud are crammed with shops selling anything and everything from bangles to bandanas and sarongs to swords.

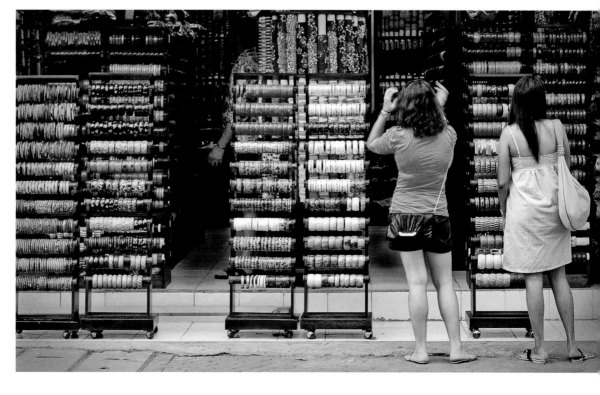

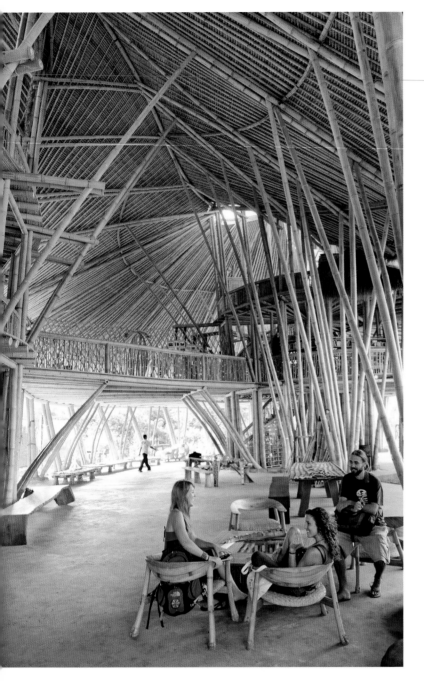

The Monkey Forest Temple

Seemingly incompatibly located at the edge of Ubud's urban sprawl is a lush forest more formally known as Mandala Wisata Wanara Wana. Owned and run by the local villagers of Padangtegal, this sacred and protected sanctuary is home to packs of cute, but thieving, long-tailed macaques, which are tolerated as descendants of the Monkey God Hanoman, who saved the wife of King Rama, as told in the *Ramayana* Hindu epic. From the magnificent banyan tree, paths lead to three diminutive temples originally built in the 14th century. Pura Prajapati, used for cremations and burials, is flanked by a leafy field of headstones, while Pura Dalem Agung Padangtegal, the 'death temple', features appropriately evil carvings of children being devoured by monsters. Across a medieval-looking stone bridge is the riverside Holy Bathing Temple, almost smothered with roots of banyan trees despite being renovated in the 1990s. A visit should also include a wander about the Community Art Exhibition under the *bale banjar*, the open-air pavilion used for meetings, which showcases the types of creations for which the inhabitants of Padangtegal are renowned. The forest is also used for research and conservation and home to about 115 species of rare plants and trees exploited for religious and medicinal purposes.

(Nyuhkuning). And each of the many villages has several temples. The most photogenic is the Pura Taman Saraswati, especially during an evening performance of traditional dance and music on the stage squeezed between the temple façade and lotus-choked ponds. These villages are best explored on foot or by bicycle from obvious turn-offs along the main roads, and walkers will be rewarded with postcard-perfect panoramas of rice terraces, volcanoes and Bali's longest and most voluminous river, the Ayung.

The long streets are crammed with galleries offering the unique styles of Balinese art first developed in Ubud during the 1930s, while villages nearby, and those strung along the roads from the southern beaches, specialize in crafts, for example, Mas for wood carving and Celuk for silverware and gold. Art museums, such

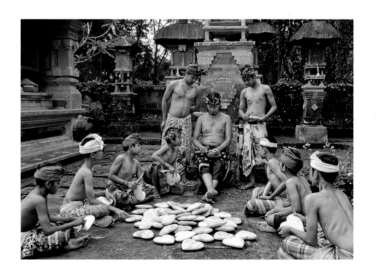

ABOVE Ancient banyan trees add to the extraordinary setting at the Holy Bathing Temple, which many visitors miss while feeding the inhabitants at the Monkey Forest.

LEFT Another larger monkey forest with temples is located at Sangeh, about an hour's drive west of Ubud.

OPPOSITE FAR LEFT The Green School's main building has a striking interior made entirely from bamboo. The school promotes eco-friendly practices to its students.

OPPOSITE BELOW Village boys learn to carve, dance or play the *gamelan* within the local village temple. During special occasions, they will wear the traditional *udeng* head cloth.

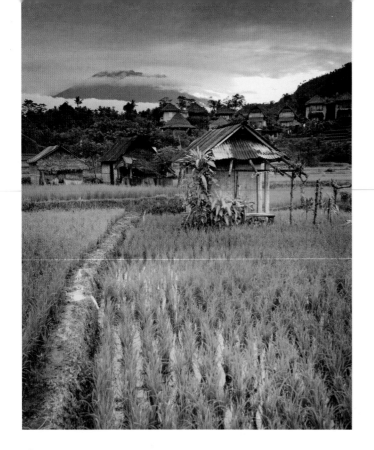

as Puri Lukisan and ARMA, not only feature vast collections of works by renowned Balinese and foreign artists but also delightful open-air cafés set among gardens overflowing with bougainvillea.

One of the most unusual sights in Bali is the inexplicable flocking of egrets and herons to the main street of Petulu, a few kilometers north of Ubud, where trees blossom every afternoon with white feathers. The sight is, in fact, best admired from poop-proof food stalls in the rice fields. Not far away is Tegallalang, a village with an excessive number of handicraft shops and a series of chiseled rice terraces fronted by cafés; and another place called Gunung Kawi, in Sebatu, with hot-water baths and spring-fed pools similar to, but smaller than, Tirta Empul, and without the crowds.

Within a bike ride of the market is the mysterious Goa Gajah. Its tiny T-shaped cave, excavated by hand over a thousand years ago, contains Hindu and Buddhist artifacts and some of the earliest known examples of Balinese inscriptions. Equally inviting is the setting with shrines, ponds and waterfalls. Also in Bedulu,

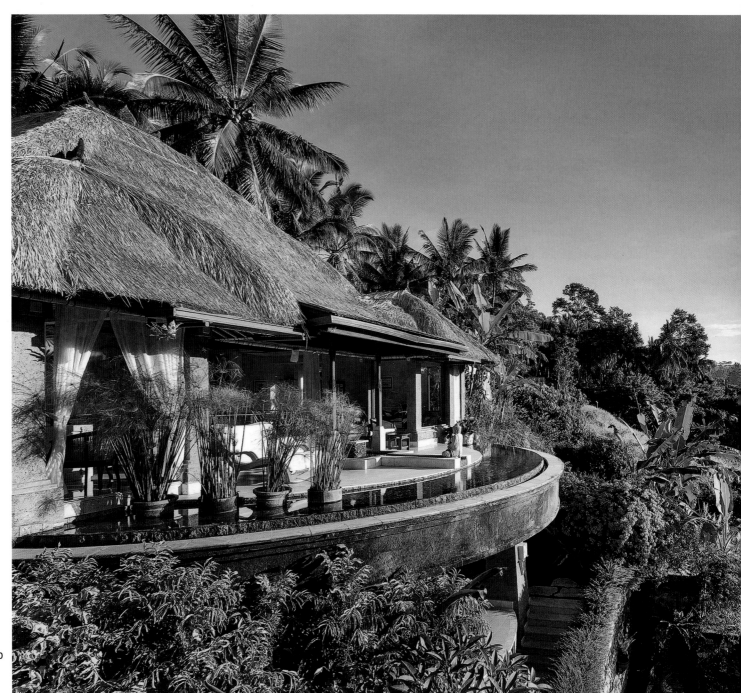

RIGHT The steep ridges of a ravine above the Ayung River are now dotted with luxury resorts like the Alila Resort at Sayan.

OPPOSITE ABOVE In the middle of the rice fields are huts used to store equipment and rest during the heat of the day.

BELOW Visitors can enjoy a massage surrounded by spectacular views at the Lembah Spa in Sayan.

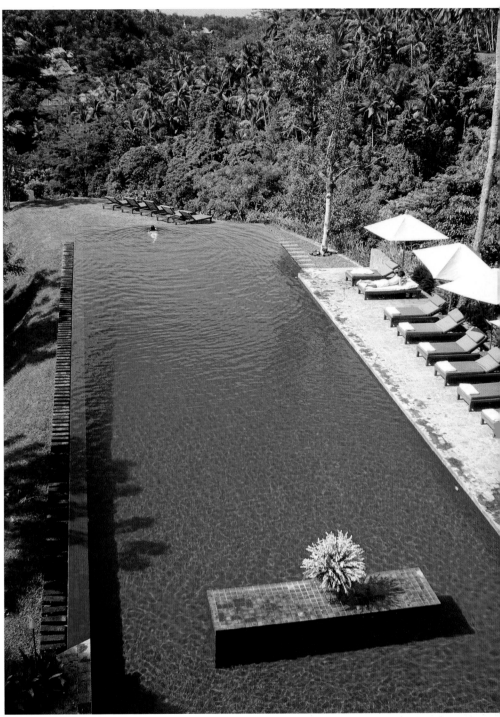

Yeh Pulu is a series of rock carvings standing two meters tall that date back to the 14th century, but the riverside setting and path flanked by rice fields is even more appealing.

Tampaksiring boasts two of central Bali's main attractions: the enigmatic rock monuments at Gunung Kawi and Tirta Empul. The latter includes springs with apparent magical powers and a sacred temple, all set amongst the most immaculately maintained garden of any tourist site on Bali. And around the corner is the Mancawara Palace, former home of President Soekarno and now a museum dedicated to the revered founding father of Indonesia. Further afield, but still an easy day-trip from Ubud or the

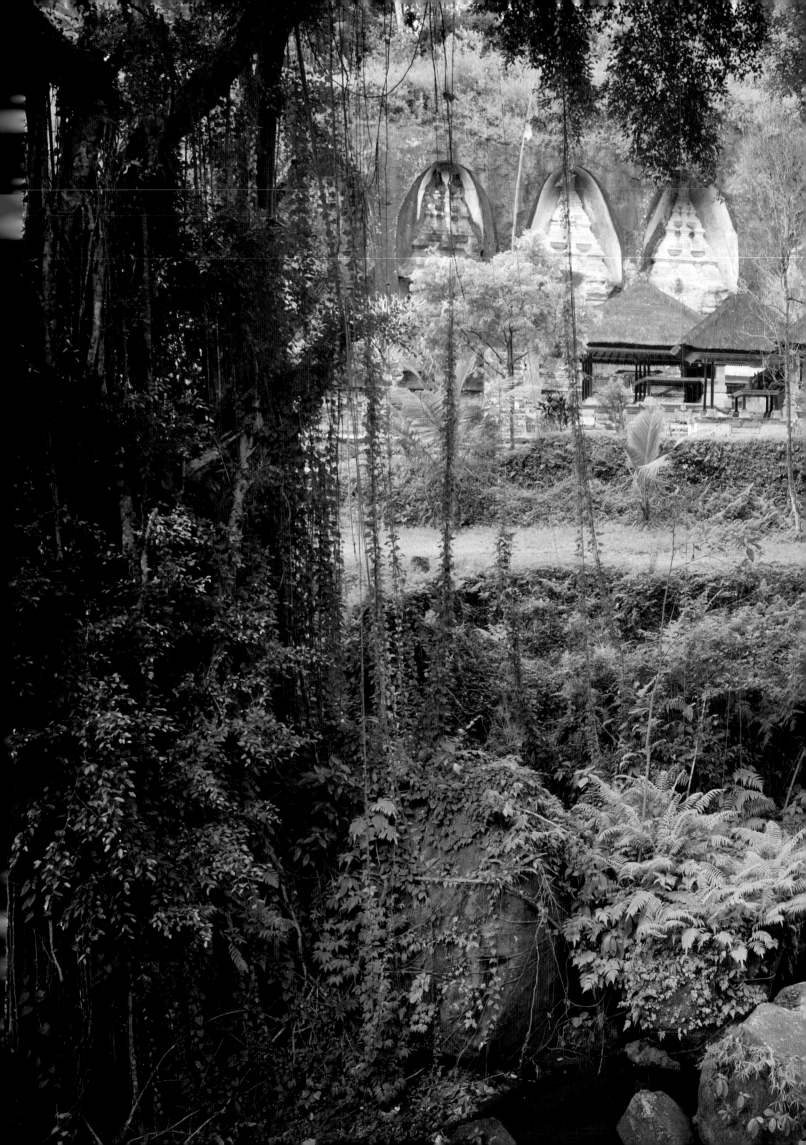

PREVIOUS SPREAD Carved from a vertical cliff face are the extraordinary and mysterious sculptures at Gunung Kawi near Tampaksiring. The surrounding area has flowing creeks and verdant rice fields that are also worth visiting.

RIGHT Carved from a vertical cliff face are the extraordinary and mysterious sculptures at Gunung Kawi in Tampaksiring. The surrounding area has flowing creeks and verdant rice fields that are also worth visiting. At any time, but particularly during special religious occasions, Balinese worshippers from all over the island flock to bathe and make offerings in the holy waters at Tirta Empul in Tampaksiring. This spring, like many in Bali, provides water that originates in the volcanic crater lakes and flows down through underground channels to emerge at various points on the slopes below. From here, the water is channeled through man-made streams and aqueducts to irrigate the rice fields.

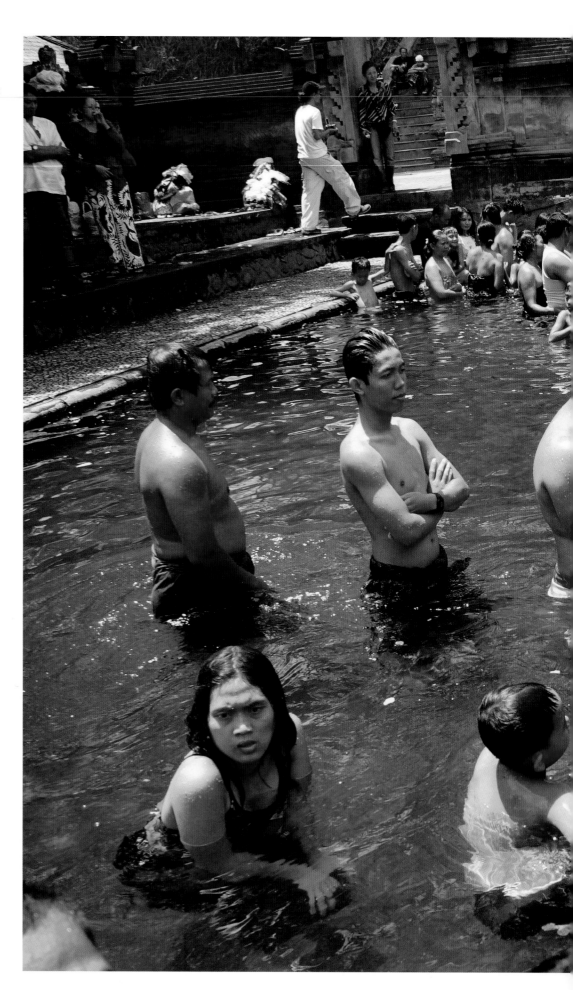

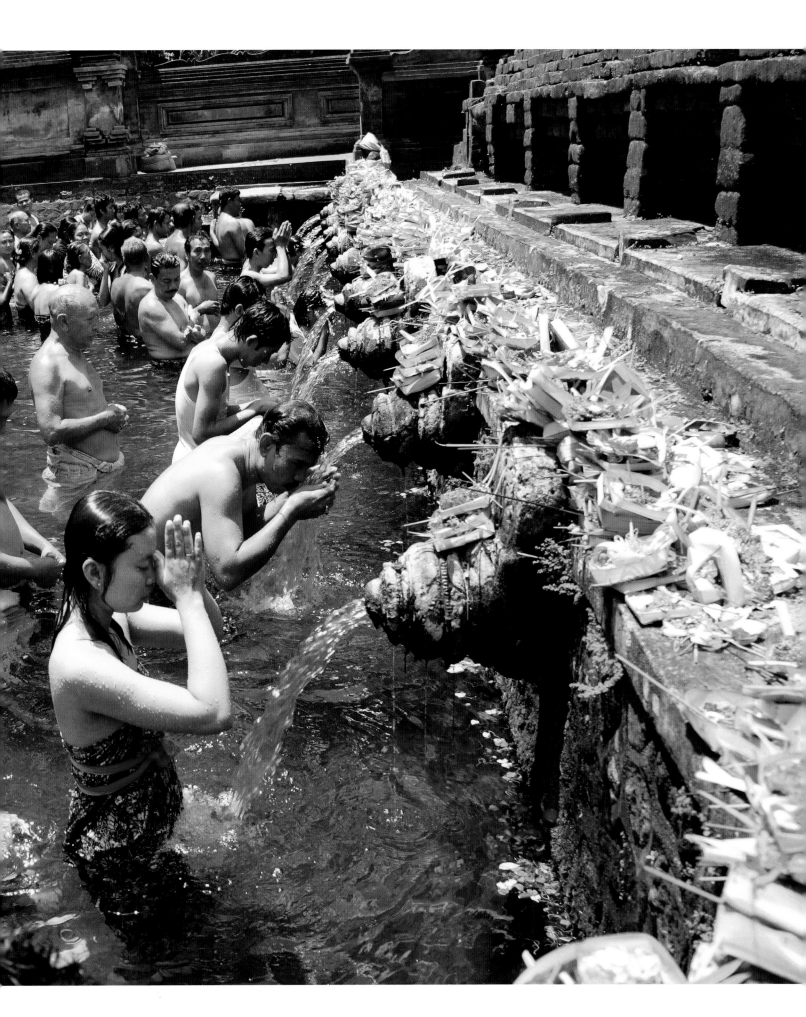

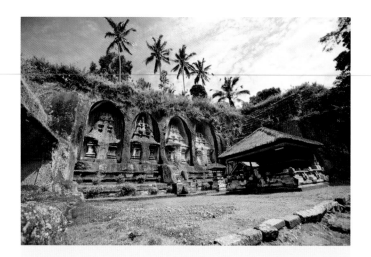

southern beaches, is the Taman Burung Bali Bird Park, home to about 1,000 winged wonders, including Indonesian species such as the elusive Bird of Paradise and endangered Bali Starling, as well as more colorful and approachable toucans and macaws.

Ubud is an overgrown series of villages, so while the variety of hotels is excellent and the range of other facilities, such as travel agencies, Internet and banking, reasonable, parking is almost non-existent and public transport limited to minivans (*bemo*) to Gianyar and Denpasar only. Remarkably, there are no metered taxis, although plenty of unofficial 'taxis' are available with negotiable fares; and shuttle buses link Ubud with all major tourist centers. Ubud is an ideal place to rent a car or motorbike or charter a car with a driver and explore the whole island in every direction. Note that Ubud is cooler than the sultry south and can even turn chilly at night.

Gunung Kawi Rock Temples

At the end of some daunting steps that in places have been hacked through solid rock are Bali's largest, oldest and most mysterious monuments. Located in Tampaksiring, about 15 km north of Ubud, these nine massive and remarkably well-preserved façades shaped like Balinese Hindu shrines were somehow carved deep into oval niches seven meters high. They were created about a thousand years ago, probably as memorials to King Udayana, a powerful Javanese king, and his sons Airlangga and Anak Wungsu, who ruled over parts of Bali and, possibly, also to their wives and concubines. Although sometimes described as 'royal tombs', no evidence of human remains has been found, probably because kings at that time were cremated, nor are there any chambers inside. With most inscriptions eroded long ago, the exact purpose of these monuments, as well as a tenth one located a kilometer away, remains unknown.

In the immediate area are the charming riverside Pura Tirta Gunung Kawi temple, dedicated to the all-important Goddess of Rice; lush rice terraces dotted with palm trees; pure streams gushing over boulders; shrines smothered in moss; and rock-cut caves dripping with water that once served as a Buddhist monastery—and all under the watchful eye of the omnipresent Gunung Agung volcano.

RIGHT The renowed Tegallalang rice terraces near Ubud are one of the most photographed sights, and a great place to shop among the multitude of handicraft stores.

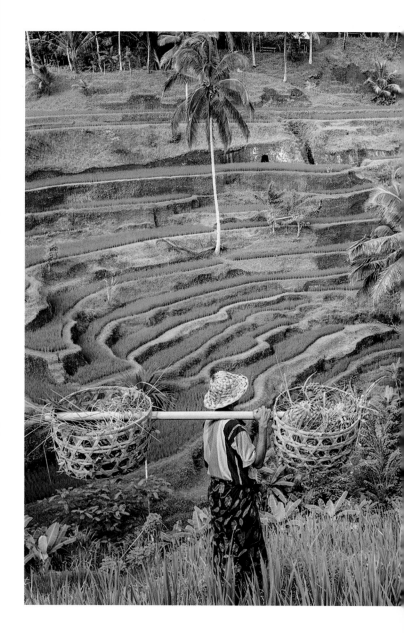

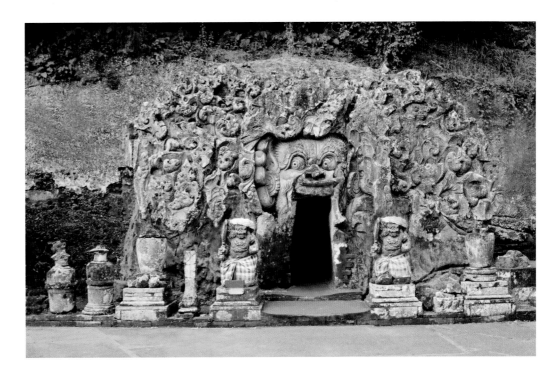

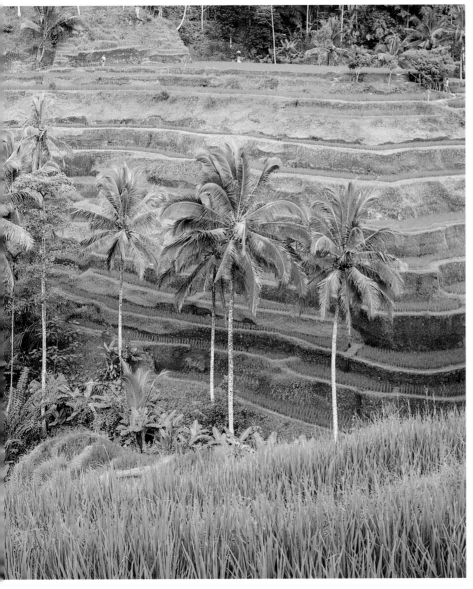

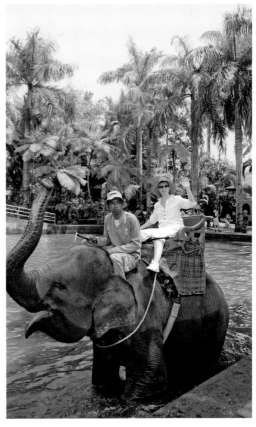

ABOVE At the Elephant Safari Park in Taro village, in Taro village, a few kilometres north of Tegallalang, visitors can enjoy an interactive elephant experience, including rides, feeding and a 'talent show'.

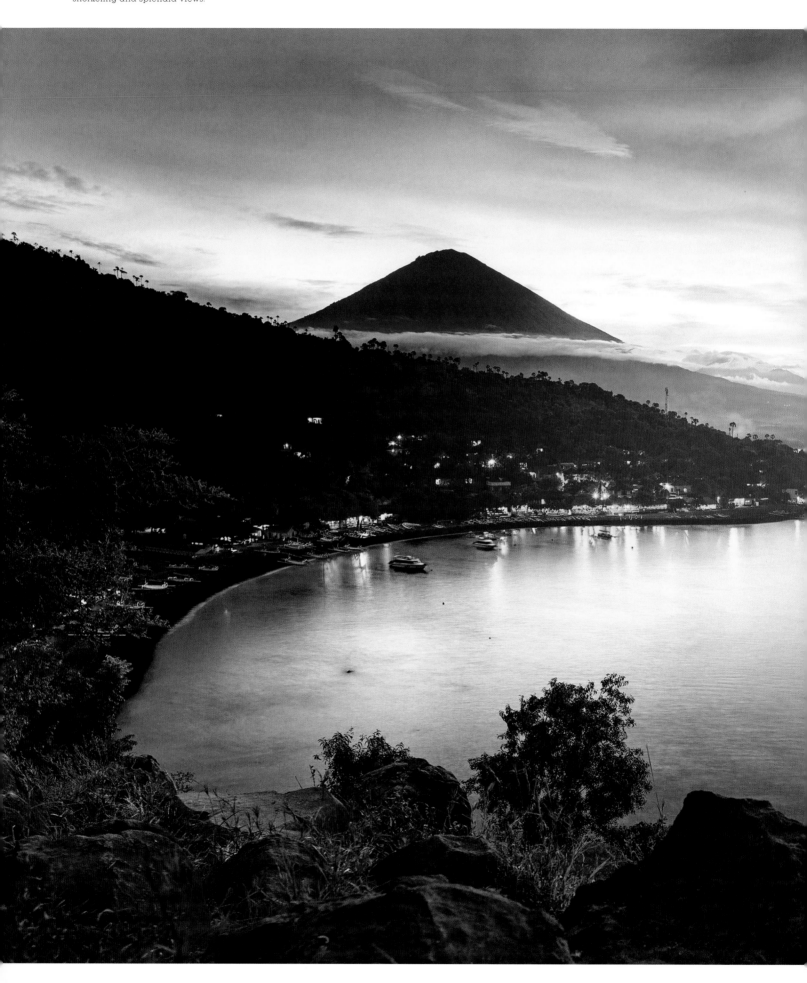

BELOW The far eastern coast of Bali is often known as Amed but is actually a collection of separate fishing villages that offer superb snorkeling and splendid views.

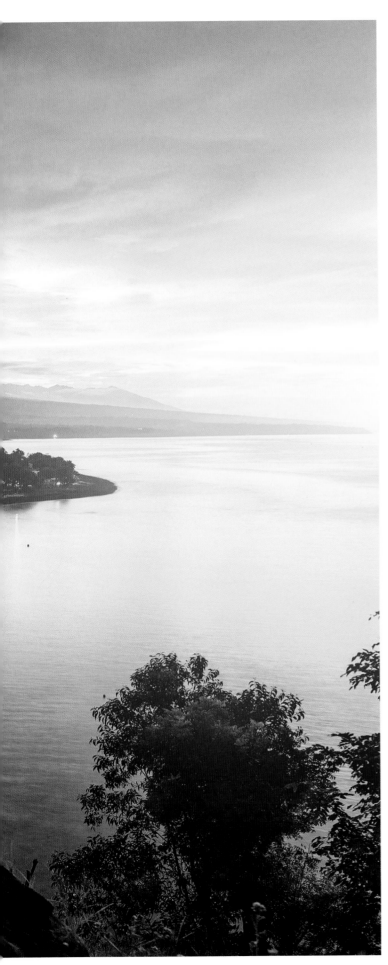

THE NEW FRONTIER

Eastern Bali is becoming increasingly popular as the road from the airport and southern beaches improves, and more Gili Island-hoppers realize the advantages of not just passing through. Dominated by the 'Mother Mountain', Gunung Agung, the most sacred of Bali's numerous volcanoes, this region boasts the only three water palaces on Bali, undeveloped and barely known beaches, several of the island's most sacred temples, including the most venerated, and the captivating capitals of former Balinese kingdoms.

All of these can be easily appreciated on day-trips from the delightful village of Padangbai or the resort area of Candidasa. Those seeking the sort of shopping and clubbing common in the southern beaches are often disappointed, yet, for many, what the east lacks is what makes the east the best.

Known more as the departure point for ferries to Lombok and speedboats to the Gili Islands, Padangbai is a perfect base for an exploration of the east coast. Some are discouraged by the lack of nightlife and shops and by the massive ferry terminal, which is surprisingly unobtrusive, but there are other reasons to visit, such as the millennium-old Pura Silayukti temple atop a headland that offers superb views of the village and far along the east coast. Padangbai's arched shoreline is photogenic but uninviting, but the Blue Lagoon and Bias Tugel beaches nearby are, happily, ideal.

The Pura Goa Lawah temple is one of the most sacred on Bali, and the seaside setting is particularly scenic, but it's perhaps more renowned for the thousands of bats that lurk menacingly at the entrance to a cave inside. Also close to Padangbai is the water palace in the ancient capital of Semarapura. Destroyed by Dutch colonialists in 1908 but lovingly rebuilt, it features a museum, frangipani-choked gardens and a 'Floating Pavilion' in a pond, with ceilings smothered by ancient traditional art. Opposite is the best produce market in eastern Bali, and a monument crafted from black volcanic rock that explains some gruesome local history.

Sadly, the beach resort of Candidasa doesn't boast much of a beach. As tourism exploded unabated decades ago, local coral reefs were dynamited to help produce cement for the construction of new hotels, so the beach virtually disappeared, but most hotels do still offer views of the sea dotted with enticing islets. Along the busy thoroughfare, the 500-year-old Pura Candidasa temple is diminutive but worth visiting, if only for the fine views across to the lagoon. The dearth of acceptable beaches at Candidasa is offset by Pasir Putih ('White Sands'), an undeveloped fishing village not far away where infrequent visitors lounge on deck-chairs, sip fresh coconut juice and splash about a glorious crescent of rare bleached-white sand.

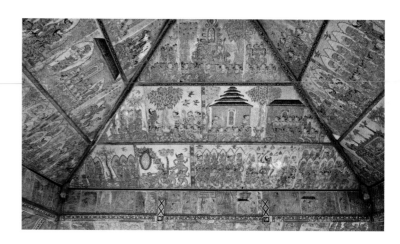

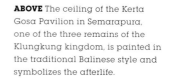

ABOVE The ceiling of the Kerta Gosa Pavilion in Semarapura, one of the three remains of the Klungkung kingdom, is painted in the traditional Balinese style and symbolizes the afterlife.

BELOW The lack of decent beaches at Padangbai and Candidasa are countered by some lovely sheltered bays nearby offering swimming and snorkeling.

LEFT The Kerta Gosa Pavilion in Semarapura was traditionally the meeting place for the king and his ministries to discuss any questions relating to justice for their kingdom. Now, it's one of the best examples of Balinese art and architecture.

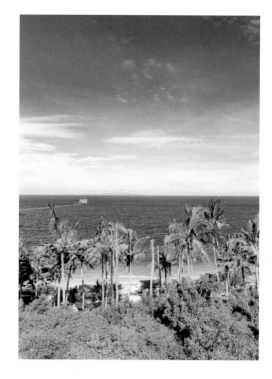

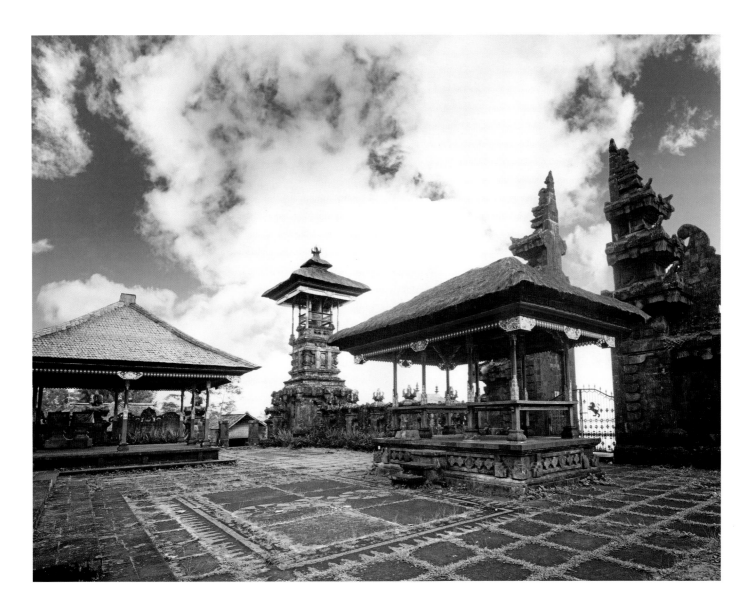

ABOVE The moss-covered compound in this temple, one of 22 at Pura Besakih, features a *candi bentar* split gate, a bale *piasan* pavilion for storing offerings and a *kul-kul* watchtower with a drum.

RIGHT Spread over three square kilometers, the vast Pura Besakih boasts hundreds of shrines, of which all but two were rebuilt after the volcanic devastation from Gunung Agung in 1917.

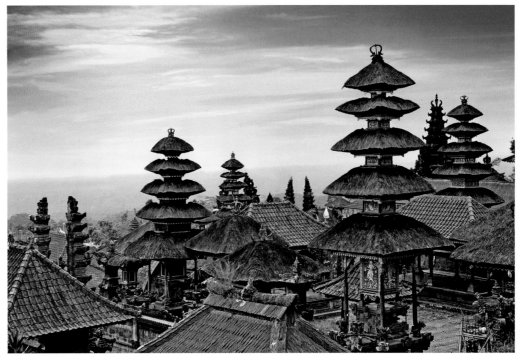

ABOVE Candidasa is a popular resort area in Eastern Bali offering all sorts of accommodation options. The lagoon along the main road and opposite the temple is popular among local boys for fishing and among young Balinese couples for strolling.

RIGHT As well as diving and surfing, other activities on offer in the east include cycling and paragliding.

OPPOSITE RIGHT During the Usaba Sambah festival in Tenganan village, usually held in May or June, the men spar with each other using sharp pandanus leaves and bamboo shields. This is done to win the hearts of the village's unmarried women.

Tenganan Village

Tucked away between the resort areas of Padangbai and Candidasa is the best example of a Bali Aga village, which predates the introduction of Hinduism to the island. Inhabitants still observe unique ancient traditions for marriage and burial, practice exclusivity in village membership and organize atypical ceremonies, but Tenganan is also a normal functioning village with temples, houses, shops and a school. With outer walls and broad stone paths shared with stray cows and chickens, this 700-year-old diminutive village still seems almost medieval. The vehicle-free lanes are lined with open-air *bale* pavilions used for meetings, storage and performances, while caged roosters used for cockfighting squawk as the metallic jangles of a unique form of *gamelan* drift across the mountain air. Since the village opened up to tourism, the main industry has become the making and selling of souvenirs and Tenganan is now one of the most fascinating shopping experiences on Bali. Popular mementoes include calendars and bookmarks etched with Balinese calligraphy on *lontar* palm leaves, *wayang kulit* shadow puppets and painted eggs, but the major trade is in weaving, especially the intricate double-ikat style known as *geringsing* that's not created anywhere else in Indonesia or, probably, Southeast Asia. Unobtrusive stone doorways lead to surprisingly expansive family compounds which serve as showrooms and factories where artisans are hard at work.

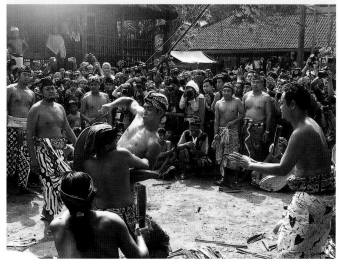

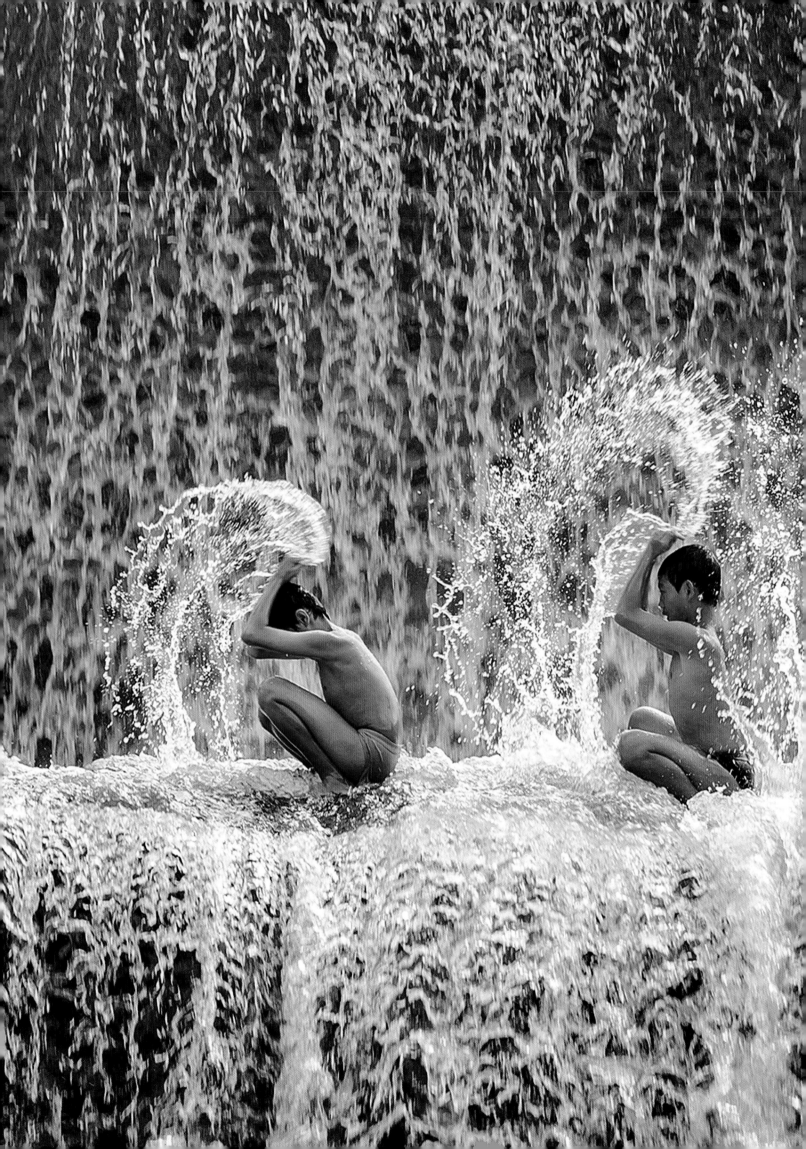

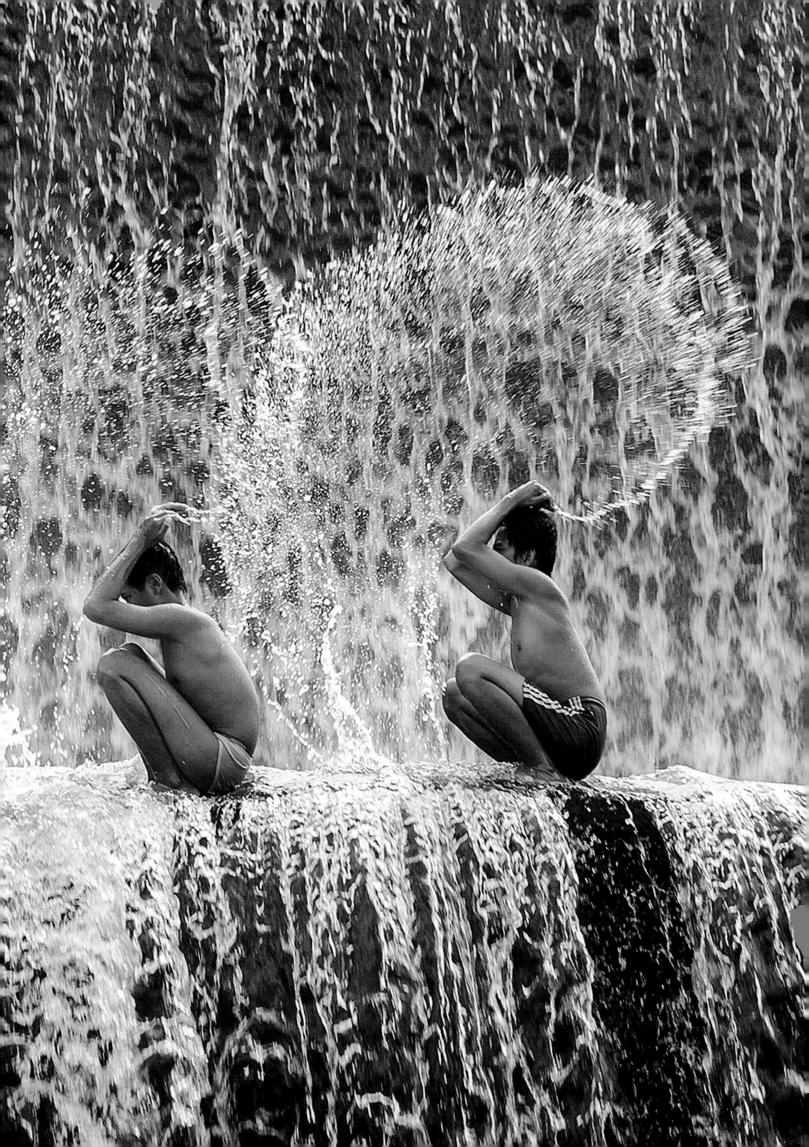

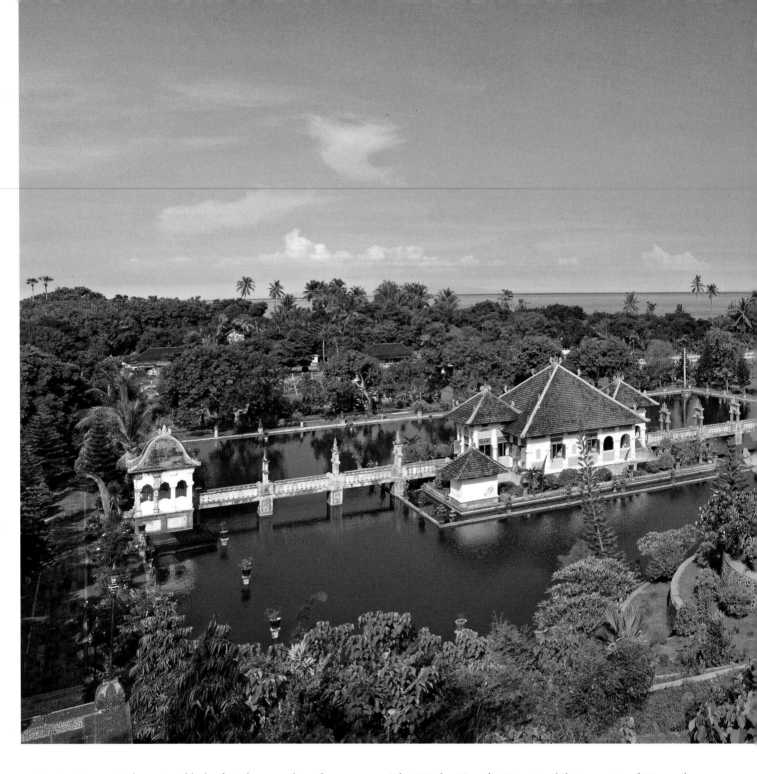

Continuing east is the regional hub of Amlapura, where the Dutch built the Puri Agung Karangasem palace in the late 18th century in a fascinating mix of Balinese, Chinese, Javanese and European styles. Opposite, the Puri Gede palace has also been attractively renovated. Down the road is another water palace, at Ujung. Originally built in 1921 but obliterated 40 years later by Gunung Agung that looms above it, the palace features expansive lawns with fountains and pavilions set among duck-filled ponds.

From Ujung, a newly paved road skirts the far eastern coast to the increasingly popular base of Amed. The driest part of Bali is not the most scenic, but the countryside is unlike anywhere else. Villagers survive by fishing and logging, with the scarred, terraced slopes evidence of failed attempts at planting trees and growing vegetables in the harsh landscape. For tourists, this area really only has one purpose—scuba diving—and much of the coast is lined with cliffs and fishing villages. The occasional beaches are mostly gray, rocky and inaccessible.

The 'Mother Temple', Pura Besakih, is a series of 22 temples and dozens of shrines and compounds spread over some three square kilometers across the slopes of Gunung Agung. Bali's most revered and feared mountain all but destroyed the complex in 1917, but it was amazingly spared Agung's wrath during the catastrophic eruption of 1963. With such veneration and so many temples, massive ceremonies are frequently held, especially during full moon, particularly in April and May.

Padangbai and Candidasa offer a broad range of hotels and other facilities, but Amed, reached also via Tirtagangga, is remote and less developed. Public transport is frequent and worth considering along the main roads, except Ujung to Amed via Seraya, because no metered taxis are available. Shuttle buses link Padangbai, Candidasa and, with enough passengers, Amed to the other major tourist centers. Car rental is best organized at Candidasa, while chartered cars with a driver and motorbike rental are also possible at Padangbai and Amed.

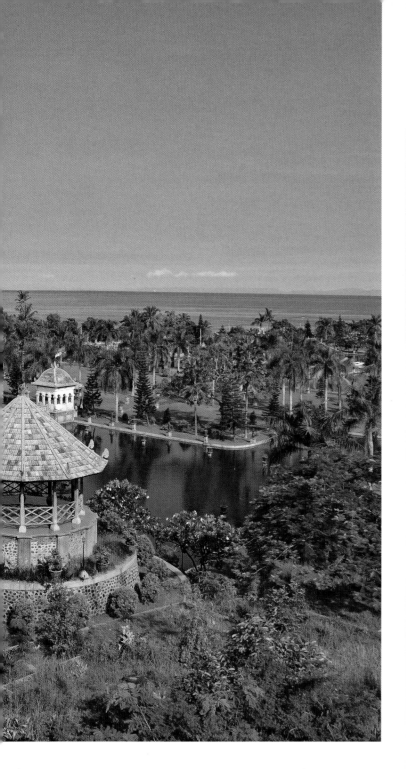

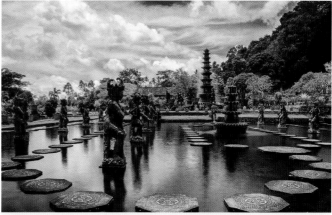

Tirtagangga Water Palace

Of the three water palaces on Bali, the most sumptuous is at Tirtagangga on the lower slopes of Gunung Agung, overlooking some of those rice terraces so often seen on brochures and postcards. The complex was built over 60 years ago by the final *raja* of the Karangasem kingdom of eastern Bali, who based the design on the Palace of Versailles in France and named it after the Ganges River in India, which is revered by Hindus worldwide. Like so many other buildings in the region, however, the palace was destroyed during the eruption of Gunung Agung in 1963. Although descendants of the royal family still dwell onsite, the palace wasn't rebuilt but the extensive gardens were, and are now lovingly maintained. They feature a fountain with eleven tiers and numerous dragonheads from which water gushes across ponds choked with lotus flowers and dotted with stepping stones and bizarre statues. And everything is overlooked by a regal hotel and charming restaurant. The two icy cold swimming pools, which are fed by sacred springs and surrounded by lush gardens, are popular with locals for their apparent medicinal powers. The air is also fresh, the weather cooler and there are sublime views of the coast and, on a clear day, Gunung Rinjani volcano on Lombok Island.

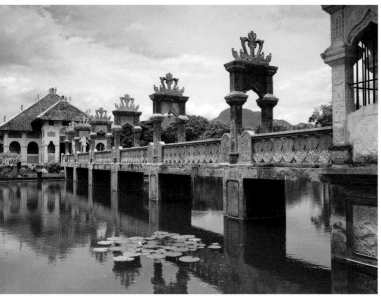

ABOVE LEFT AND LEFT The setting of the water palace at Ujung, squeezed between the sea and the mighty Gunung Agung volcano, is superb. The duck-filled ponds around the water palace are lined with delightful pathways and centered with substantial pavilions.

PAGES 114-5 Children splashing water on themselves at the Tukad Unda Dam in Klunggkung, Bali.

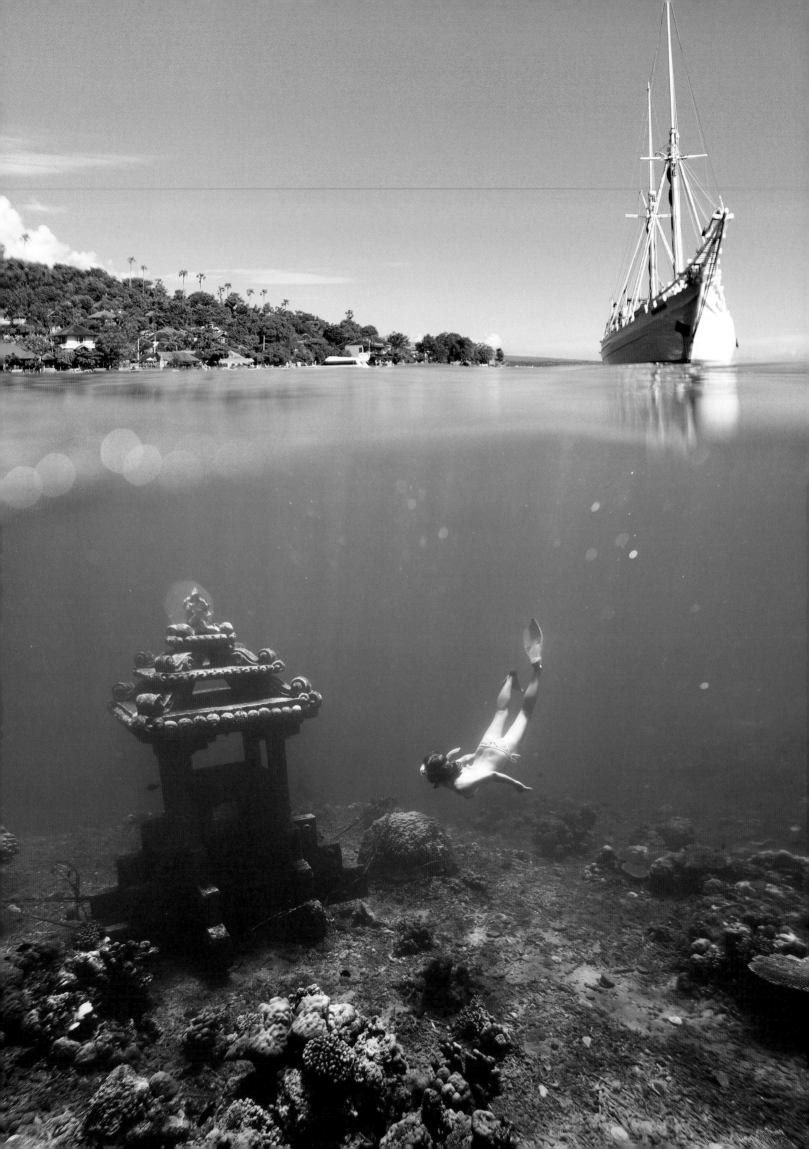

BALI UNDERWATER

Although the islands off the coast of Bali, such as Pulau Menjangan and Nusa Penida, remain popular for scuba diving, their isolation does involve significant cost and time. Thus, it's no surprise that the majestic east coast, stretching from the port of Padangbai to the shipwreck shore at Tulamben, has become Bali's primary diving destination. With improved roads from the south and more accommodation being built, especially at Amed, many flock straight to the east coast and rarely venture further.

As well as enhanced accessibility and exquisite landscapes, the attraction of the east coast for most divers are the shallow, clear and often warm waters, although the waves and currents can be strong in places. Among the myriad underwater delights are the Green and Olive Ridley species of turtle, which are protected but still hunted illegally, and the massive manta rays up to four meters wide. Around the reefs divers are likely to spot schools of striped emperor angelfish, the intriguing but poisonous lionfish with its plentiful fins, and the ubiquitous batfish. Much more elusive, however, is the *mola mola* sunfish, which is a little daunting at up to two meters long but docile. Thankfully, sharks are confined to Nusa Penida but very rarely present any dangers to divers anyway.

In the past, reefs have been damaged by indiscriminate fishing practices, such as anchoring on coral, 'fish bombing' (as horrific as it sounds), and collecting tropical fish for private aquariums. And in Candidasa, much of the coral was even destroyed to help make cement, so the beach (the reason for hotel development in the first place) disappeared. Nowadays, however, most locals understand that preserving reefs is better than destroying them, if only for the benefit of the lucrative diving industry.

Along the east coast, Amed boasts coral gardens teeming with marine life and spectacular drop-offs, but it's a strung-out village that's not easy to reach. The established resort regions of Padangbai and Candidasa are thus popular bases and still accessible to Amed, nearby islets and the magnificent Nusa Lembongan Island. The prize attraction at Tulamben, just north of Amed, is the shipwreck of the USAT *Liberty Glo*. This abandoned American supply ship from World War II slid off the beach during the eruption of Agung in 1963 and was pushed about 25 meters back into the sea by lava flows. The wreck has become encrusted with coral and attracts an extraordinary array of fish, including rare seahorses.

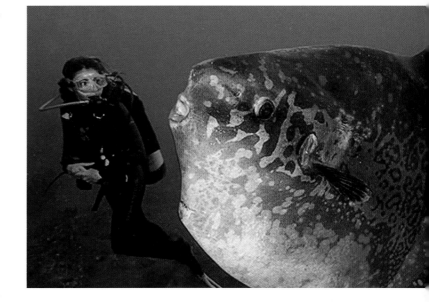

OPPOSITE The waters off the coast of Jemeluk in eastern Bali are fantastic for diving. The small concrete structure here is actually a functioning post box!

ABOVE Scuba diving, which can be arranged at Candidasa, Padangbai, Amed and Tulamben, offers the chance to get up close and personal with an array of extraordinary creatures like the *mola mola*.

Companies, mostly foreign-owned, offer full training courses and both day and night trips, but even without the time, energy or money to invest in a scuba diving licence, there is still plenty to enjoy with just a mask, snorkel and flippers. Snorkeling gear is easy to rent from shacks along the beaches manned by locals who usually know the best snorkeling spots. Some of these are just offshore, which is ideal for children, at Padangbai and the sublime Pasir Putih, near Candidasa. Alternatively, join a scuba diving trip, but beware of cold waters and strong currents so far from the beach.

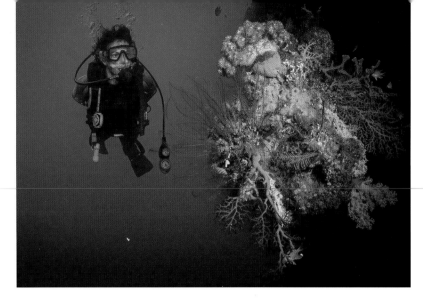

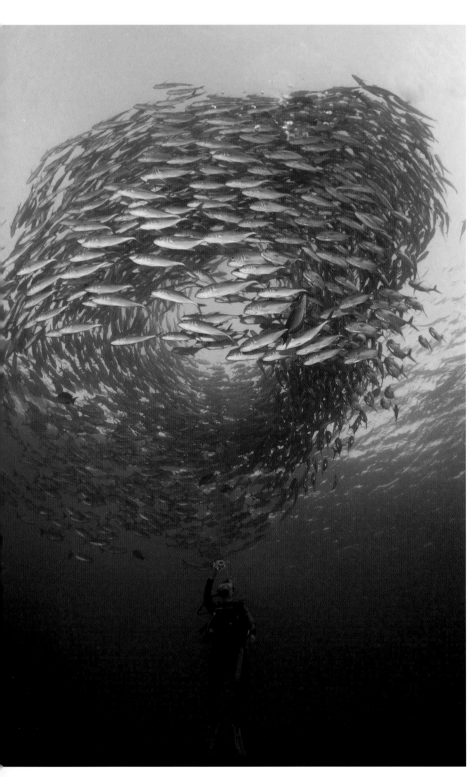

ABOVE LEFT Exquisite coral gardens and reefs are easy to find with some guidance from instructors, but always beware of the strong currents.

ABOVE Despite destructive fishing practices, and even reef bombing, the ocean floor is still filled with an array of marine life that can be enjoyed with just a snorkel and mask.

LEFT Swirls of fish are common, but even more colorful are the black-and-gold Moorish Idol, the startling multi-finned lionfish, and the huge but harmless manta rays.

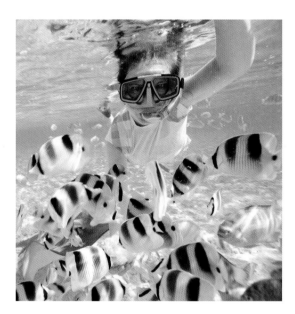

ABOVE Even inexperienced swimmers with snorkeling gear can revel in the colorful marine life on display in the warm shallow waters.

OPPOSITE ABOVE The east coast boasts several shipwrecks. While mostly only accessible by chartered boat, some coral formations can be enjoyed without the need for scuba equipment.

OPPOSITE Large inquisitive turtles are a common sight. Although officially protected, they're still hunted illegally for their eggs and meat, which is used during special ceremonies.

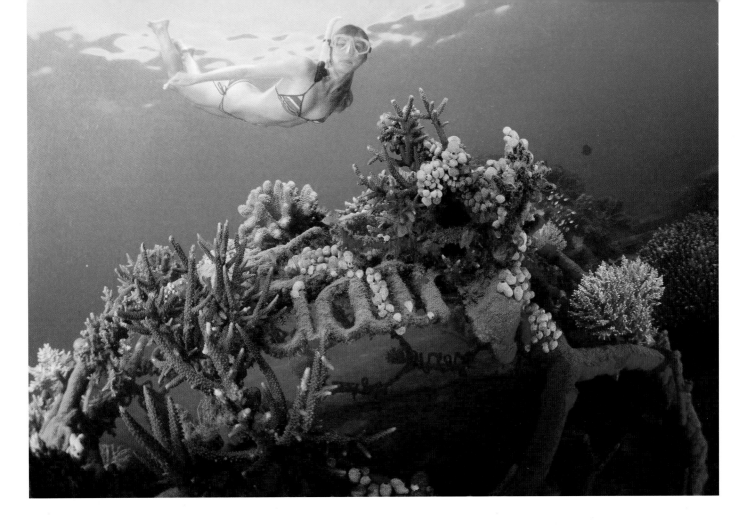

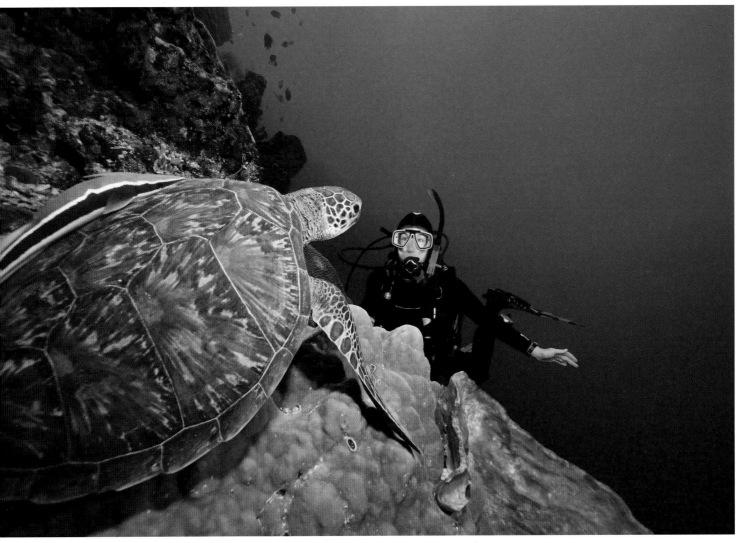

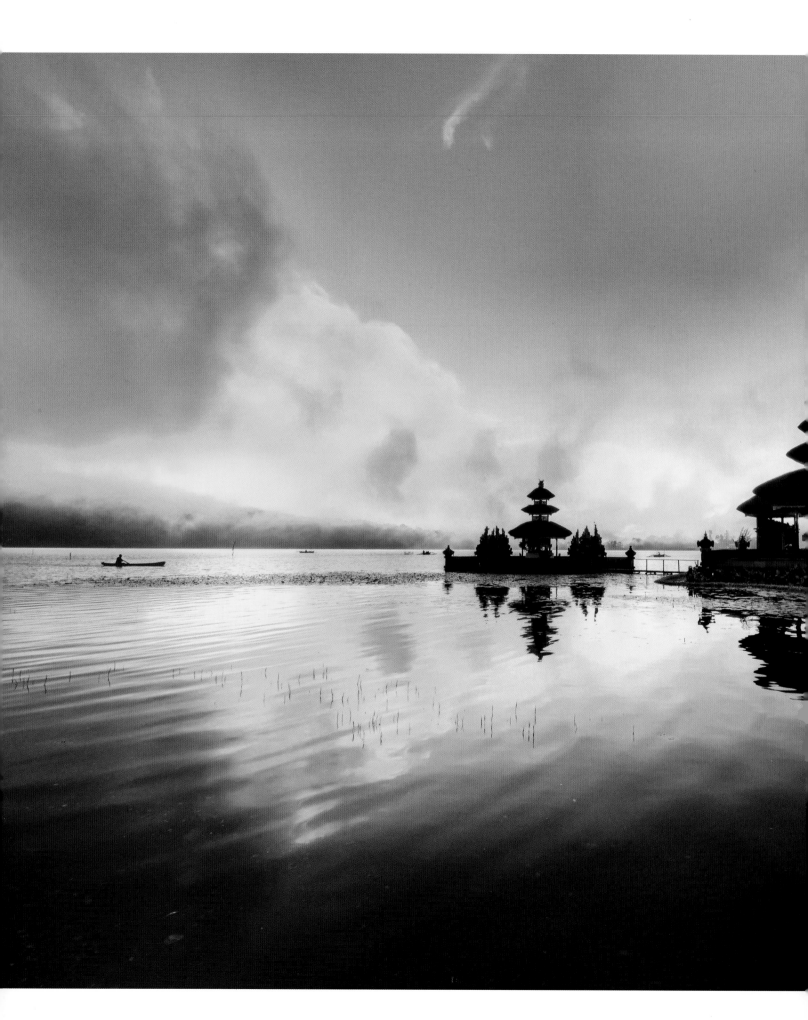

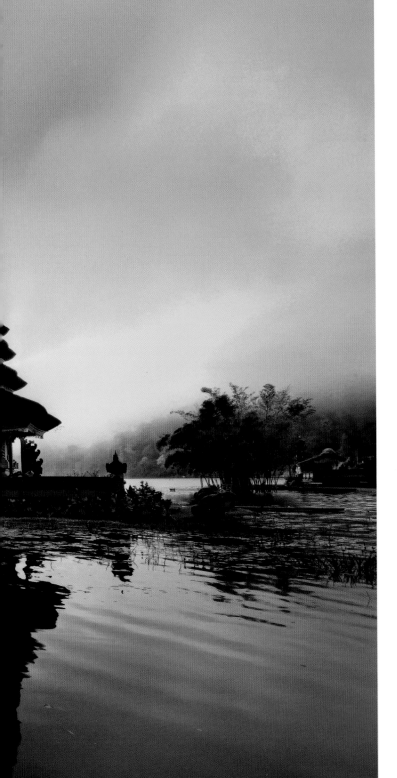

CRATER LAKES, SPECTACULAR VIEWS

Although the central region boasts lakeside resorts with volcano-fed hot springs, the cheapest water sports and some of Bali's most scenic temples and rice terraces, not to mention fresh air and cool temperatures, it is remarkably ignored by those who prefer lazing about the southern beaches.

Between Ubud and the beaches along the northern coast, the central highlands include two of Bali's pre-eminent volcanoes: Gunung Batur, with the island's largest lake nestled inside its caldera, and Gunung Batukau, Bali's second highest peak. Tropical rainforests blanket the central ranges, which at 1,400 meters above sea level, provide temperatures several degrees lower than the plains.

Along the busy thoroughfare between Bali's only two cities, the capital Denpasar and Singaraja, lies Candikuning. It has a sizable Muslim community and is renowned for its roadside market where day-tripping Balinese create traffic jams by stopping to buy rarities like locally grown strawberries. Just down from the peculiar 'Corn Cob Statue' is the 160-hectare Bali Botanic Garden, one of only four in Indonesia and a welcome escape from the heat and chaos in the south.

A brief stroll downhill is the Pura Ulun Danu Beratan temple, built over 350 years ago. Dedicated to the Goddess of Lakes, it features immaculate waterside gardens and the type of pagoda-style *meru* shrines featured so often on postcards and on the Indonesian 50,000 rupiah note. The grounds are particularly photogenic during late afternoons when boys with fishing rods replace busloads of tourists, and the sun glistens on the *meru* roofs.

Along the southern edge of Lake Bratan is Bedugul, a water sports and recreation site established for, and almost exclusively patronized by, Indonesian tourists. Watching them enjoying themselves, whether zipping around the lake on a speedboat or tucking into a seafood meal at the extensive lakeside restaurant, is half the attraction. Further north are the twin volcanic lakes of Danau Buyan and Danau Tamblingan. Viewpoints along the road leading west to the quaint village of Munduk, with its waterfalls and faded Dutch colonial charm, are congested with pesky macaques.

The region around Gunung Batukau (2,271 m) is surprisingly overlooked but features two key attractions. The beauty of the

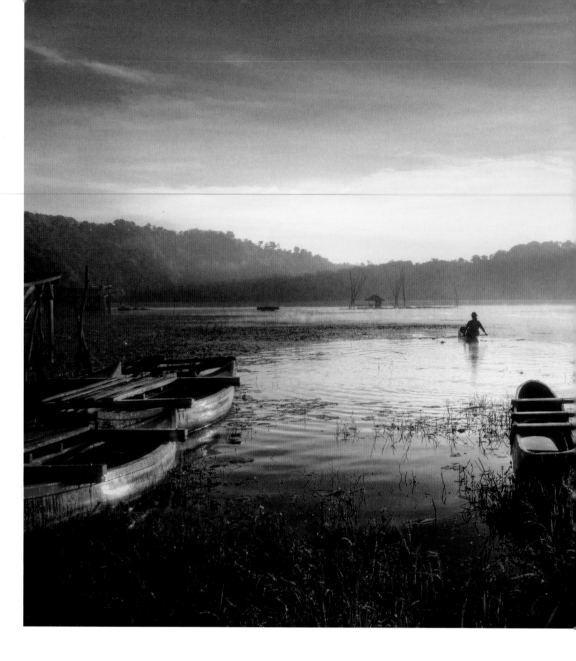

PREVIOUS SPREAD Perched alongside a crater lake in the central highlands, Pura Ulun Danu Bratan is one of the most picturesque and photographed temples on Bali.

RIGHT Buyan and Tamblingan lakes, (the latter pictured here) which were once joined together, are still revered by locals but generally overshadowed by the more scenic and accessible lakes at Bratan and Batur.

FAR RIGHT Nestled inside a vast caldera, Lake Batur offers hot springs and water sports as well as superb locations for places to stay and eat.

emerald green amphitheaters of rice fields cascading down the volcanic slopes at Jatiluwih, and the ancient methods of growing, harvesting and irrigating rice there, have been recognized by UNESCO. The grandeur of this area is best enjoyed from trails along ridges in Jatiluwih that afford marvelous all-round views, or from the inevitable row of buffet restaurants. Perched on the southern slopes is Pura Luhur Batukaru, a sacred former state temple meant to protect Bali from evil spirits, swathed in a verdant forest humming with insects and birds.

A popular pause on many organized tours is one of the countless restaurants hanging off the rim of Gunung Batur, Bali's most active volcano. The best are located at Penelokan, where views of the lava-scarred slopes are extraordinary, and a stimulating museum expounds the history and geological evolution of the volcano. A road hugging the crater lip stretches through Kintamani to Penulisan, where Bali's highest temple provides superb 360-degree views, cloud and rain permitting. Even more majestic is Pura Ulun Danu Batur. This is Bali's second-most sacred temple because it is the Supreme Water Temple of Batur Lake, regarded as the original source of every spring and river that irrigates farms and provides for villages in the southern and central regions of Bali, and because it's located alongside Bali's most active volcano.

Few tourists venture along the road that snakes down inside the crater. From Kedisan, boats whizz across Bali's widest and most voluminous lake to the traditional Bali Aga village of Trunyan, which predates the introduction of Hinduism to the island a millennium ago. Also worth exploring are the picturesque village of Songan and the original site of the Pura Ulun Danu Batur temple, while the more adventurous organize hikes around Gunung Batur that last up to seven hours to witness the sunrise at the summit. At the main village of Toya Bungkah, two resort complexes offer the chance to luxuriate on lounge chairs or splash about in swimming pools and hot-water baths across the lake from towering volcanoes.

Not surprisingly, these mountainous regions are the wettest, foggiest and coldest parts of Bali, so come prepared. The two bases, Candikuning for the Bratan and Batukau mountains and Toya Bungkah for Batur, provide basic but comfortable accommodation but no hotel resorts. Shuttle buses from the southern beaches, Lovina and Ubud travel daily to Candikuning/ Bedugul and, with enough passengers, to Kintamani, while public transport is also frequent to these three places. The only options for Jatiluwih, however, are a chartered/rented car available from Ubud, a chartered motorbike from Candikuning or an organized tour from the south or Ubud.

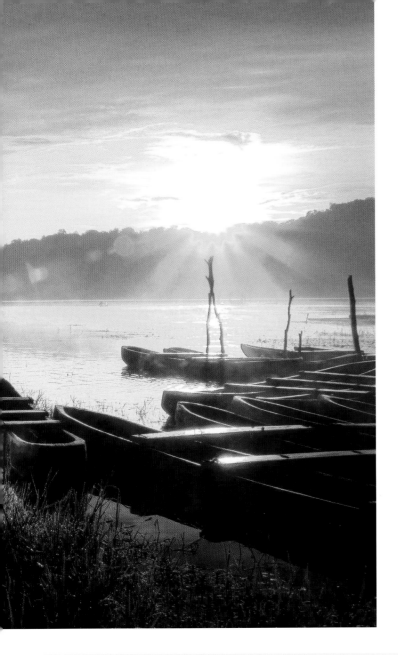

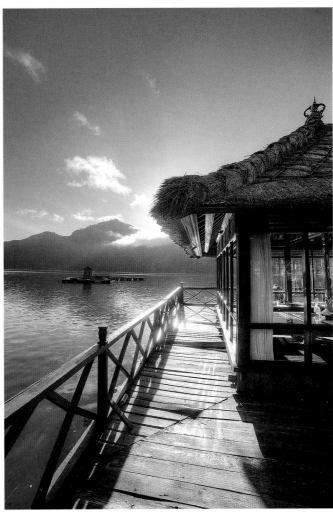

Brahmavihara Arama: Bali's Only Buddhist Monastery

Elevated along the slopes of Banjar, a delightful village near Lovina, is the only real manifestation of a religion that flourished in Bali during the 8th and 9th centuries. Although not as impressive as monasteries found in Thailand, the lofty setting and panoramas to the north coast are inspiring. The surprisingly extensive gardens feature open-air *bale* pavilions alongside a ravine for reflection, a prayer room choked with incense and a gilded Buddha, and the usual religious icons and golden statues. To the side, a gray volcanic rock stupa resembles a miniature version of the magnificent Buddhist complex at Borobudur in Java. Balinese Hindu influences are apparent around the monastery, however, such as the *kul-kul* tower with a drum used for announcements and *candi bentar* split gate. Construction of this Theravada Buddhist temple commenced in 1970 but took about 10 years to complete because of an earthquake, and it has been blessed with a visit by the Dalai Lama. It was built by a converted Balinese man from the Brahman caste living in Banjar, while other monks have originated from the Buddhist enclave at Budakeling village in eastern Bali. Visitors are welcome, but this is a functioning monastery and not a designated tourist attraction, although serious ten-day meditation courses are occasionally run.

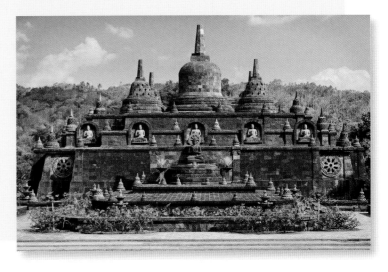

NORTHERN AND WESTERN BALI

FAR FROM THE MADDING CROWDS

An overwhelming percentage of visitors to Bali stay in the southern beaches, in Ubud or along the eastern seaboard, while only a few trickle up to Lovina along the northern coast. About half of Bali, therefore, including much of the island west of the main road between Denpasar and Singaraja, is almost completely devoid of tourists.

Many tourists are discouraged from visiting the north and west because of Lovina's relatively unappealing beaches and the distance from the airport, which is why another airport in the west has been mooted for years. But those in the know, especially scuba divers, truly appreciate the beauty and isolation of this region.

Several places, including some rugged surfing beaches like Medewi, are close enough to enjoy on day-trips from Ubud or the southern beaches. Tabanan is the busy and admirably tidy capital of a particularly fertile region, but the Rice Museum is disappointingly lackluster. Far more enticing is the 16th-century Puri Agung Mengwi at Taman Ayun in Mengwi. It is unique among the hundreds of temples across Bali because it is surrounded by gorgeous gardens and a moat fed by the *subak* canals normally used to irrigate rice fields.

Many parts of the Jembrana district in the far west are more Javanese and Islamic than they are Balinese and Hindu. The capital Negara is renowned for the frantic bull races with chariots that are regularly held between July and October, which involve much cheering, (illegal) betting and, sometimes, devouring of injured competitors.

To the east of Negara, Pura Rambut Siwi temple boasts a hilltop setting and reverence to rival Ulu Watu and Tanah Lot, but without the crowds, and to the west are two remarkable villages with churches: Palasari (Catholic) and Belimbingsari (Protestant), both remnants of former missionary success.

Off the far western tip is the Taman Nasional Bali Barat national park comprising some 19,000 hectares. It helps protect pristine rainforests, coral islands and native flora and fauna, including Ridley turtles and highly endangered Bali starlings, the only surviving bird species endemic to the island. The associated Marine Reserve conserves the reefs and marine life around Pulau Menjangan, so this uninhabited island now boasts some of the world's most exquisite scuba diving. The usual base for divers is Pemuteran, with the sort of beaches and laid-back village vibe reminiscent of southern Bali from the 1970s.

Along the northern coast, the collection of villages known as Lovina stretches for some 10 kilometers. The calm waters are ideal for swimming but the beaches are gray and gritty and often strewn with rubbish and lined with *jukung* fishing boats. The attraction is the relaxed and compact village-style atmosphere, an appealing antithesis to the hedonistic south. Almost obligatory is the much-lauded early morning boat trip to spot and pursue curious and amenable dolphins along the Lovina coastline.

With wide streets, bearable traffic and colonial architecture, Bali's former capital Singaraja is far more likable than the current one, Denpasar. The dilapidated Dutch port badly needs restoring but is popular for wandering about and admiring the outlandish Independence Monument and uncommon Chinese temple before dining at one of the open-air cafés perched above the sea. The colonial-era Royal Palace of Singaraja is also worth visiting.

OPPOSITE ABOVE A popular excursion from Lovina is a boat trip at dawn to see sometimes elusive dolphins frolicking in the sea.

OPPOSITE INSET A statue of a dolphin is at the end of one of the two streets in Kalibukbuk, one of the villages that make up the region known as Lovina.

ABOVE The black sand beaches at Lovina lead out to calm waters perfect for swimming. Lovina is also great for diving and snorkeling.

BELOW Along the inner western part of the island, bulls have been raced for centuries, but it is now an organized sport with training and competitions held for the benefit of locals, not tourists.

Halfway between Singaraja and Candikuning is Bali's highest (35 m) waterfall at Gitgit, but the regional highlight is undoubtedly Banjar, a charming village nestled in the foothills near Lovina. As well as a plethora of temples and a sprawling roadside market, Banjar is justifiably renowned for the hot springs superbly positioned among lush, tropical gardens. Visitors can splash about in the hot-water pools or stand under dragon-shaped spouts for a massaging spray. Within walking distance and past some rare vineyards is Brahmavihara Arama, the only Buddhist monastery on Bali, which plays a central role in Buddhist religious life and education on the island.

Kalibukbuk is the best base within Lovina for hotels and other facilities, while more accommodation is being built, including resorts, at Pemuteran. Except for Lovina and Pemuteran, and a handful of resorts in the national park, this entire region is undeveloped for tourism. There are no organized tours or places to rent cars. Few restaurants will serve Western food, and accommodation will cater for Indonesians and probably be unappealing for many foreigners. Public buses and minivans (*bemo*) hurtle along the busy roads leading to Gilimanuk from Singaraja and Denpasar, and stop everywhere in between.

The Endangered Bali Starling

The Bali Starling (*leucopsar Rothschildi*) is the only bird endemic to Bali and features on the (rare) 200 rupiah coin. Remarkably striking with white feathers, a blue 'mask' and black-tipped wings, the bird is critically endangered but still hunted by locals. These days, only a few dozen pairs survive in the wild at the national park in western Bali and on Nusa Penida Island. Admirable attempts at breeding and releasing are continuing through the Begawan Foundation (www.begawanfoundation.org), based at the Green School near Ubud, with aid from several international zoos.

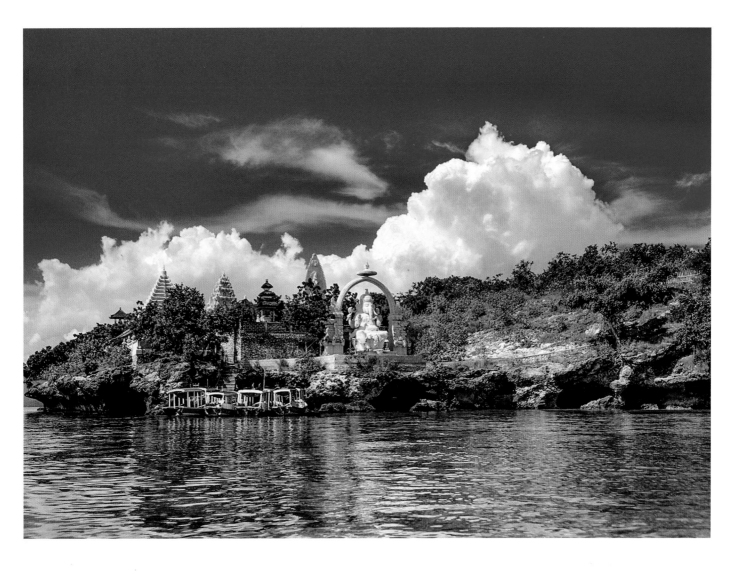

ABOVE On the uninhabited island of Pura Gili Kencana is believed to be one of the oldest temples on Bali and the destination of many pilgrimages.

LEFT Hiking to the Yeh Mampeh waterfall in the village of Les in the Tejukula district.

OPPOSITE Cycling down a quiet road through the Bali Barat National Park.

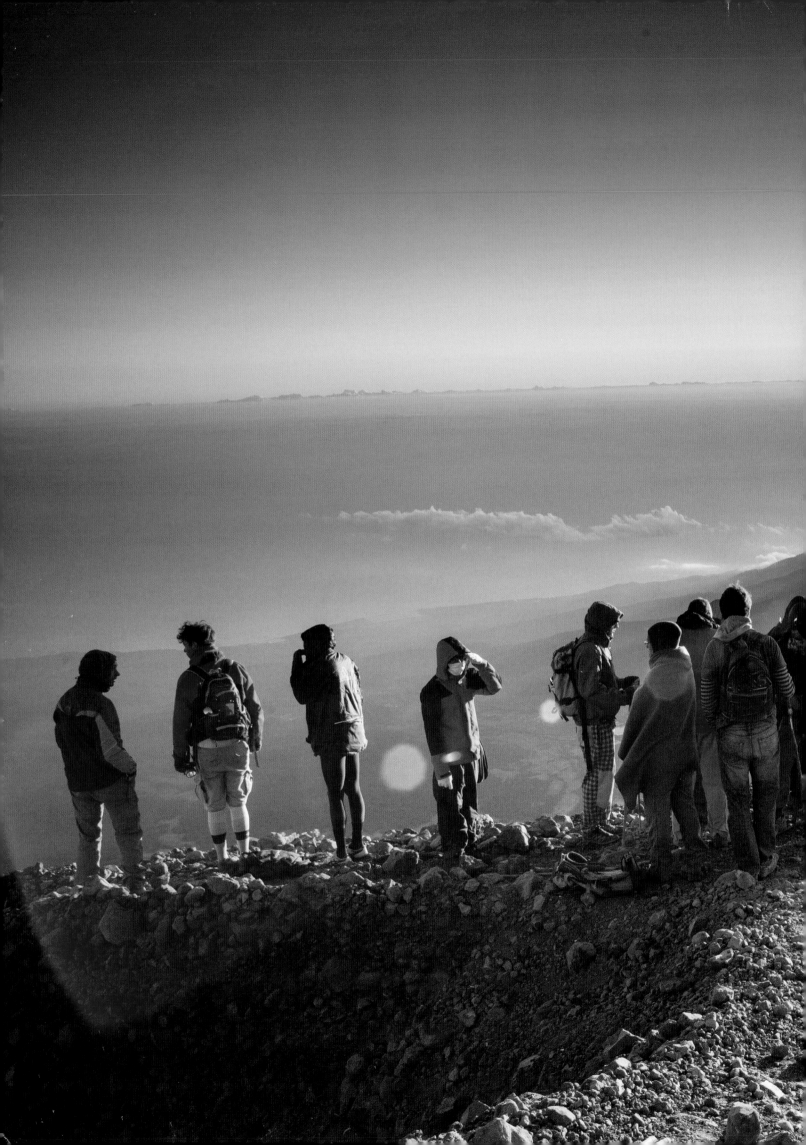

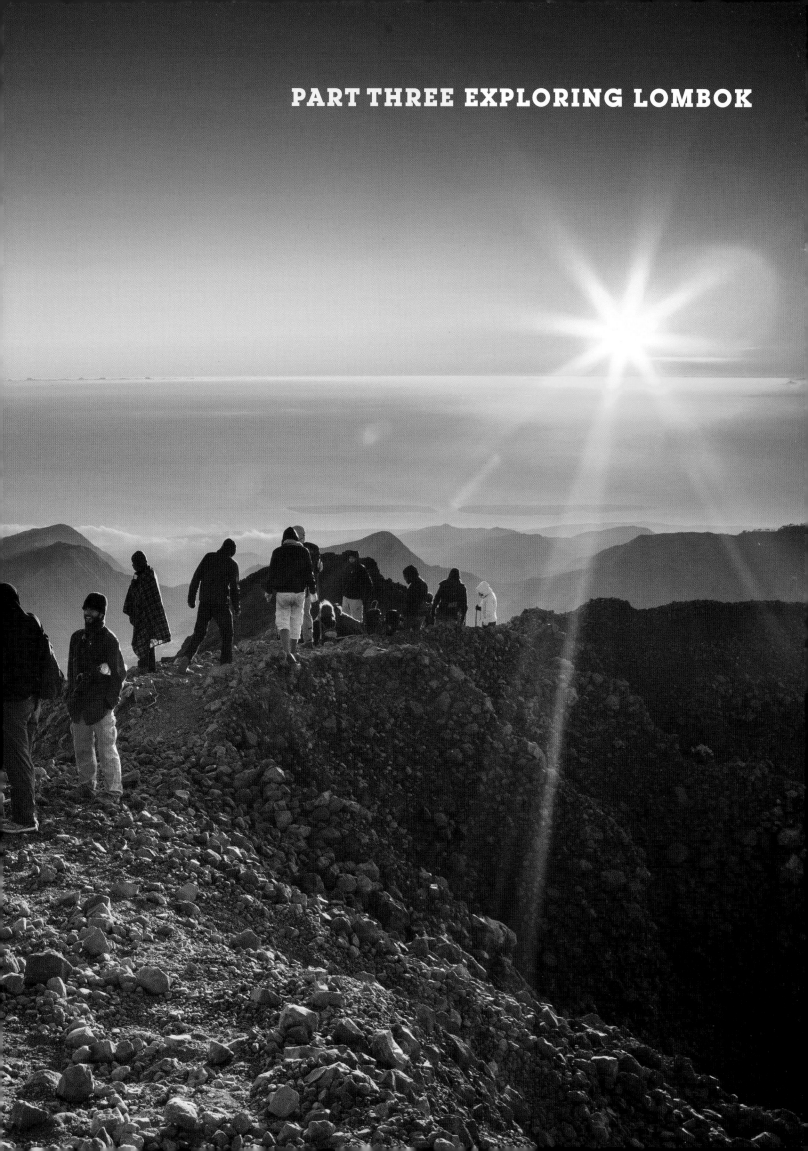

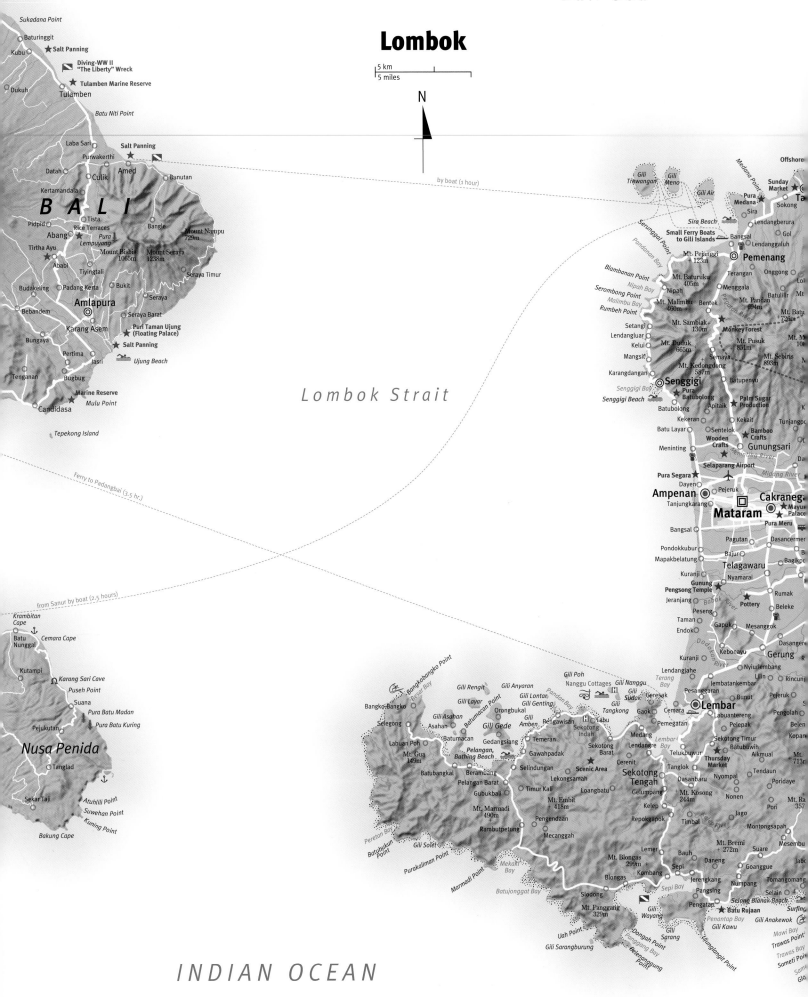

Lombok

5 km
5 miles

N

Bali Sea

Sukadana Point
○ Baturinggit
Kubu ○ ★ Salt Panning
✈ Diving-WW II
"The Liberty" Wreck
Dukuh ○ ★ Tulamben Marine Reserve
Tulamben ○

Batu Niti Point

Laba Sari ○ ★ Salt Panning
Purwakerthi ○ ★
○ Culik ✈
Datah ○ Amed ★
Kertamandala ○ ○ Bunutan

B A L I
Pidpid ○ ○ Tista
Abang ○ ★ ○ Bangle
Pura ○ Mount Nampu
Tirtha Ayu ○ Lempuyang 729m
Ababi ○ Mount Bisbis Mount Seraya
○ ○ 1065m 1238m
Budakeling ○ Padang Kerta ○ Bukit ○ Seraya
Bebandem ○ Tiyingtali ○ Seraya Timur
○ Amlapura ○ Seraya
○ Karang Asem ○ Seraya Barat
Bungaya ○ ○ Puri Taman Ujung
Pertima ○ (Floating Palace)
Tenganan ○ Jasri ○ ★ Salt Panning
Bugbug ○ ✈ Ujung Beach
★ Marine Reserve
Candidasa ○ Mulu Point

Tepekong Island

Ferry to Padangbai (3.5 hr.)

from Sanur by boat (2.5 hours)

Krambitan Cape ⚓
Batu ○
Nunggal
Cemara Cape

Kutampi ○
Ω Karang Sari Cave
♦ Puseh Point
Suana ○
♦ Pura Batu Madan
Pejukutan ○ ♦ Pura Batu Kuring

Nusa Penida

○ Tanglad
⚓
Sekar Taji ○ *Atuhili Point*
Suwehan Point
Kuning Point
Bakung Cape

INDIAN OCEAN

Lombok Strait

by boat (1 hour)

Gili *Gili*
Trawangan *Meno* Offshore ○
Gili Air *Medana Point* **Sunday**
Pura ○ **Market** ★ Ta
Medana ○ Sira ○ Sokong
Sira Beach ○ Lendangberura
Small Ferry Boats ✈ ○ Bangsal
to Gili Islands Gol ○
○ Lendanggaluh
Serunggai Point Mt. Pejanggi ○ Terangan ○ Onggong ○ Lo
Pandonan Bay 123m ○ **Pemenang**
Blambanan Point Mt. Baturuku ○ Menggala
405m ○ Mt. Pandan Batulilir ○
Nipah Bay ○ Nipah 694m
Serombong Point Mt. Malimbu ○ Bentek Mt. M
Malimbu Bay 460m ○ ○ 726m
Rumbeh Point Mt. Sambiak+ Monkey Forest Mt. M
Setangi ○ 130m ○ ○ 10
Lendangluar ○ Mt. Duduk Mt. Pusuk Mt. Sebiris
Kelui ○ 665m ○ 851m 893m
Mangsit ○ Semaya ○
Karangdangan ○ Mt. Kedongdung
587m
Senggigi Bay ○ **Senggigi** ○ Batupenyu
Pura ○
Senggigi Beach Batubolong
Batubolong ○ Apitaik ★ Palm Sugar
Kekeran ○ ○ Kekait Production
○ Sentelok Tunjangpo ○
Batu Layar ○ ★ Bamboo
Wooden ★ Crafts
Crafts ○ Gunungsari
Meninting ○ Da
Selaparang Airport ✈
Pura Segara ★
Dayen ○
Ampenan ○ Pejeruk ○ **Cakraneg**
Tanjungkarang ○ Mayu
○ Palace
Mataram ○ Pura Meru
Bangsal ○
Pagutan ○ Dasancermer
Pondokkubur ○ Bajur ○ Bagik
Mapakbelatung ○ Telagawaru
Kuranji ○ Nyamarai ○
Gunung ○ Rumak
Pengsong Temple ★ Pottery ○ Beleke
Jeranjang ○ Peseng ○
Taman ○ Gapuk ○ Mesanggok ○
Endok ○ Kebonayu ○ Dasanger
Kuranji ○ ○ Gerung
Lendangjahe ○ Nyiurlembang ○
Jembatankembar ○ Lilin Rincung
Terang Pesanggaran ○ Pejeruk ○
Bay ○ Bunut ○ Pengola
Gili Poh **Lembar** ○ Labuantereng ○ Pelepak ○
Nanggu Cottages ✈ *Gili Nanggu* Lembar Pelepak ○ Belen
Gili Rengit *Gili Anyaran* *Gili* Bay ○ Kopar
Gili Layar *Gili Lontar* *Südak* Telukbuwur ○ Sekotong Timur Batubuwih
Bangko-Bangko ○ *Gili Genting* *Gili Tangkong* Geresak **Thursday** Aikmual Mt. 713n
Selegong ○ *Batumacan Point* Orongbukal ○ Gaok ○ Cemara Medang ○ **Market** ○ Nyompal ○
Gili Asahan Asahan ○ *Gili* Pemegatan ○ Lendangre Tanglok ○ Dasanbaru ○ Tendaun
Labuan Poh ○ Amben Rengawisan ○ Labu Sekotong Cerenit ○ ○ Poridaye
Mt. Gua ○ Batumacan ○ Temeran ○ Sekotong ○ Gelumpang Mt. Kosong ○ Jago Mt. Ra
149m Gedangsiang ○ Indah Barat ○ 244m ○ 357
Pelangan, ○ Gawahpadak ○ Lekongsamah ○ Loangbatu Kelep ○ Montongsapah ○
Bathing Beach Selindungan ○ Repokgapok ○ Mt. Bremi
Batubangkal ○ Berambang ○ Timur Kali ○ Mt. Embit Lemer ○ Timbal ○ + 272m Mesemb ○
Pelangan Barat ○ + 418m Bauh ○ Daneng ○
Gubukbali ○ Pengendaan ○ Mt. Blongas ○ Sepi ○ Goanggue ○
Mt. Marmadi ○ Mecanggah ○ 299m Kombang ○ Jerengkang ○ Numpang ○
Gili Solet 490m ○ Blongas ○ Pangsing ○ *Selong Blanak Beach*
Rambutpetung ○ Slodong ○ Pengatap ○ *Surfing*
Batubukun Point *Mekaki* Mt. Panggang ○ *Gili* ★ Batu Rujaan ○
Bay 329m *Wayang* *Penantap Bay* *Gili Kawu*
Purakaliman Point *Gili Sarang* *Gili Anakewok* ✈
Marmadi Point Uah Point ○ *Gili* *Mawi Bay*
Batujonggat Bay *Sarangburung* *Dongah Point* *Gili Kawu* *Trawas Point*
Gelenganggung *Trawas Bay*
Point *Sameti Poi*
Panggang Bay *Glo*

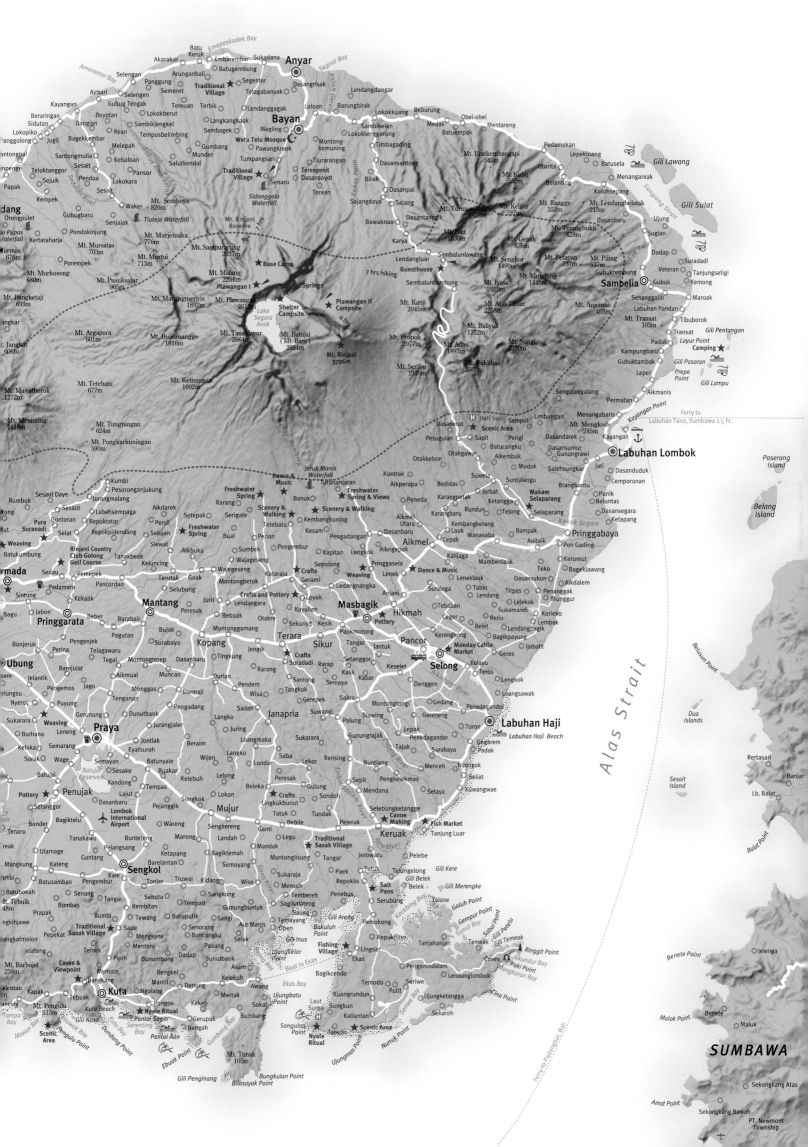

BALI'S EASTERN NEIGHBOR

A worthy alternative to the crowds, high prices and unabated development of Bali, the sister island of Lombok is a short hop by boat or plane to the east. Although the landscapes of rice-fields, volcanoes and sandy beaches are similar, Lombok is different, particularly as most people are Moslem, not Hindu, but they are just as welcoming.

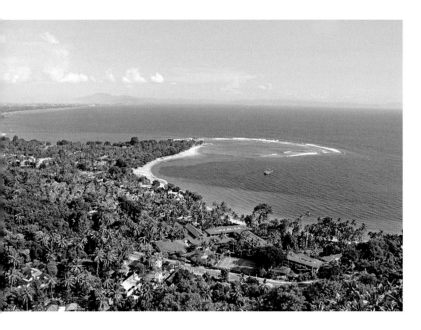

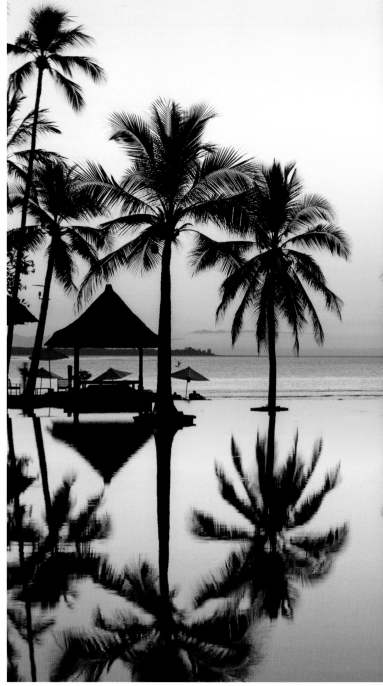

Many base themselves in Senggigi, which has the kind of hotels, cafés and nightclubs found (but in smaller numbers) along the southern side of Bali, while the sublime beaches around Lombok's Kuta are increasingly popular. The more adventurous hike around the omnipresent Gunung Rinjani volcano or visit the enticing villages clinging to its slopes.

A short skip across from the Gili Islands, Senggigi is an extended series of crescent-shaped beaches that seem almost Crusoe-esque at times, except for weekends when locals from Mataram, the nearby capital, happily share their sand and sunset with tourists. A particularly enjoyable spot for sweeping coastal panoramas across to Bali, and for the local Hindu population to worship, is the cliffside Pura Batu Bolong temple, which faces the almighty Gunung Agung volcano on Lombok's sister island.

The agreeable capital Mataram has several notable attractions, such as the Pura Mayura water palace and Lombok's most venerable temple, Pura Lingsar, revered by Hindus and followers of a minority Islamic sect called Wektu Telu. Spotting sacred eels enticed to the surface from the temple's ponds by priests with hard-boiled eggs is regarded by locals as a sign of good fortune. The immaculate gardens are also the location of the Perang Topat

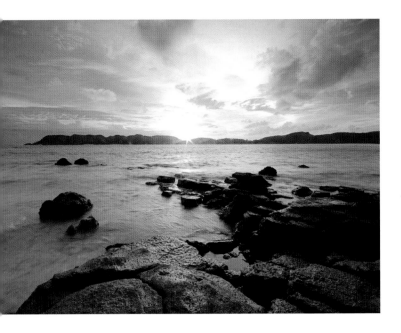

('Rice Cake War'), when local Hindus and Muslims engage in good-natured rivalry by hurling food at each other. A little further east is Pura Suranadi, Lombok's oldest and most sacred Hindu temple, and Taman Narmada park, built in 1727 to pay homage to the mighty Rinjani, which features a temple and pond shaped like the volcano and crater lake.

The arched beach at Lombok's Kuta (Kute) is still lined with the same thatched stalls and open-air beachside cafés first erected in the 1970s. Kuta is also home to one of Lombok's most enthralling weekly markets (Sundays) and the remarkable Bau Nyale festival, when every February or March thousands flock to catch seaworms, regarded as an aphrodisiac and sign of a

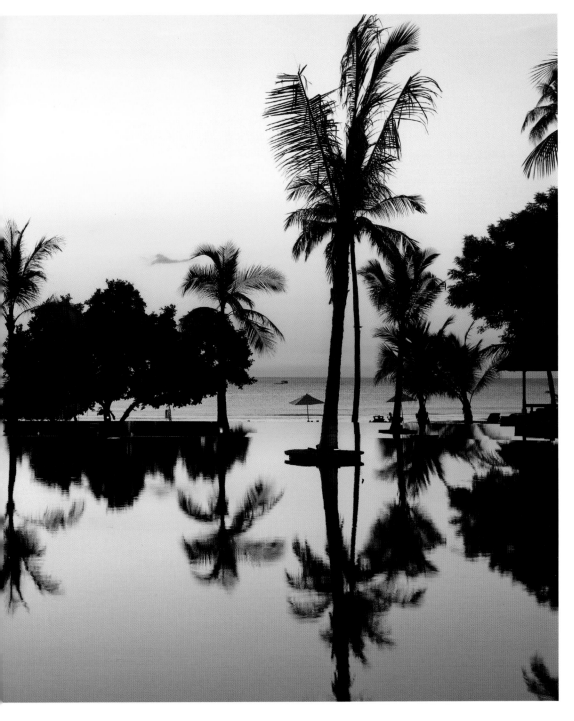

PAGES 130-1 The second highest mountain in Indonesia, Gunung Rinjani stands at 3726 meters. Views from the summit are spectacular.

ABOVE Lombok's Kuta Beach, as yet gloriously undeveloped and uncrowded, is a stark contrast to its namesake in Bali.

LEFT South Lombok also entrances visitors with stunning sunsets, such as this one, reflected in the swimming pool.

OPPOSITE ABOVE Senggigi Beach along Lombok's western shore is the most developed resort area on the island. It is home to several luxury hotels along with many restaurants and tourist stops.

bountiful harvest. For decades, Kuta, like its Balinese namesake, has been slated for major development but it may become a replica of Bali's resort complex Nusa Dua instead, with a golf course, theme park and motor racing track.

Along the road between Kuta and the airport, workshops produce and sell the distinctive and decorative style of clay pottery called *gerabah*, and indigenous Sasak villages, such as Sade, with their distinctive *lumbung* rice barns, are open to tourists.

Guided treks to the summit and/or crater lake atop Lombok's eminent volcano, Gunung Rinjani (3726 m), are popular, but also worth exploring are the villages perched along its slopes. Providing blissful views and respite from the coastal humidity are Senaru, also renowned for its thunderous waterfalls, and Tetebatu, equally famed for its lush mountainous landscapes.

Lombok enjoys the same climate as Bali but peak seasons are less pronounced. Senggigi offers hotels in every category, but so far there's only one resort in Kuta. Accommodation in other places may be basic. Flights which frequently connect Lombok to Bali and other hubs in Indonesia and Southeast Asia now arrive at the new international airport near Praya. Hardier travelers arrive by boat from Bali, but the voyage takes four to six hours and can be uncomfortable, even in calm weather. Public transport links all major towns but is infrequent elsewhere. Shuttle buses between Senggigi and Kuta are a worthier option. Otherwise, cars and motorbikes can be rented, or chartered with a driver in Senggigi, and metered taxis are available at Mataram, the airport and Senggigi.

Lombok's Southern Beaches

Kuta is remarkably undeveloped but the beaches within a few kilometers east and west are even more so. This is likely to change drastically before long given that the location of the island's new international airport is within a 15-minute drive. There is no public transport in this region of southern Lombok and roads to the west can be rough, so the only option is to rent a motorbike or charter a car with a driver in Kuta.

On top of the hill just to the west of Kuta, the village of Bangkang offers views of astonishing bays such as Mawun, a pristine and almost circular cove but with undertows that are dangerous for swimming. The friendly village of Selong Blanak is along another magnificent protected inlet that is safe for swimming and ideal for sunset watching, so massive villa construction is imminent.

Less than four kilometers east of Kuta, but half the distance on foot along the beach, is yet another gorgeous sheltered bay with rocky islets called Pantai Seger, where there are usually more goats than tourists. You think you've found heaven, but wait ... barely two kilometers further on is Pantai Aan, where the sand is even whiter, the sea bluer and the bay almost circular. This is also the finest spot for swimming and snorkeling anywhere around Kuta, and the perfect place to enjoy lunch at one of the two beachside cafés. The road east of Kuta soon ends at Gerupuk, a thriving village that produces seaweed and lobsters, and has a lucrative sideline in homestays, shops and boats for weather-beaten surfers.

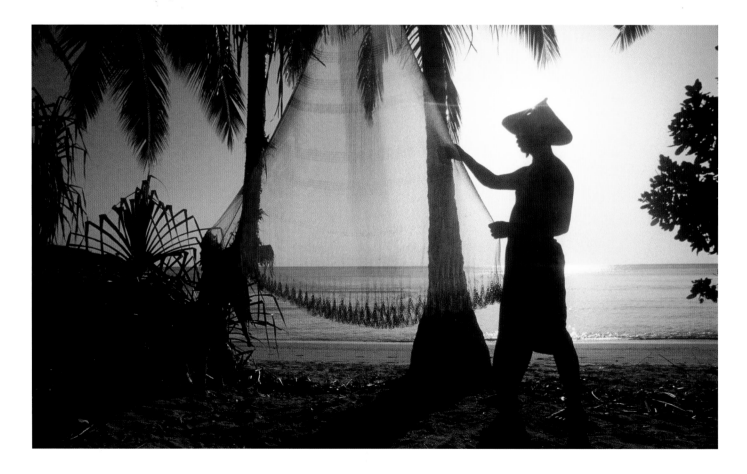

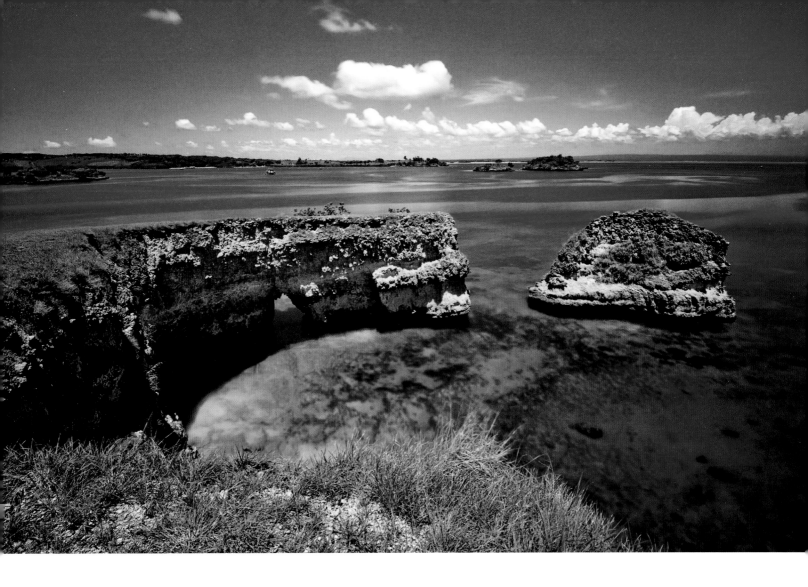

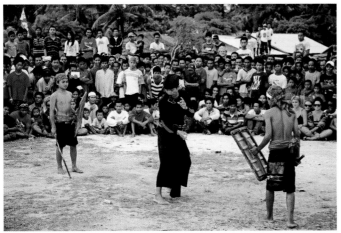

ABOVE The coastline of Gili Temeak in east Lombok is crammed with extraordinary rock formations.

LEFT Residents of Kuta in Lombok celebrate special occasions quite differently than on Bali, with, for example, mock fights with spears and shields reminiscent of those held in Sumba and other islands further east.

BELOW LEFT The bizarre Bau Nyale festival, where locals head into the sea to find seaworms, symbols of a fertile harvest, is held in southern Lombok each year and attracts thousands from across the island.

OPPOSITE Fishing is still a primary source of income and food for villagers along the remote eastern coast and islands along the south-west shore.

BELOW The best surf on Lombok is along the southern coast near Kuta, such as the surfing enclave at Gerupuk, but facilities like transport, rental and repairs are nowhere near as developed as on Bali.

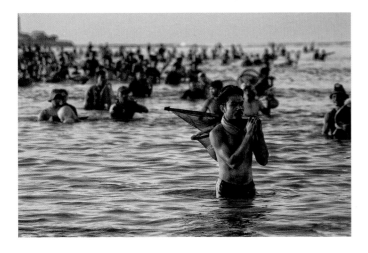

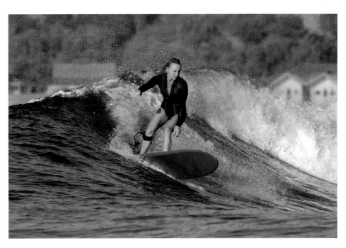

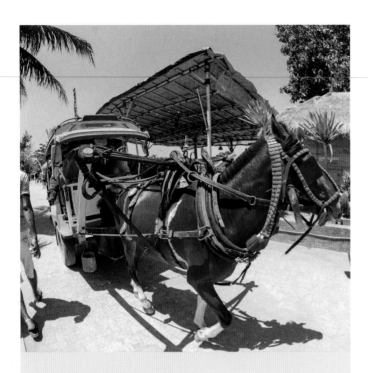

The Gili Islands

The most popular destination in Lombok, and rivaling parts of Bali for visitor numbers, is this sublime trio of islets surrounded by turquoise seas where the only forms of transport are bicycle and horse and cart (*cidomo*). While only a kilometer or two apart, 'The Gilis', as they're known, although *gili* means 'island' in the local language, are delightfully dissimilar. The main one, Gili Trawangan, has a justifiable reputation as a 'party island', although there are isolated beaches and a turtle conservation center. In stark contrast, Gili Meno appears almost uninhabited but has several attractions, including a salt lake and a bird park with macaws, toucans and, inexplicably, a museum dedicated to the Beatles. Fitting snugly between boozy Gili T and snoozy Gili M is Gili Air, which is the closest to Lombok and has an authentic village lifestyle. Sauntering around the perimeter of each island takes less than two hours, and the bleached-white beaches are dotted with a variety of homestays, resorts and cafés with cushions and gazebos on the sand that are impossible to ignore. But for many, the attractions are underwater. The 3500 species of marine life (double the number at Australia's Great Barrier Reef), including harmless sharks and gigantic turtles, are often accessible with only mask, snorkel and flippers.

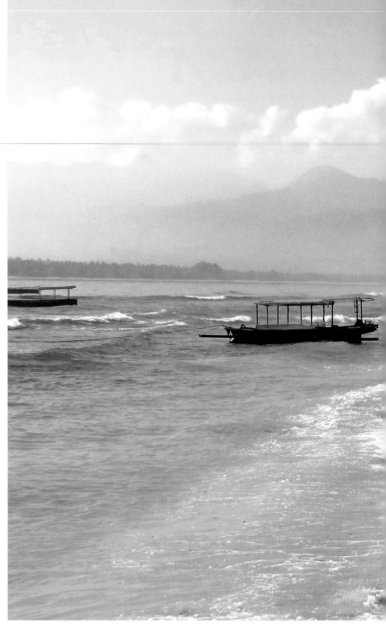

ABOVE LEFT No motorized vehicles are allowed on the Gilis, only horse carts and bicycles. This adds tremendously to their charm.

BELOW It is not unusual for foreigners to join an impromptu performance, such as this one on Gili Trawangan, where drums are a more dominant instrument than on Bali.

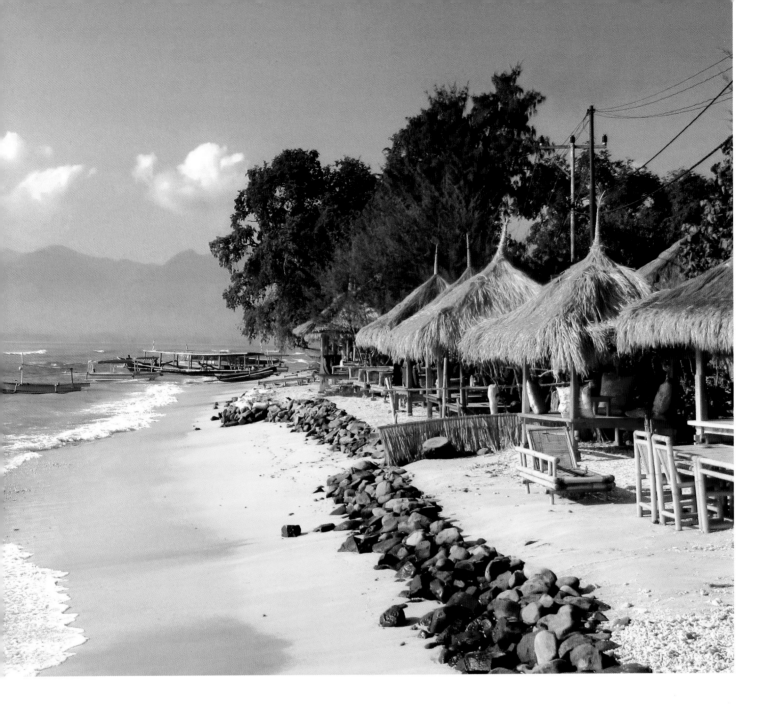

ABOVE Each of the three tiny Gili islets—this one is Gili Air—are surrounded by beaches and much of the sand is sprinkled with cafés and bars offering heavenly views and refreshing breezes.

RIGHT Tourists without a scuba diving licence can still relish in the underwater delights around the Gili Islands with snorkeling gear available for rent onshore.

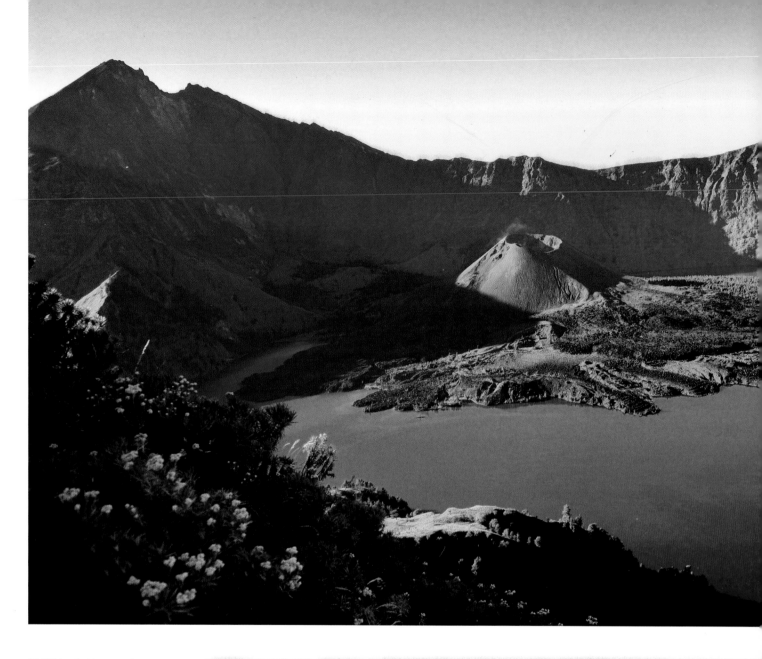

ABOVE Lombok's pre-eminent volcano, Gunung Rinjani, was formed over 14000 years ago during an explosion and is dormant, unlike the newer volcano inside the lake, which has erupted several times in recent years.

OPPOSITE ABOVE Treks last from two days/one night to four- or five-day expeditions, but even the shortest trip will provide spectacular sunrises, clouds permitting.

RIGHT Views from the top of the caldera are spectacular. On a clear day, you can see all the way to neighboring Bali.

FAR RIGHT All visitors to Rinjani, even those hiking for just a few hours, must be accompanied by qualified guides.

BACK ENDPAPERS Magnificent sunsets are a mainstay on Bali, especially at Double-Six Seminyak Beach.

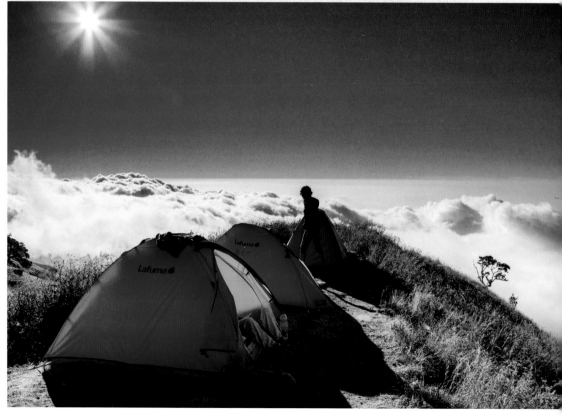

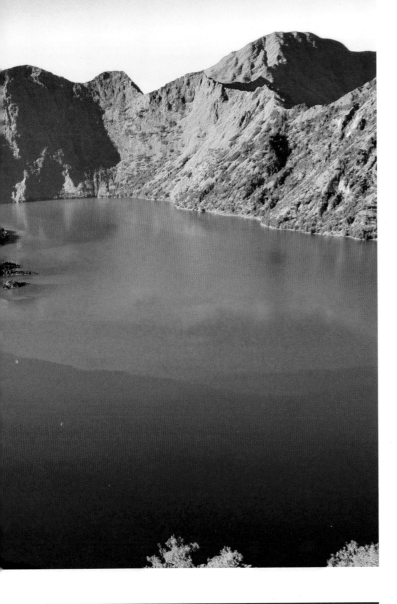

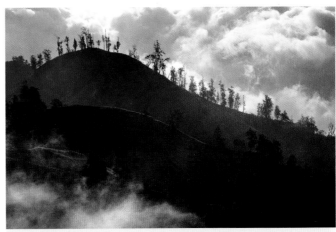

Scaling Mount Rinjani

Formed during an explosion 14000 years ago, Gunung Rinjani (3726 m) is dormant but Gunung Baru ('New Mountain') at 2351 m inside the crater has erupted several times, most recently in 1994 when van-sized boulders hurled down the valleys. The Taman Nasional Gunung Rinjani national park was established in 1997 and now covers 41330 ha.

Organizing treks at a departure point, such as Senaru, may be cheaper but arranging everything in Senggigi or the Gili Islands is advisable because the cost will include transport to the starting and finishing points. Deal with a reputable company and you'll be assured the necessary equipment is included, the guides and porters will be experienced, and everything will run smoothly except, possibly, the weather, which can be unpredictable at any time. The park closes when the rains start in December/January and won't reopen until March/April, but during the wet season day hikes to Pos (post) I or II from Senaru or Sembalun Lawang are possible with a guide.

There are three main routes: (1) two days/one night, overnighting at the camp site at the Danau Segara Anak crater lake; (2) three days/two nights, including the hot springs, starting in Senaru and finishing at Sembalun Lawang, or vice versa; and (3) the masochist four- or five-day expedition, including the summit and caves, starting in Senaru and finishing at Sembalun Lawang, or vice versa.

Otherwise, you can walk without a guide in the dry season for a one-way journey that will take about two to three hours from Senaru to Pos II. Sembalun Lawang is already high, so the 2½ hour hike with compulsory guide to Pos I is comparatively gentle.

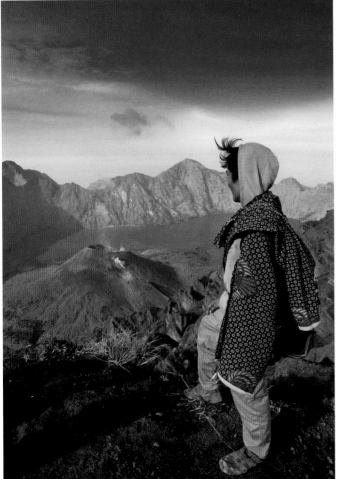

Airports and Access

Most travelers to Bali arrive at the only airport, Ngurah Rai, usually simplified to 'Denpasar' (DPS). Located only minutes from Kuta, a long overdue expansion was completed in 2014 and the international terminal is now spacious and reasonably functional. If you've pre-booked a packaged tour, your hotel should pick you up. If not, only pay for a 'hotel transfer' if you're staying in a remote area that taxis don't know or won't go to. Immediately outside the arrivals area of the separate domestic and international terminals, a short walk apart, official taxi counters sell overpriced and set-priced vouchers to all destinations.

The brand new Bandara Internasional Lombok (BIL) airport for Lombok has moved to Praya, which is handy for Kuta Beach but not for the Gili Islands or Senggigi anymore. (Codenamed LOP, the airport is still also confusingly called 'Mataram' and 'Praya'.) Official taxis loiter outside the arrivals area and use meters and are cheaper than touts with private cars. Irregular DAMRI buses link with the Sweta (Mandalika) terminal in Mataram, and shuttle buses from tourist areas drop off passengers but won't pick ny up.

Departure Taxes All tickets for international and domestic flights to/from Bali and Lombok bought after February 2015 now include the departure tax, so no extra payments are needed at the airport.

Best Time to Go

Bali and Lombok are tropical, not monsoonal. There's a definite wet season (October to March) and dry season (April to September), but there may be downpours during the 'dry' and it might not rain for a week in the 'wet' and it usually comes down in short blasts, often late in the afternoon or evening. The climate shouldn't really affect your decision about when to travel, but the peak seasons may: July and August (when Europeans flock) and mid-December to late January (major Australian school holidays).

Electricity

Indonesia uses the 220 volt system. Plugs are the two round pin variety used in Western Europe. Blackouts are not uncommon in rural areas and at times when demand is extreme.

Health and Safety

Bali and Lombok are no more, and probably less, dangerous than your own country. Much of the infrequent crime is opportunistic, for example, bag snatching, and many of the dangers, such as motorbike accidents and drowning, are caused by recklessness. Both islands are healthy enough, but take the usual precautions like bottled water and sunscreen. No vaccinations are required and major diseases such as malaria are very rare. However, rabies from the numerous stray dogs roaming the streets in Bali and dengue fever are not uncommon. International standard private hospitals, doctors and dentists can be found in major tourist centers in Bali.

Getting Around

Taxis Every second vehicle in the resort areas of Kuta/Legian and Sanur seems to be a taxi, but they are rare or non-existent elsewhere. They are all official, metered, air-conditioned and (almost always) driven by honest, helpful and English-speaking drivers. Fares are not negotiable. On Lombok, metered taxis can only be found in Mataram, at the airport and along the main road through Senggigi.

Chartering Cars Where there are no taxis you may have to charter a car with a driver. These vehicles, which are usually modern, air-conditioned and can carry up to six passengers, are also cost-effective alternatives to taxis and shuttle buses if you're in a small group. Rates are negotiable; about 70,000rp per hour or 300,000/500,000rp for six/twelve hours is reasonable. Costs should include petrol, although you'll be obliged to pay for the driver's food and accommodation if you travel overnight.

Internet

Many hotels, bars and cafés in the tourist areas offer free wi-fi, but it's rare elsewhere. While 'free wi-fi' signs are common at hotel entrances, access is often limited to the reception area or hotel restaurant because routers haven't been positioned to connect the rooms. A few Internet centers have survived the smartphone revolution, although connections can still be slow. If you're staying a few weeks and need constant access, buy a pre-paid modem that plugs into a USB port in your laptop. You'll be charged by the byte, not by time, so if you're just emailing and not downloading movies costs are low.

Mobile Phones

To avoid a horrific bill when you return, check the costs of global roaming with your phone company before using your mobile phone in Indonesia. If you intend making many local calls, buy a pre-paid SIM card from a mini-mart for your phone or buy a local phone and SIM card. Costs are so cheap that even market traders chat on their *handfones*.

Money

The national currency is the Indonesian rupiah (roo-PEE-ah), often abbreviated to Rp or IDR. By law, all payments must be made in rupiah, even if prices are quoted in USD or other foreign currencies. Many upmarket restaurants and hotels don't include the compulsory 10 percent government tax on their menus/tariffs but put them later on the bill, while also adding an unofficial 'service charge' of 5–11 percent. If a service charge is added, no tip is needed. If not, rounding up to the nearest 5000 Rp is always appreciated by underpaid staff. Tipping is not normal, however, but if you wish to reward someone 5,000–10,000 Rp is enough. Automatic teller machines (ATMs) are found in all tourist areas and larger towns. But to avoid inevitable, and often hefty, transaction fees, bring cash, which can be

changed in all tourist areas but less commonly in smaller towns. Always use banks or licensed money-changers rather than shops, verify if commission is charged (it shouldn't be), and triple-check the wad of rupiah you're given. Major credit cards are only viable in department stores and better hotels, restaurants and travel agencies, but a surcharge of 3–5 percent will probably be added. Bargaining is expected and happily encouraged by vendors in stalls and markets. In supermarkets, mini-marts and department stores where prices are marked, bargaining is bad form. Accommodation prices are almost always negotiable but food in restaurants is not.

Time

Bali and Lombok are eight hours ahead of Greenwich Mean Time, the same as Western Australia, Singapore and Malaysia. Both islands use Central Indonesian Time (WIT), which is one hour ahead of Java. There is no daylight saving anywhere in Indonesia.

Visas

On arrival in Indonesia, visitors from most countries are issued 30-day visas, which are now free for most, except Australians who are still slugged about AUD$50 to enter the country. Remember that some airlines, especially in Australia, won't allow tourists on flights to Indonesia without a return or onward ticket within 30 days. The day of arrival and departure are included in those 30 days.

ACKNOWLEDGMENTS

Many thanks to Eric Oey, publisher at Periplus, for taking the chance and sending me to Bali, and to the editor Nancy Goh for her patience and skills. Greetings to the extended Greenway, Reeve and Mogg families. And much gratitude to the exceptionally hospitable and amiable people of Bali.

BIBLIOGRAPHY

A Bali Conspiracy Most Foul by Shamini Flint—an enjoyable whodunit set around a fictional bombing
A House on Bali by Colin McPhee—a fascinating memoir by one of the first European settlers during the 1930s
A Little Bit One O'clock by William Ingram—an insightful and amusing tale of the author's life with a Balinese family
A Short History of Bali by Robert Pringle—detailed chronicle from the Bronze Age to the Bali bombs
Bali: A Paradise Created by Adrian Vickers—perceptive blend of history and culture with refreshing observations
Bali Moon by Odyle Knight—true spiritual experiences with mystics and shamans
Fragrant Rice by Janet de Neefe—a combination of culture and cuisine by Ubud's eminent restaurateur
Island of Bali by Miguel Covarrubias—a classic observation during the 1930s by a Mexican artist/anthropologist
The Art and Culture of Bali by Urs Ramseyer—the definitive work about what makes Bali so unique

ONLINE RESOURCES

- www.baliblog.com—useful articles, advice and reviews
- www.balidiscovery.com—tours, links, practicalities and updated travel news
- www.balieats.com—handy searches, reviews and explanations
- www.bali.net—informative and colorful, with links and photos
- www.bali-paradise.com—relevant business and travel information and links
- www.baliplus.com—online version of helpful local pocket guide
- www.balitravelforum.com—visitors and expats answer questions and share experiences

ABOUT TUTTLE
BOOKS TO SPAN THE EAST AND WEST

Our core mission at Tuttle Publishing is to create books which bring people together one page at a time. Tuttle was founded in 1832 in the small New England town of Rutland, Vermont (USA). Our fundamental values remain as strong today as they were then—to publish best-in-class books informing the English-speaking world about the countries and peoples of Asia. The world has become a smaller place today and Asia's economic, cultural and political influence has expanded, yet the need for meaningful dialogue and information about this diverse region has never been greater. Since 1948, Tuttle has been a leader in publishing books on the cultures, arts, cuisines, languages and literatures of Asia. Our authors and photographers have won numerous awards and Tuttle has published thousands of books on subjects ranging from martial arts to paper crafts. We welcome you to explore the wealth of information available on Asia at **www.tuttlepublishing.com**.

PHOTO CREDITS

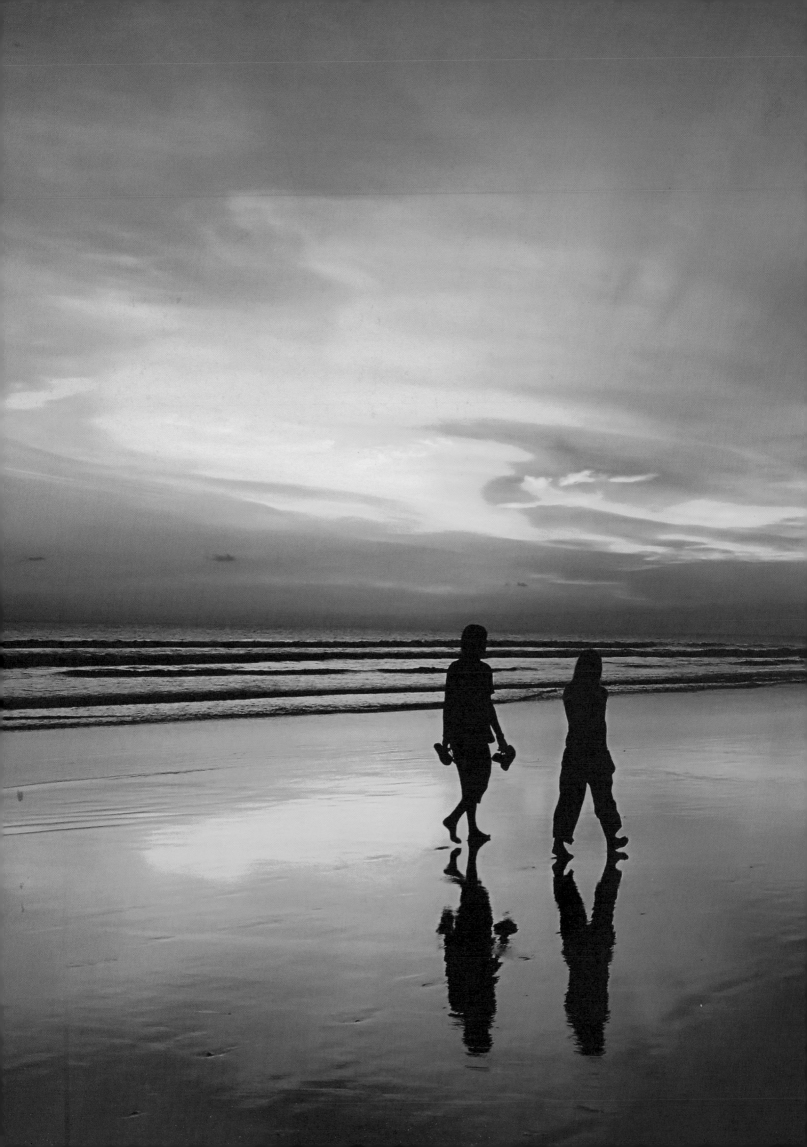